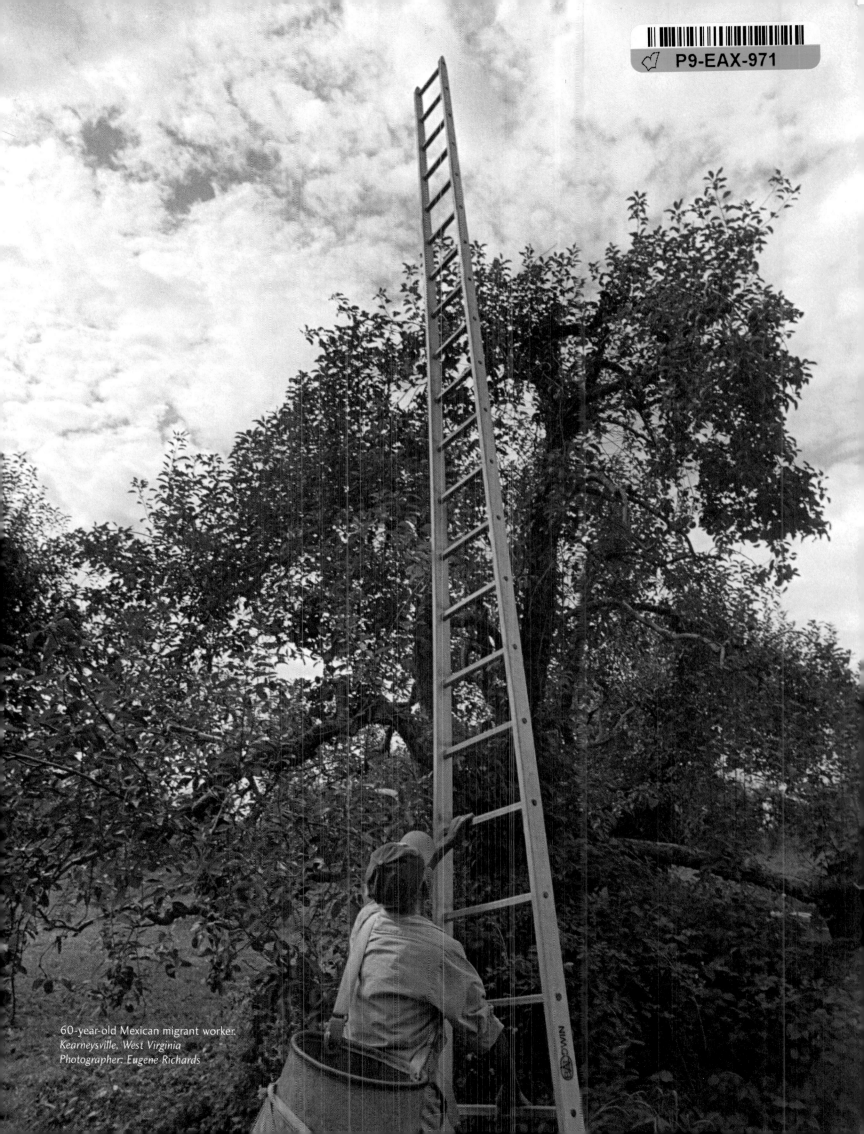

60-year-old Mexican migrant worker.
Kearneysville, West Virginia
Photographer: Eugene Richards

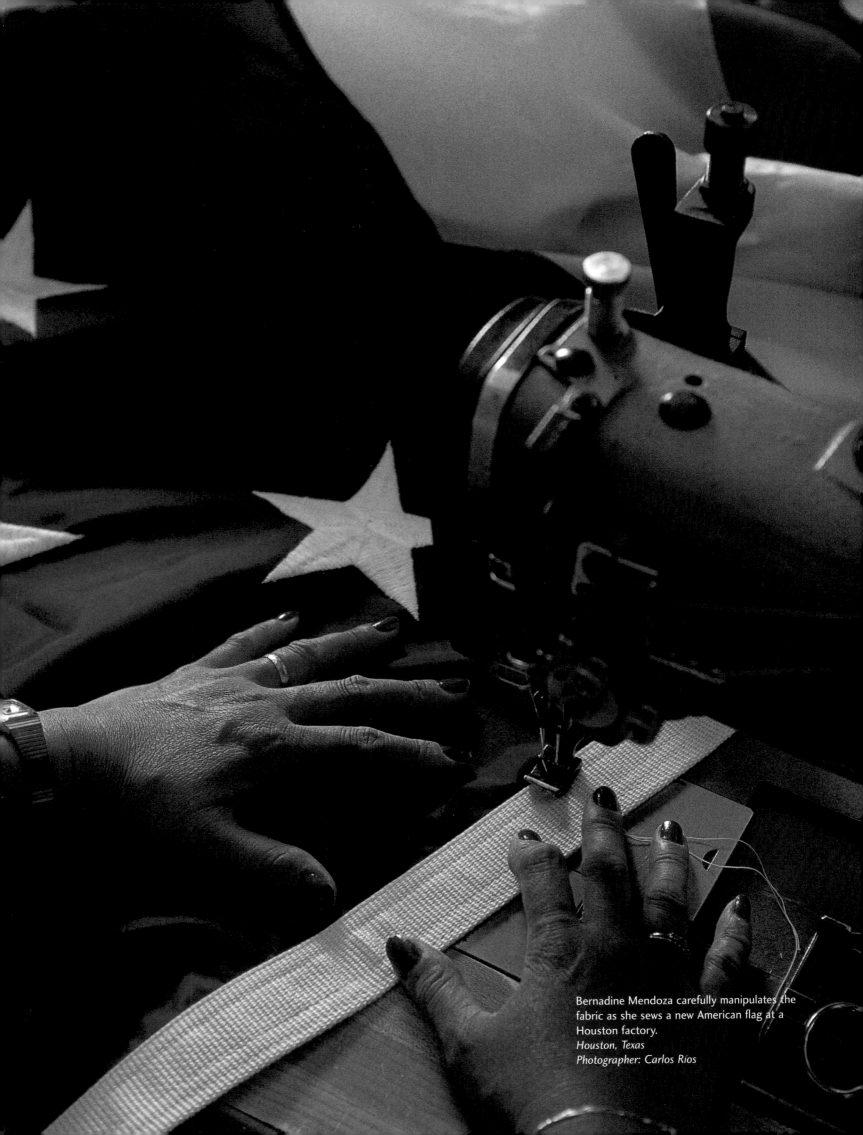

Bernadine Mendoza carefully manipulates the fabric as she sews a new American flag at a Houston factory.
Houston, Texas
Photographer: Carlos Rios

AMERICANOS

Latino Life in the United States
La Vida Latina en los Estados Unidos

Preface by Edward James Olmos, Introduction by Carlos Fuentes

Edward James Olmos
Lea Ybarra
Manuel Monterrey

Little, Brown and Company
Boston, New York, London

In-kind support for this book was provided by Time-Life Photo Laboratory and by Fujifilm.

This book accompanies the exhibition *Americanos: Latino Life in the United States*, organized by the Smithsonian Institution Traveling Exhibition Service and the Smithsonian Center for Latino Initiatives. The exhibition was made possible through the generous support of Time Warner Inc. and U.S. West. Additional support was provided by Farmers Insurance.

A forthcoming documentary film, also entitled *Americanos*, has been coproduced by Olmos Productions and Home Box Office.

Related music products available from subsidiaries of Warner Music Group.

First Edition

LIBRARY OF CONGRESS CATALOGING-IN-PUBLICATION DATA
Olmos, Edward James.
 Americanos: a portrait of the Latino community in the
United States / Edward James Olmos, Lea Ybarra, Manuel
Monterrey; preface by Edward James Olmos; introduction by
Carlos Fuentes.
 p. cm.
 Text in English and Spanish.
 ISBN 0-316-64914-7 (hc.)
 ISBN 0-316-64909-0 (pbk.)
 1. Hispanic Americans — Social life and customs —
Pictorial works. 2. Hispanic Americans — Social conditions —
Pictorial works. 3. Hispanic Americans — Social life and cus-
toms. 4. Hispanic Americans — Social conditions. I. Ybarra,
Lea. II. Title.
 E184.S75 O48 1999
 305.868'073 — dc21
 98-51930
HC: 10 9 8 7 6 5 4
PB: 10 9 8 7 6 5 4

RRD-OH

Design: Rey International

Printed in the United States of America

> The **Americanos** photo documentary has left an indelible imprint on our minds and in our hearts. We hope our work will leave a legacy that expresses true commitment to community, a pride and love of family and culture, a remembrance of our past, a celebration of our present, and a hope for the future.

V El documental fotográfico llamado **Americanos** ha dejado una huella imborrable en nuestras mentes y en nuestros corazones. Esperamos que nuestro trabajo deje una herencia que exprese una verdadera dedicación a la comunidad, un orgullo y amor por la familia y cultura, una añoranza por nuestro pasado, una celebración de nuestro presente y una esperanza por el futuro.

Edward James Olmos, Lea Ybarra, Manuel Monterrey

Dedicated to our children

Dedicado a nuestros niños

acknowledgments *reconocimiento*

> The completion of *Americanos* would not have been possible without the assistance of many dedicated and talented individuals. First and foremost, we must thank the thirty-two photographers who participated in this project and provided us with a portrait of Latino life in such beautiful and dramatic images. We owe a large debt of gratitude to the team of photo editors — Mark Hinojosa, Eric Easter, Liliana Nieto del Rio, Michel du Cille, José Gálvez, and John Castillo — who reviewed over 50,000 photographs. Eric Easter served as a consultant to the project and we benefited greatly from his guidance and expertise. A deep appreciation to the writers, who added a deeper sense of understanding of the photographic images. We especially thank Carlos Fuentes for his eloquent introduction. Thank you to Dr. David Carrasco of Princeton University who shared his creative spirit and helped us identify many of those talented writers. Thank you also to Robert M. Young for his support. A special thank you to Hortencia Gonzalez who provided Spanish translations for the majority of the material, and did a superb job despite tight deadlines. And thank you to the writers who provided translations of their own works. Many, many tasks are associated with a project of this magnitude. Many thank yous to John Castillo, project coordinator, and to Jimmy Dorantes, for helping us complete those many tasks that arose throughout the project. Thank you to Noelia Cantu-Martin for patiently and efficiently assisting on a daily basis with a myriad of project duties, and to Belinda Morales for her assistance throughout the project. We are also grateful for the assistance provided by the Olmos Productions staff, Fernando Cubillas and Steve Hunt. To Michael G. Rey, the *Americanos* book designer, our heartfelt appreciation and gratitude. He and his staff were creative and committed to the project, and did a great job of bringing it all together — the photographic images and the text — and designing a book that we can all be proud of. Our special thanks to Miriam Campiz for her suggestions and consultation in the book design process.

We are very appreciative of the tremendous support we have received from Time Warner for this book project. Thank you especially to Toni Faye for her unwavering enthusiasm for *Americanos* and for her wisdom and guidance. Thank you to Angelo Gonzalez for his assistance. Thank you also to Lisa Quiroz, John Paterson, and the staff from *People en Español* for their efforts on behalf of the project. This book would not have been possible without the support of Bill Phillips and his wonderful staff at Little, Brown and Company. We benefited tremendously from the editorial assistance and suggestions provided by the staff in Little, Brown's New York and Boston offices. They were a great team to work with and we sincerely thank all of them. Thanks a million to all the wonderful people who have been captured in the photographs of *Americanos*.

Americanos no hubiera sido posible sin la asistencia de muchos individuos talentosos y dedicados a este libro. Primeramente, damos las gracias a los treinta y dos fotógrafos que participaron en este proyecto y quienes nos dieron un retrato de la vida latina con imágenes bellas y dramáticas. Les debemos una enorma gratitud a los redactores de fotos — Mark Hinojosa, Eric Easter, Liliana Nieto del Río, Michel du Cille, José Gálvez, y John Castillo — quienes revisaron más de 50,000 fotos para este libro. Y gracias a Eric Easter por ser consultor de este proyecto. Nos beneficiamos de su dirección y experiencia. Apreciamos mucho a los escritores, que con sus contribuciones nos dan un mejor entendimiento de las imágenes fotográficas. Unas gracias especiales a Carlos Fuentes por su elocuente introducción. Gracias a David Carrasco, quien compartió su espíritu creativo y nos ayudó a identificar a muchos de estos escritores talentosos. Gracias también a Robert M. Young. Unas gracias especiales a Hortencia González, que hizo muchas de las traducciones en español, por su excelente trabajo. Gracias también a los escritores que hicieron sus propias traducciones. Siempre hay muchas tareas asociadas con un proyecto de esta magnitud. Unas gracias especiales a John Castillo y Jimmy Dorantes por ayudarnos con estas tareas. Muchísimas gracias a Noelia Cantu-Martin por ayudarnos todos los días con muchas tareas y por hacerlo con paciencia y eficiencia. Gracias también a Belinda Morales por su ayuda durante el proyecto. Gracias al personal de Olmos Productions, Fernando Cubillas y Steve Hunt. A Michael G. Rey, el diseñador de *Americanos,* nuestro gran aprecio y gratitud. Él y sus colegas hicieron un gran trabajo en diseñar un libro que nos llenará de orgullo a todos. Gracias por su creatividad y dedicación a este proyecto. Gracias especiales a Miriam Campiz por sus sugerencias y ayuda en el diseño del libro.

Apreciamos mucho el apoyo que recibimos de Time Warner para este libro. Gracias especialmente a Toni Faye por su gran entusiasmo por *Americanos* y por su sabiduría y dirección, y a Angelo González por su asistencia. Gracias también a Lisa Quiroz, John Paterson y al personal de *People en Español* por sus esfuerzos en favor del proyecto. Este libro no hubiera sido posible sin el apoyo de Bill Phillips y los empleados de Little, Brown and Co. Nos beneficiamos mucho con la ayuda editorial de las oficinas en Nueva York y Boston. Fue un placer trabajar con ellos y les damos las gracias a todos. Mil gracias a toda la gente maravillosa que está representada en los fotos de *Americanos*.

Don Adrián Quiñonez Segovia, 87, gently cradles an old worn photograph of his wife, María Teresa González Berumen de Quiñonez, who had passed away.
Taylor, Texas
Photographer: Magdalena Zavala

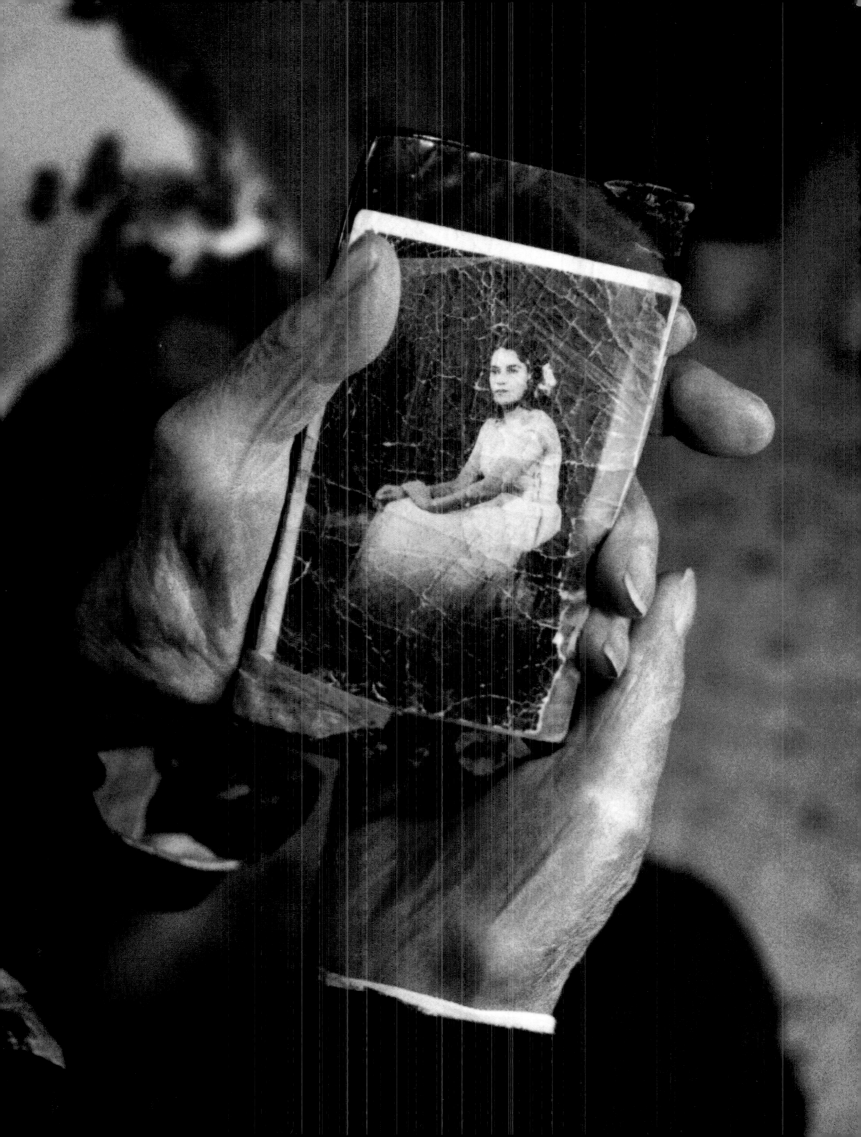

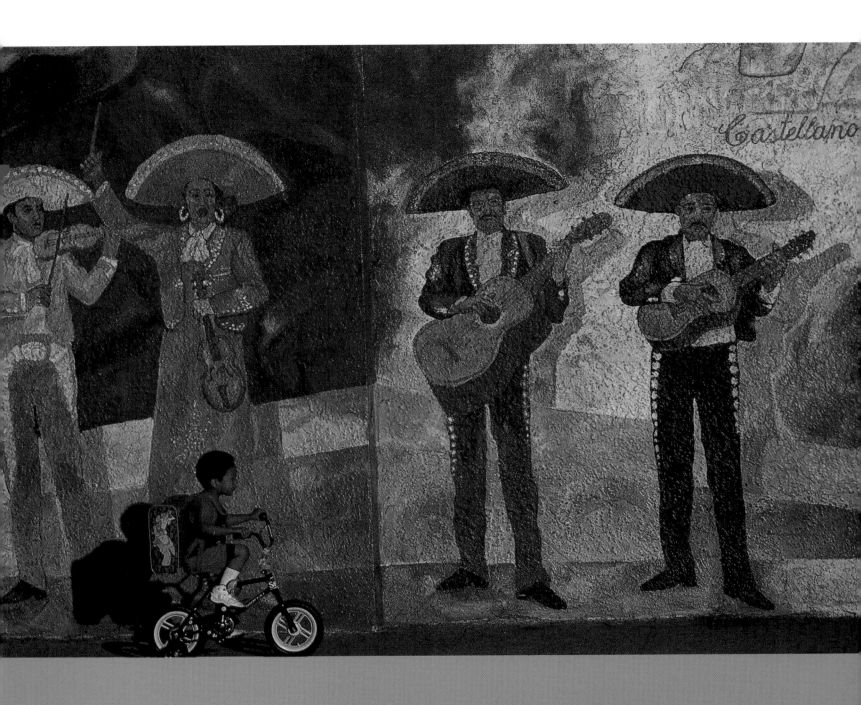

Gustavo González, 3, rides his bike past
a mural of mariachis at Mariachi Plaza in
Boyle Heights.
Los Angeles, California
Photographer: Genaro Molina

preface *prefacio*

Edward James Olmos

> I have had few experiences that have been as rewarding to me as the making of *Americanos*. As the book evolved, it became a source of inner peace. Aside from the birth of my children, nothing has ever inspired me more.

Why *Americanos?* Why would we give this title to a book on Latinos? There are several reasons. One is that too often society sees us not as Americans but as strangers to this land. We have worked hard to help build this country and we continue to do so every day. The face of America should include us. Second, as Latinos we often think of *Americanos* as the others in this country, not us. We, and especially our children, need to see that we are an integral and equal part of U.S. society. Third, we wanted a title that would recognize and honor our bilingual heritage and would be easily understood in both English and Spanish. And, finally, we wanted to illustrate that, much like a quilt woven intricately with many beautiful fibers, Latinos are a proud and diverse people interwoven with indigenous, Spanish/European, African, and Asian roots. We are citizens not only of the United States of America, but also of all the Americas and of the Latin American countries around the world. My colleagues and I gave much thought to the title and the content of this book, and we hope we have created a work that will endure the passing of time.

This book has been over two years in the making. Thank you to Manuel Monterrey for walking into my office to present the idea, and to Dr. Lea Ybarra for sharing the dream and the responsibility for its evolution. We worked with a team of editors, who reviewed more than fifty thousand photographs taken by thirty-two photographers from across the country. Fifteen writers have supplemented the selected photos with the imagery and creativity of the written word.

The photographers, writers, and designers who bring life to these pages have blessed our children with inestimable riches. The contributions of Latinos to the United States of America — documented in all their beauty and diversity — are gifts that will go down in the history of the United States and its art as one of a kind. Many people have worked to make this book a reality because we all believe that a positive and realistic portrayal of Latinos has been long overdue.

Too often, only one aspect of Latino culture is apparent. That is the culture that we see from our car windows, on newscasts, in restaurants, and from the stadium seats. That's the Latino culture that others know about, that is obvious and visible. There are also those aspects of Latino culture that are unseen or unknown because Latinos have become so fully integrated in the United States.

Latinos are the doctors, teachers, business owners, cooks,

V

Son pocas las experiencias en mi vida que hayan sido tan gratificantes para mí como el del proyecto *Americanos*. Según tomó forma esta obra se convirtió en un caudal de paz interna. Con la excepción del nacimiento de mis hijos, nada me ha inspirado más.

¿Por qué le dimos el título de *Americanos* a un libro sobre latinos? Hay ciertas razones que guiaron nuestra decisión. Una de ellas es que demasiadas veces esta sociedad no nos ha visto como americanos, sino como extranjeros en este país. Hemos trabajado demasiado para ayudar a edificar este país y continuamos haciéndolo todos los días. Cuando la gente vea la cara de América, necesita ver nuestra imagen incluida en esa cara. Además, como latinos nosotros mismos pensamos que los "americanos" son los otros en este país, no nosotros.

Nosotros, y especialmente nuestros hijos, necesitan ver que somos una parte integral e igual en esta sociedad. También queríamos ver un título que reconociera nuestra herencia latina y que se pudiera entender fácilmente tanto en español como en inglés. Finalmente, queríamos presentar que al igual que una colcha tejida con fibras hermosas e intrínsecas, los latinos son un pueblo con orgullo, con diversidad entretejida con raíces indígenas, españolas/europeas, africanas y asiáticas — ciudadanos no sólo de los Estados Unidos de América, sino de las Américas, y de todos los países latinoamericanos que son parte de estos continentes. Dimos mucha importancia y sometimos a discusión el título y contenido de este libro y esperamos que hayamos creado una obra que perdure con el paso de tiempo.

El proceso de realizar este libro tomó más de dos años. Gracias a Manuel Monterrey por entrar a mi oficina y presentarme la idea, y a la Dra. Lea Ybarra, por compartir el sueño y la responsabilidad de su evolución. Trabajamos con un equipo de editores que recibieron más de 50,000 fotografías tomadas por treinta y dos fotógrafos de todo el país. Dieciocho escritores han contribuido a nuestra comprensión de estas fotos por medio de la imagen y creatividad de la palabra escrita.

Los fotógrafos, escritores y diseñadores que dieron vida a estas páginas han bendecido a nuestros hijos con una riqueza inmensa. Las contribuciones de los latinos en los Estados Unidos de América — documentada en toda su belleza y diversidad — es un regalo que será parte de la historia de esta sociedad y su arte como algo único. Muchos han trabajado para que este libro se hiciera realidad porque todos creemos que ya era tiempo de presentar una imagen positiva y realista de los latinos.

Demasiadas veces, sólo un aspecto de la cultura del latino

politicians, farm workers, baseball players, astronauts, and many others who daily contribute to this society. This book shows both that which we see and take for granted as well as that which is unseen or ignored. It shows Latinos in our many roles and reveals the indelible mark we have made in the United States. We have needed this book for a long time. Too often, the non-Latino community learns only one part of our story. The Latino community as well — whether we are the Chicano in East Los Angeles, the Puerto Rican in the Bronx, or the El Salvadoran in Chicago — often knows only part of the story. The story of Latinos in the United States and our contributions to U.S. society have too often been excluded from the history books we read in our schools and from the images we see in the media.

We hope these photographs will reveal a people who are diverse in culture, color, ideas, and dreams, but who share a common desire to make a better life for themselves, their families, and their communities. These still images, through their silent dignity, embrace, explore, and define the very essence of American culture. They reveal the story of Latinos and, in so doing, tell the story of America. When you see this book, you will see America.

Gracias to everyone who has given time, dedication, and energy to this book. We present it to you, the reader, *con respeto y amor.*

ha estado a la vanguardia. Así que cuando hablamos del latino, hablamos de una cultura conocida y desconocida. Hay una cultura que podemos ver por los cristales de nuestros coches, por los medios de comunicación, en restaurantes y desde nuestros asientos del estadio. Ésa es la cultura latina que otras culturas conocen del latino, la que es obvia a la vista. Pero también hay aspectos de la cultura latina que muchos no ven o conocen porque los latinos se han integrado completamente a este país.

Hay latinos que son doctores, maestros, empresarios, cocineros, políticos, campesinos, jugadores de béisbol de las ligas mayores, astronautas, y muchos más que contribuyen a esta sociedad. Este libro muestra ambos lados: tanto lo que se ve y toma como verdad como lo que no se ve o ignora. Muestra al latino en nuestras muchas capacidades y revela la marca indeleble que hemos dejado en este país. Necesitábamos este libro desde hace mucho tiempo. Demasiadas veces la comunidad no latina sabe sólo una parte de nuestra historia. La comunidad latina también necesitaba este libro porque ya sea el chicano de East Los Ángeles, el puertorriqueño o el salvadoreño en Chicago nosotros a menudo conocemos sólo parte de la historia. Constantemente nuestra historia y nuestras contribuciones a esta sociedad han sido excluidas de los libros de historia de este país que leemos en las escuelas, y de las imágenes que vemos por los medios de comunicación.

Esperamos que estas imágenes fotográficas empiecen a relatar la historia sobre una gente que es diversa en su cultura, color, ideas, y sueños, pero que comparte un deseo común de mejoramiento en sus vidas para ellos, sus familias, y sus comunidades. Estas imágenes, por medio de su silenciosa dignidad, abrazan, exploran y definen la esencia misma de la cultura americana. Revelan la historia de los latinos y, a la vez, cuentan la historia de América. Cuando usted vea este libro, usted verá a América.

Gracias a todos los que han dado de su tiempo, dedicación y energía a este libro. Se lo presentamos a usted, el lector, con respeto y amor.

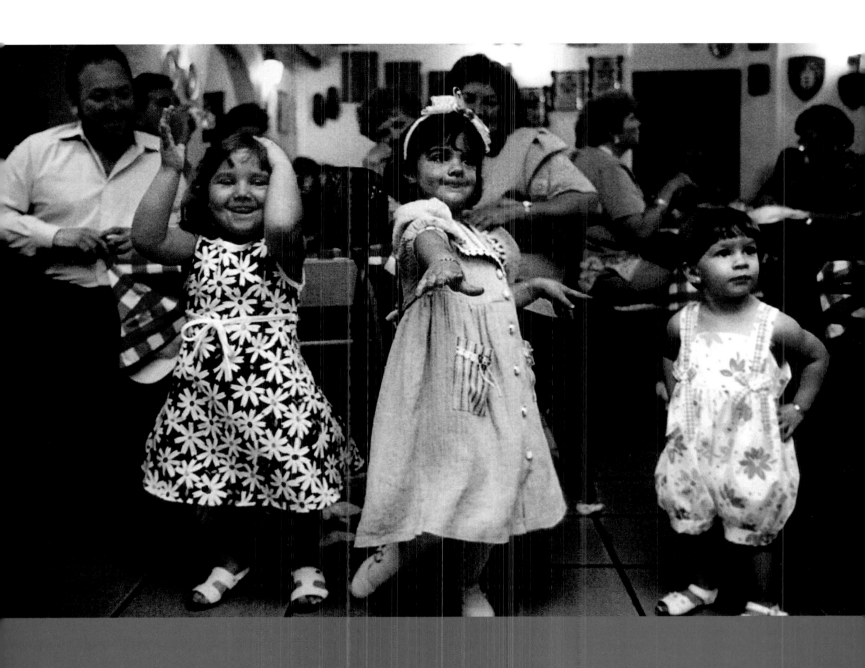

Michelle Avalos (left), Melissa Ramos (center),
and Melissa Avalos dance the Macarena at El
Gallego restaurant.
Miami, Florida
Photographer: Nuri Vallbona, courtesy of the
Miami Herald

introduction *introducción*

Carlos Fuentes

> See them. *Miralos.* They are here. *Están aquí.* They were always here. *Siempre estuvieron aquí.* They arrived before anyone else. *Llegaron antes que nadie. Nadie les pidió pasaportes, visas, tarjetas verdes, señas de identidad.* Nobody asked them for passports, visas, green cards, signs of identity. There were no border guards at Bering Strait when the first men, women, and children crossed over from Asia fifteen thousand to thirty thousand years ago. There were no green cards demanded of the Spanish conquerors, settlers, and missionaries who came into the Southwest and Florida in the sixteenth century. Just as nobody was there to demand entry permits of the Pilgrims who landed on Plymouth Rock in 1620 — one hundred years after Cortés discovered California, Ponce de León *la Florida,* and Cabeza de Vaca was shipwrecked on the coast of Texas.

No había nadie aquí. There was no one here. We all came from somewhere else. *Todos llegamos de otra parte. Y nadie llegó con las manos vacías.* Nobody arrived empty-handed. The first migrations from Asia into North America brought the skills of hunting, fishing, building fires, baking adobes, raising families, planting corn, establishing townships, singing songs, dancing to the rhythm of the sun and the moon so that the earth would not come to a halt.

Los indios were the first poets, they chanted clapping their hands both to praise and to enumerate the metaphors of the world: the woman as field, the father as seed, the child as plant, the young bride as flower, the young lover as river, the whole community as a god-like incarnation of the powers of love, communication, protection of the weak, rejection of the aggressor, compassion for those who suffer, the eternal mission of society to look after the sick, the insecure . . . *los olvidados.* All together now, keep your eyes open beyond yourselves, see the margins of the world, where those who are different from us are waiting to demonstrate that they are as human as we.

Recognize yourselves in he or she who are not like you or me.

This ancient mandate reverberates in the pictures assembled in this extraordinary book. The faces, the bodies, the movements of the men and women hark back to the great dawn of North America, but they are not only the great dreamers of the origin, but also the grand memory of the past, they are descendants of Iberia as well as Aztlan and Borinquen and Cuba, first imagined as Cipango, the oriental island Japan. We descend from all the islands naming themselves twice or thrice, Indian and Spanish and African, in the waters of the Caribbees. We have come down from the mountains in the great backbone of the Americas, the vast ranges stretching from the Rockies to the Sierra Madre to the Andes to the Archipelagos, falling off

V

See them. Míralos. *They are here.* Están aquí. *They were always here.* Siempre estuvieron aquí. *They arrived before anyone else.* Llegaron antes que nadie. Nadie les pidió pasaportes, visas, tarjetas verdes, señas de identidad. No había guardias fronterizas en los Estrechos de Behring cuando los primeros hombres, mujeres y niños cruzaron desde Alaska hace quince mil a treinta mil años. Nadie les pidió tarjetas verdes a los conquistadores, exploradores y misioneros españoles que llegaron al suroeste y a la Florida en el siglo XVI. De la misma manera que nadie les solicitó permisos de entrada a los puritanos ingleses que desembararon en Plymouth Rock en 1620 — un siglo después de que Cortés descubrió California, Ponce de León la Florida y Cabeza de Vaca naufragó en la costa de Texas.

No había nadie aquí. *There was no one here. We all came from somewhere else.* Todos llegamos de otra parte. Y nadie llegó con las manos vacías. Las primeras migraciones de Asia a la América del Norte trajeron la caza, la pesca, el fuego, la fabricación del adobe, la formación de familias, la semilla del maíz, la fundación de los pueblos, las canciones y los bailes al ritmo de la luna y el sol para que la tierra no se detuviese nunca.

Los indios fueron los primeros poetas, cantaban palmeando para elogiar y enumerar las metáforas del mundo: la mujer como campo sembrado, el padre como semilla, el niño como planta, la novia como flor, el joven enamorado como un río, la comunidad entera como encarnación divina de los poderes del amor, la comunicación, la protección del débil, el rechazo del agresor, la compasión hacia los que sufren, la misión eterna de la sociedad de cuidar al enfermo, apoyar al inseguro, recordar al olvidado.

Todos juntos, miremos más allá de nosotros mismos, abramos los ojos hacia las márgenes del mundo, donde nos aguardan todos los que siendo distintos a nosotros, nos aguardan para demostrarnos que son tan humanos como nosotros.

Reconozcámonos en él o ella que no son como tú y yo.

Este antiguo mandato reverbera en las fotografías incluidas en este libro extraordinario. Los rostros, los cuerpos, los movimientos de nuestros hombres y mujeres se remontan a la gran aurora de la América del Norte, pero ellos y ellas no son solamente los grandes soñadores del origen, también son la gran memoria del pasado, son los descendientes de Iberia como lo son de Aztlán y Borinquen y Cuba, imaginadas primero como Cipango, la isla del Oriente, Japón. Descendemos de todas las islas que se nombraron por partida doble y hasta triple, nombres indígenas y españoles y africanos, en la columna dorsal de las Américas, las cordilleras que recorren el continente desde las Rocallosas a la Sierra

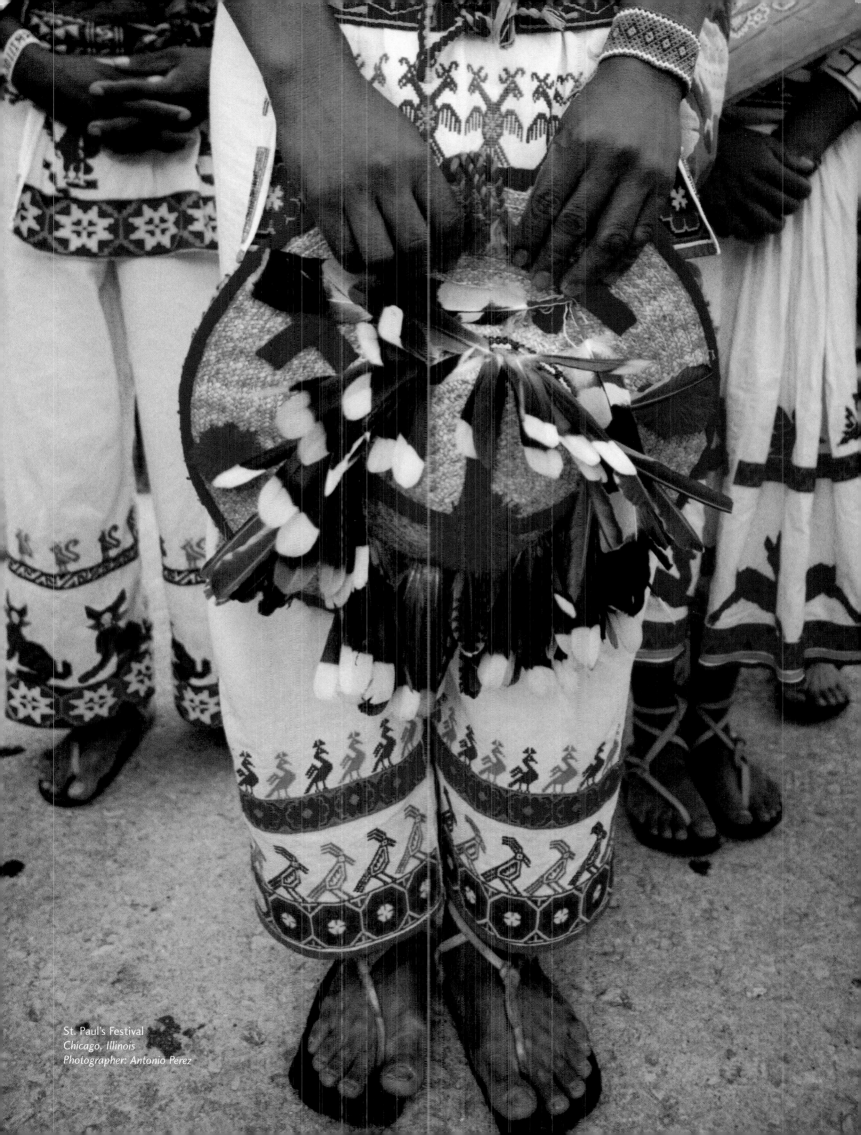

St. Paul's Festival
Chicago, Illinois
Photographer: Antonio Pérez

Amber Ramírez, dancer in the Quetzalcoatl Citlalli Aztec dance group performs in Sacramento's Fiesta de la Familia Festival. *Sacramento, California* *Photographer: José Luis Villegas*

like cold, beautiful grapes at the foot of the continent, Chile, Argentina . . .

Mestizos. Indios. Negros. Europeos. Indo-Afro-Euro Americanos. Latinos, Hispanics, call them what you will: they are the children of movement and encounter, meeting in love and suffering in slave ships and plantations, in mines and in chapels, in carnivals and in tool shops. How many hands in the Americas first met over a carpenter's bench or a silversmith's table, digging the treasures of Potosí or rowing the Magdalena or plowing the fields of Puerto Rico? How many friendships in the Americas did not begin in kitchens as perfumed as gardens, in the delicious blending of maize and chile, herbs and mushrooms, *huachinango* from the Gulf, *congrio* from the Pacific. Smell the "sagrado olor de la panadería," asked the Mexican poet López Velarde, breads as varied as the conch names, sword names, ball names, powder names, *conchas, banderillas, bolillos, polvorones* . . .

How many songs were sung to recall the history of the mestizo epic, from Murrieta in California to Pancho Villa in Chihuahua to Martin Fierro in the Pampas, dance bringing together all that makes the body beautiful, rhythmic, delighted to be of the world, in the world, the Indo-Afro-Iberian world where the tango is Andalusian and African, the Mexican corrido a descendent of the Castilian *romancero*, the soulful bolero a child of the Arab love-call, the whole Caribbean a carnival of sounds and pleasures derived from all the traditions of the human voice and the human body, its passions, its pains, its longings, its rebellions.

These are the hands that took up arms with Bolívar and Martí and Zapata, but also the hands that fashioned the perfect altar and the candy skull, the mural by Orozco and the anonymous graffiti in East L.A. These are the arms that plowed and cut and shaped and smoothed out the world as lovers smooth out each other's backs, and these are the hands that brought food and flowers into the world as they brought their children into their homes: to love and nourish and hope and protect . . .

These hands have fought and worked. These mouths have sung and kissed. These ears have heard and feared. These eyes have seen and dreamed.

They are all here, from Alaska to Magellan.

They are all here, from California to New York.

Madre a los Andes a los archipiélagos, que se desgranan como uvas frescas y hermosas al pie del continente, en Chile y Argentina…

Mestizos, indios, negros, europeos, indo-afro-euro-americanos, latinos, hispánicos, llámenlos como quieran: son los hijos del movimiento y el encuentro, citados por el amor pero sujetos al sufrimiento en barcos esclavistas y plantaciones, en minas y en iglesias, en carnavales y en talleres.

¿Cuántas amistades en las Américas no se iniciaron en cocinas perfumadas como jardines, mezclas deliciosas de maíz y chile, hierba y hongo, huachinango del Golgo, congrio del Pacífico. Hay que oler "el sagrado olor de la panadería", nos pidió el poeta mexicano Ramón López Velarde, el perfume de panes tan variados como sus nombres de concha, banderilla, polvorón, bolillo, arepa…

¿Cuántas canciones no se habrán cantado para contar la historia de la épica mestiza, de Joaquín Murrieta en California a Pancho Villa en Chihuahua a Martín Fierro en la Pampa? ¿Cuántos bailes no se habrán bailado para exaltar la belleza de los cuerpos, el ritmo de los cuerpos felices de ser parte del mundo, de ser en el mundo, el mundo indo-afro-ibero-americano donde el tango es andaluz y es africano, el corrido mexicano desciende del romancero español, el alma del bolero es el llamado árabe al amor y el Caribe entero es un carnaval de sonido y placeres derivados de todas las tradiciones de la voz y el cuerpo humanos, sus pasiones, sus dolores, sus deseos, sus rebeliones.

Éstas son las manos que tomaron armas con Bolívar y Martí y Zapata, pero también las manos que formaron el altar perfecto y la calavera de azúcar, el mural de Orozco y los graffiti de las paredes de East L.A.

Éstos son los brazos que araron, cortaron y dieron forma al mundo de la misma manera que los amantes le dan forma con sus caricias a la espalda del ser amado.

Éstas son las manos que trajeron al mundo comida y flores mientras traían niños a los hogares: todo para amar y alimentar, y proteger y tener esperanza.

Estas manos han luchado y han trabajado. Estas bocas han cantado y han besado. Estas orejas han oído y han temido. Estos ojos han visto y han soñado.

Aquí están todos, desde Alaska al Cabo de Hornos.

Aquí están todos, desde California a Nueva York.

¿Dónde estaríamos sin ellos?

¿Dónde estarían ellos sin nosotros?

Porque esto es lo que esta historia y la historia de estos retratos, tan amorosamente reunidos, nos quieren contar.

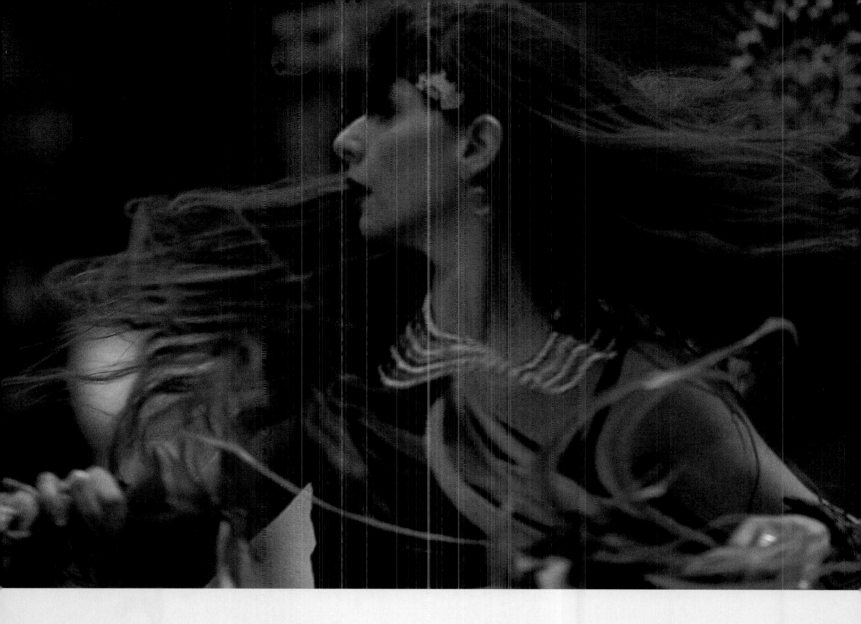

Where would we be without them?

Where would they be without you?

For this is the point of the story and the story of these pictures so lovingly assembled for you. All the individuals who appear in this remarkable book need and are needed. They are picking the food we need on our tables, they are serving us our meals and taking care of our children, they are cutting our hedges and driving our buses and bringing dignity to the indispensable, never the "lowly," the indispensable tasks of life. Without them, prices would rocket, inflation would inflate, and food would be scarce.

But they are also the young teachers of their own and others, they are the new businesspeople rapidly growing and diversifying U.S. services and production, they are the new doctors and lawyers and architects and biologists and politicians, they are the new singers and actors and dancers and stage directors and painters and musicians enriching U.S. culture with contrast, diversity, and generosity.

Out of fifty thousand photographs, two hundred are presented in this book.

They represent all the rest.

They rediscover each one of us.

We are all here.

Todos estamos aquí.

Todos y cada uno de los individuos que aparecen en este libro notable necesita y se necesita. Están recogiendo los frutos que necesitamos en nuestras mesas. Nos están sirviendo nuestras comidas y atendiendo a nuestros hijos. Están cortando nuestros céspedes y manejando nuestros transportes y dándole el sello de la dignidad a las indispensables, nunca inferiores, sino indispensables tareas de la vida. Sin ellos, los alimentos escasearían.

Pero éstos son también los jóvenes maestros de los suyos y de los otros, son los nuevos empresarios que están creando, creciendo y diversificando los servicios y la producción en los Estados Unidos. son los nuevos cantantes y actores, y bailarines y directores teatrales, y pintores y músicos que están enriqueciendo la cultura de los Estados Unidos con los dones del contraste, la diversidad y la generosidad.

Se tomaron cincuenta mil fotografías. Doscientas están representadas en este libro.

Representan a todos.

Nos redescubren a cada uno de nosotros.

We are all here.

Todos estamos aquí.

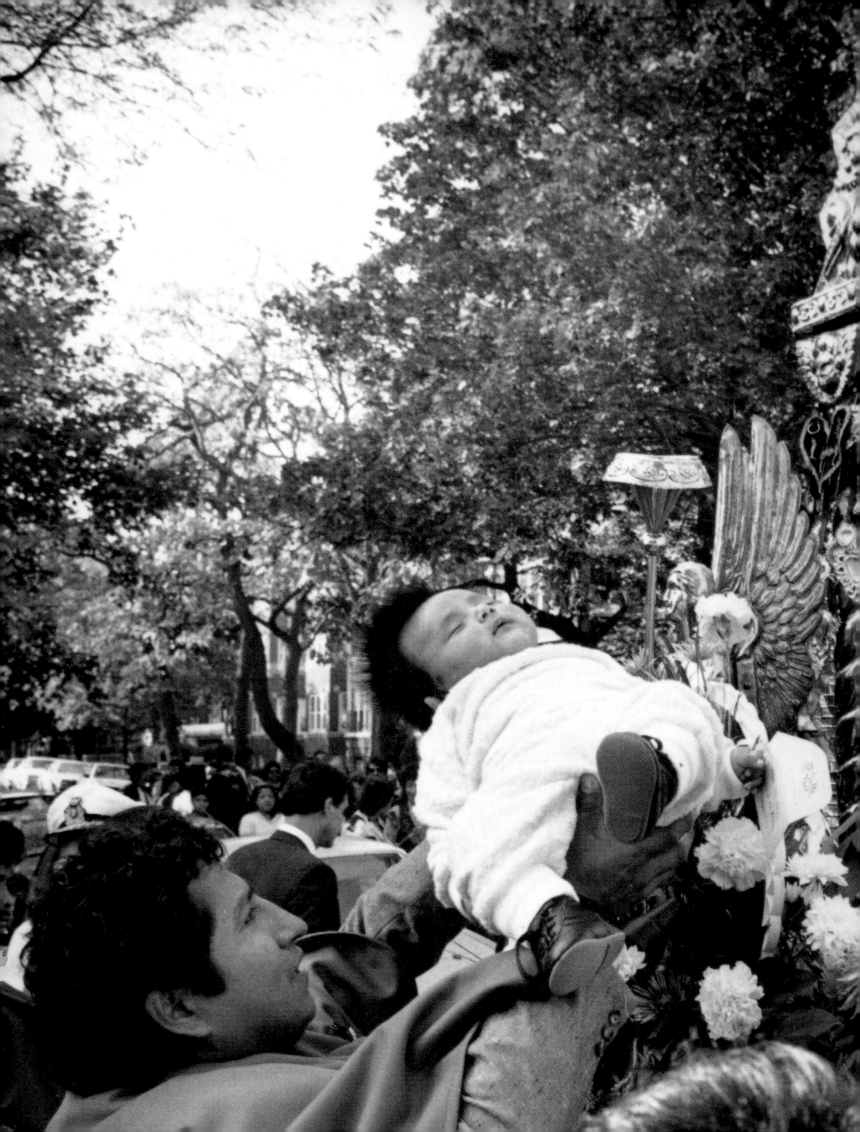

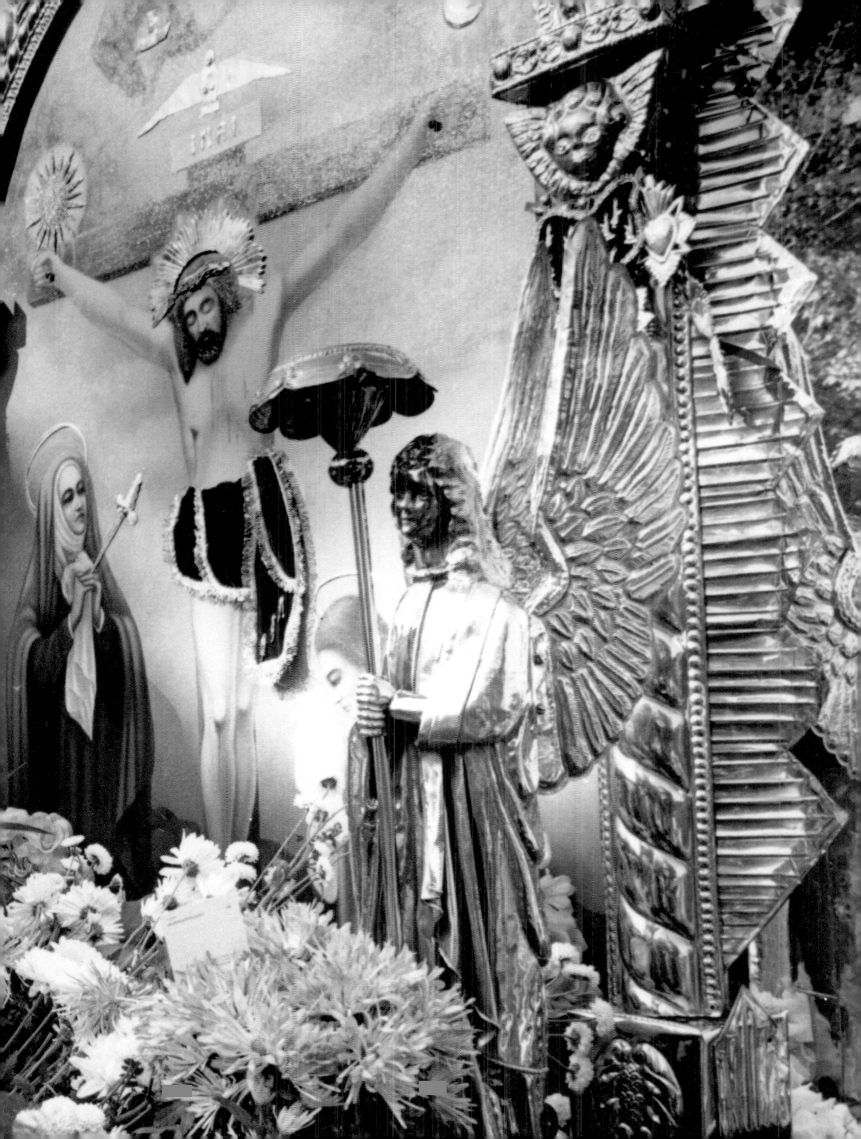

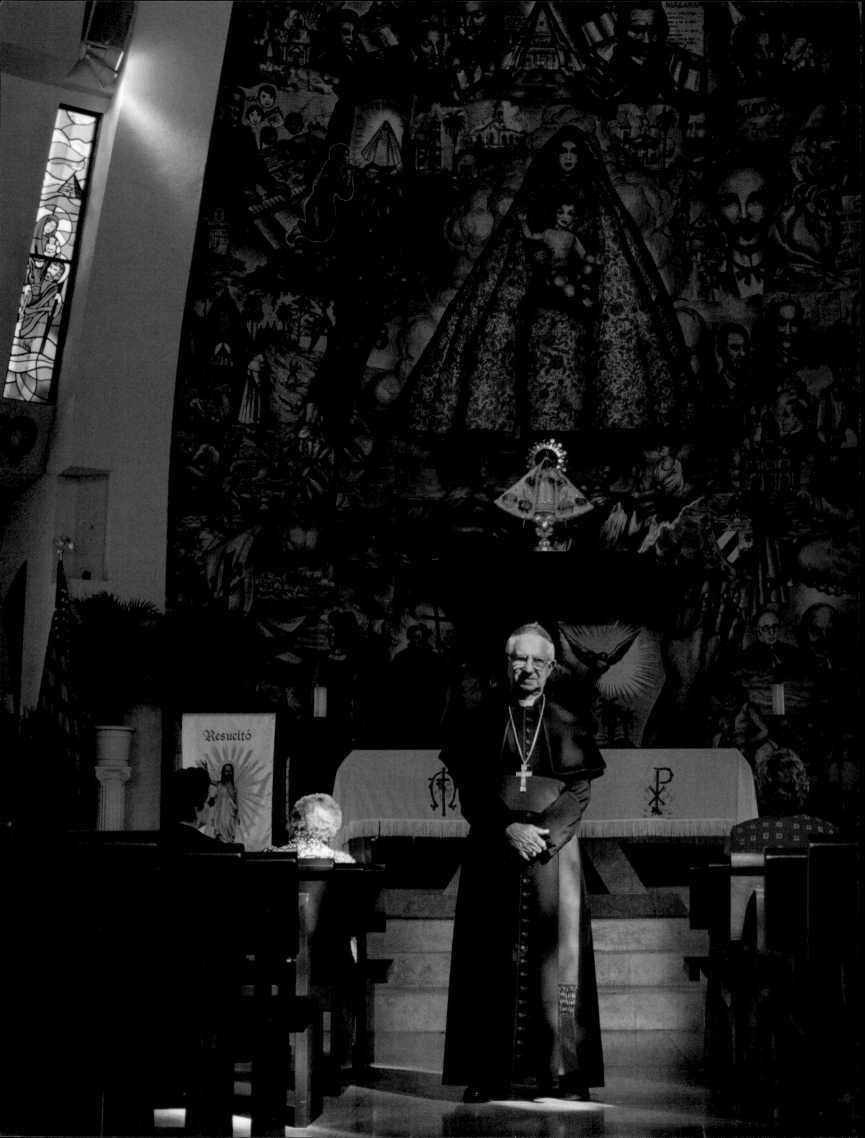

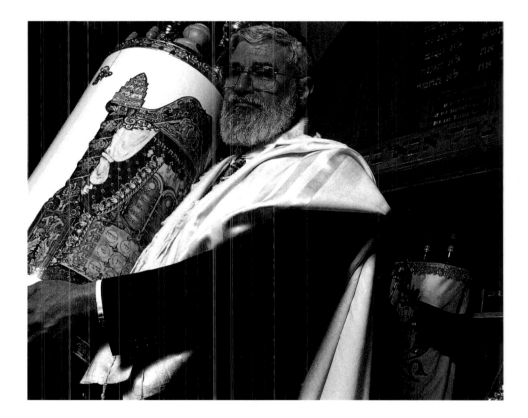

Previous page: At a procession in the Rogers Park neighborhood of Chicago, blessings are sought for a child being lifted before "Our Lord of the Miracles," a ritual parishioners have brought from their native Perú.
Chicago, Illinois
Photographer: Antonio Pérez
Left: Bishop Agustín A. Román, auxiliary bishop of Miami.
Miami, Florida
Photographer: Al Díaz

Top: Sara Ellis Cardona.
Dallas, Texas
Photographer: Beatriz Terrazas
Above: Rabbi Michael Azose, religious leader for one hundred fifty Sephardic Jewish families of Hispanic ancestry.
Evanston, Illinois
Photographer: Antonio Pérez

the sacred in the latino experience
lo sagrado en la experiencia latina

Virgilio Elizondo

> From the earliest day of my life, my people introduced me to *Papacito Dios, Jesús, María, y los santos.* They were very much a part of our immediate and extended family. They were not dogmas to be believed in, but personal friends to visit, converse and even argue with. In our mestizo Christianity — a profound and beautiful blend of Native American religions with Iberian Catholicism — we do not just know about God, but rather we know God personally. *No solamente sabemos cosas de Dios sino que conocemos a Dios personalmente.* We converse easily with God and appreciate the many simple, visible, and tangible representations of the spiritual world, like *estampitas, estatuas, medallitas, y veladoras,* as much as we appreciate pictures of our *Mamacita* and loved ones. They help to put us in the conscious presence of our invisible friends, guides, and protectors.

Latinos understand that life is a pilgrimage and when the pilgrimage stops, life comes to an end. This truth seems to be ingrained in our genes. From our most ancient memories, we remember being on pilgrimage. From Aztlan we marched toward the South until we arrived at the valley of Anahuac. Like the Hebrews of old, we became a great people for a brief period of time. Today, we continue our pilgrimage toward the North. Regardless of the direction, we are a pilgrim people. Even though the future is unknown, we are confident and determined. Nothing can stop us, for we are protected and guided by the spirits of earth and heaven, by the *Virgencita* who never abandons us and walks with us through the struggles of life.

The difficult moments of the pilgrimage will not stop us. We know that suffering and disappointment are part of life, but they cannot destroy us. If even God suffered the crucifixion for us, there must be something good in suffering, especially in suffering for the sake of others, that we don't fully understand. In our Latino realism, we do not go looking for suffering as if it were something desirable, but neither do we deny it or run away from it. We assume it, transcend it, and dare to celebrate life in spite of it.

We carry memories on our pilgrimages: memories of our ancestral lands and people, memories of our losses and realized hopes. Memory is the soul of a people. Without it we are just individuals living and working in a common space. The earliest creed of the Hebrew people was "My father was a wandering Aramean . . . God brought us out of Egypt" (Dt 26:5–11). Throughout the Bible, God always calls upon the people to remember their ancestors, to remember what God has done for them. The living memory of how God has walked with us through deserts and mountains, through triumph and defeat, through enslavement and freedom, through life and death is the source of our strength. We have unquestioned faith in the

V

Desde muy temprana edad en mi vida, mi gente me introdujo a papacito Dios, Jesús, María y los santos. Ellos eran gran parte de nuestra familia inmediata y de nuestro grupo de familiares. Ellos no eran el dogma que se podía creer, sino que eran amigos personales a los que podíamos visitar, con quienes podíamos conversar y hasta discutir. En nuestra cristiandad mestiza — una hermosa y profunda mezcla de religión indígena con el catolicismo de Iberia — nosotros no sólo sabemos de Dios, sino que lo conocemos personalmente. Conversamos fácilmente con Dios y apreciamos las representaciones del mundo espiritual visibles y tangibles como son las estampitas, estatuas, medallitas y veladoras tanto como apreciamos las fotografías de nuestra mamacita y de nuestros seres queridos. Eso nos ayuda a estar siempre en la conciencia de nuestros amigos invisibles, guías y protectores.

Los latinos comprenden que la vida es un peregrinar y cuando la peregrinación termina, la vida llega a su fin. Esta verdad parece estar en nuestras células. Desde nuestros más antiguos recuerdos, nosotros recordamos nuestro peregrinar. Desde Aztlán marchamos hacia el sur hasta que llegamos al valle de Anahuac. Como los judíos de hace tiempo, nosotros nos convertimos en una gran civilización por un corto período de tiempo. Hoy día continuamos nuestro peregrinar hacia el Norte. No importa la dirección, somos peregrinantes. Aunque el futuro no se sepa, nosotros tenemos determinación y confianza. Nada puede detenernos, ya que estamos protegidos y guiados por los espíritus de la tierra y del cielo, por la Virgencita que nunca nos abandona y camina con nosotros por todas las luchas de la vida.

Los momentos difíciles de la peregrinación no nos detendrán. Sabemos que el sufrimiento y el desaliento son parte de la vida, pero que no pueden destruirnos. Si aun Dios sufrió la crucifixión por nosotros, ha de haber algo bueno en el sufrimiento, especialmente en el sufrimiento por otros, que nosotros no comprendemos totalmente. En nuestro realismo latino, nosotros no vamos en busca del sufrimiento como si fuera algo deseable, pero tampoco lo negamos ni le huimos. Lo tomamos en cuenta, lo vencemos y nos atrevemos a celebrar la vida a pesar de todo.

Llevamos recuerdos en nuestro peregrinar, recuerdos de nuestras tierras natales y de la gente, recuerdos de nuestras esperanzas que fallaron y las que se realizaron. Los recuerdos son el alma de la gente. Sin eso somos sólo individuos que viven y trabajan en un mismo lugar. El credo más antiguo de los hebreos era "mi padre fue araneo errante… Dios nos trajo fuera de Egipto" (Dt 26:5–11). Por medio de la Biblia, Dios nos llama a nosotros, su gente, para recordar a nuestros

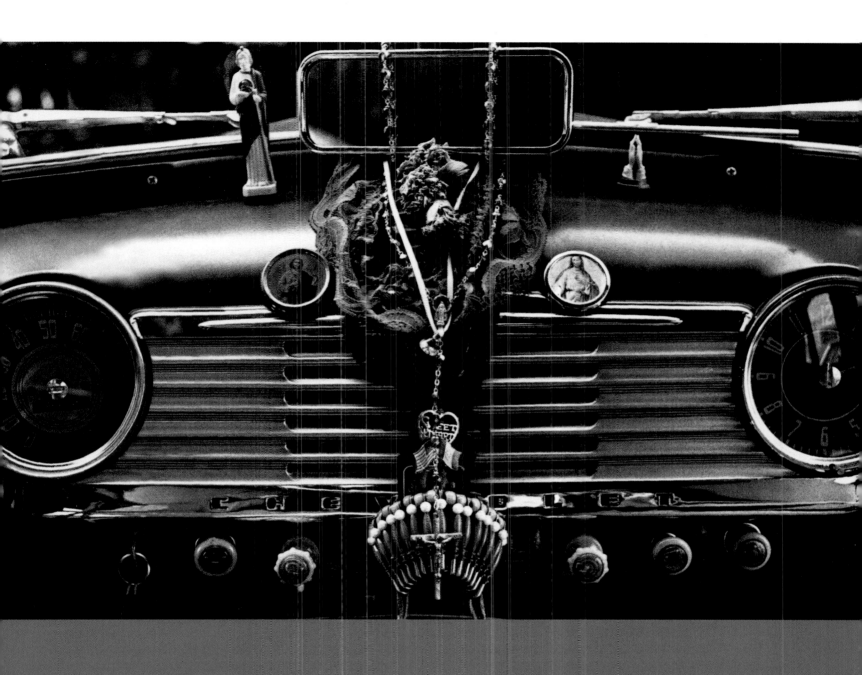

Above: Religious symbol on an automobile
dashboard.
Los Ángeles, California
Photographer: Aurelio José Barrera

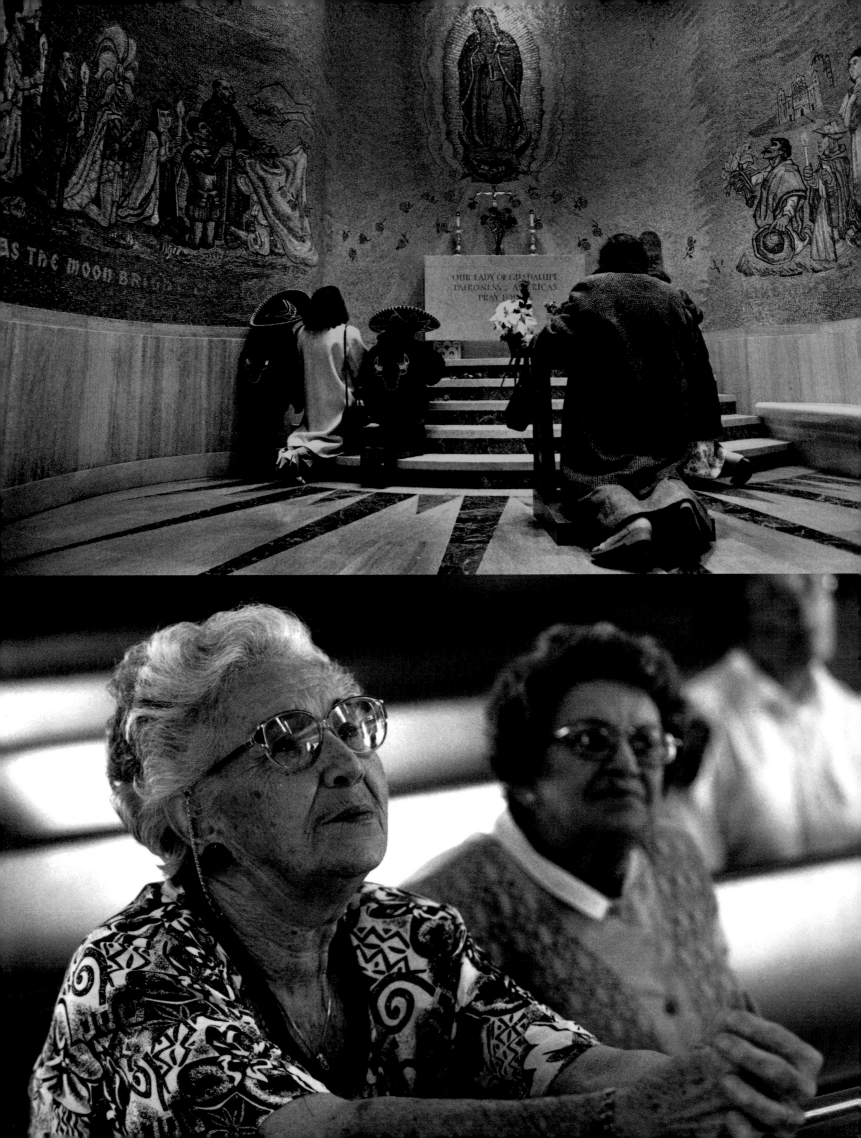

god who is near and far away, a god who sees and hears, a god who feels in the heart, and a god who always accompanies us on the march.

And we carry our crucified Lord, the embodiment of our own crucified lives; his own unlimited power of endurance is transferred to us. They could kill him but could not destroy him. So it is with us — they can humiliate us, exploit us, kill us, but they cannot destroy us! *Aguante* is the guarantee of life! Others might see it as a weakness; we see it as the greatest strength, which transcends the many destructive forces all around us. Even when we are killed, we cannot be destroyed, for others carry on, and we continue to live in them! This is the divine energy, which keeps us moving, alive and human.

The future is mestizo, and to bring it about we will work, laugh, play, study, vote — to renew democracy and renew the lives of all *Americanos*. The new *mestizaje* is the joyous birth of a new humanity. No more barriers, no more racism. The past will not be forgotten but will be blended into the new bodies and cultures that will emerge out of our coming together not in battle or conquest, as in the days of old, but in love, which is the only force that can unite us without destroying us. That is the way to world peace and harmony, and Latinos struggle, dream, and work for that future.

antepasados, a recordar lo que Dios ha hecho por nosotros. El recuerdo viviente de cómo Dios ha caminado con nosotros por desiertos y montañas, por triunfos y fracasos, en la esclavitud y la libertad, en la vida y la muerte, es la fuente de nuestra fortaleza. Hemos tenido fe ciega en el dios que está cerca y lejos, el dios que ve y que oye, el dios que siente en su corazón y un dios que siempre nos acompaña en la marcha.

Nosotros traemos a nuestro Dios crucificado, la prueba de nuestras propias vidas crucificadas; su propia fuerza de resistencia sin límite se convierte en nuestra. Pueden matarlo, pero no lo pueden destruir. Así es con nosotros mismos — ipueden humillarnos, explotarnos, matarnos, pero no pueden destruirnos! ¡El aguante es la garantía de la vida! Otras personas tal vez lo vean como debilidad de carácter; nosotros lo vemos como la fuerza más grande, que transciende a las muchas fuerzas destructivas que nos rodean. ¡Aun cuando nos maten no podemos ser destruidos porque otros nos llevarán con ellos y continuaremos viviendo en ellos! Ésta es la divina energía, que nos mantiene en movimiento, vivos y humanos.

El futuro es mestizo y para traerlo nosotros trabajaremos, reiremos, jugaremos, estudiaremos, votaremos — para renovar la democracia y para renovar le vida de todos los americanos. El nuevo mestizaje es el gozoso nacimiento de una nueva humanidad. No más barreras, no más racismo. El pasado será olvidado, pero nosotros seremos mezclados con los cuerpos nuevos y las culturas que emerjan de esta unión, no en guerra o conquista como en otros tiempos, sino en amor, que es la única fuerza que puede unirnos sin destruirnos. Éste es el camino para la paz y la armonía en el mundo. Y los latinos luchan, sueñan y trabajan por ese futuro.

Opposite top: Basilica of the National Shrine of the Immaculate Conception. Days of the Virgin of Guadalupe.
Washington, D.C.
Photographer: Héctor Emanuel
Opposite bottom: Manuela Llanio (left), 83, and Caridad Rodríguez, 75, praying at the Our Lady of Charity Shrine.
Miami, Florida
Photographer: Nuri Vallbona

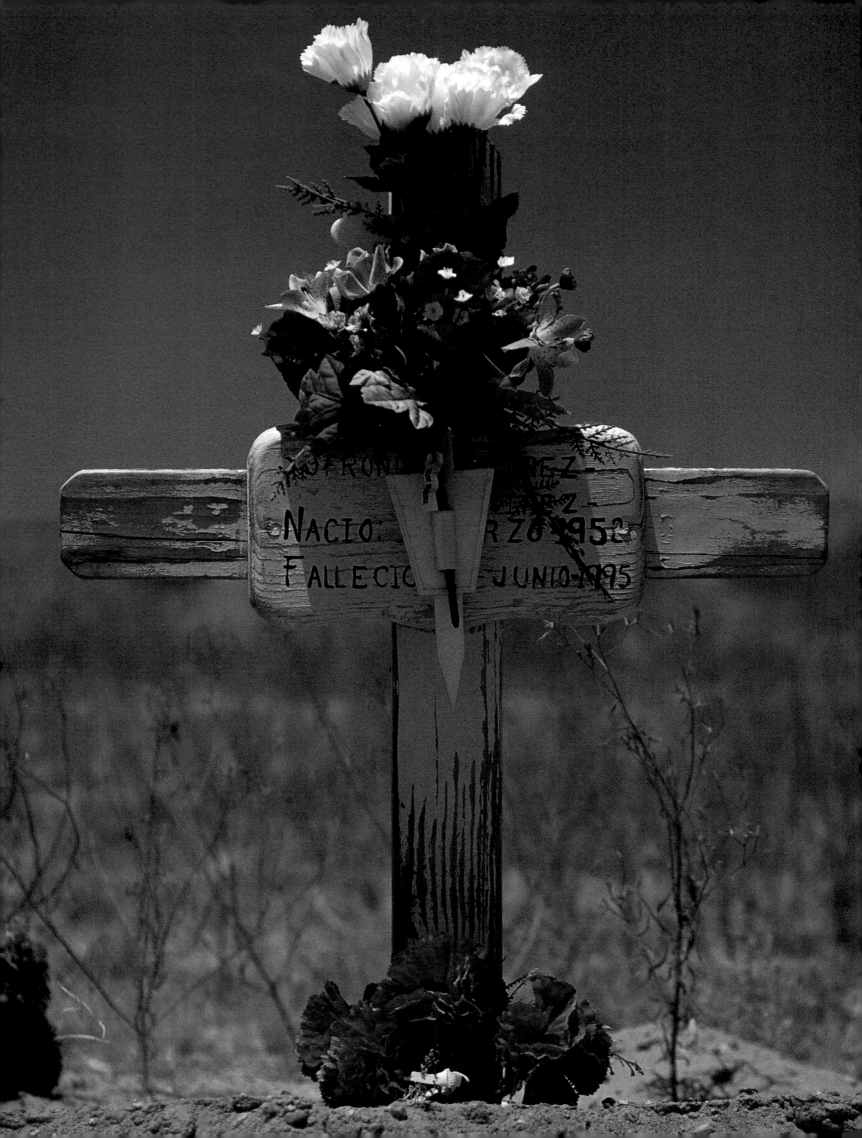

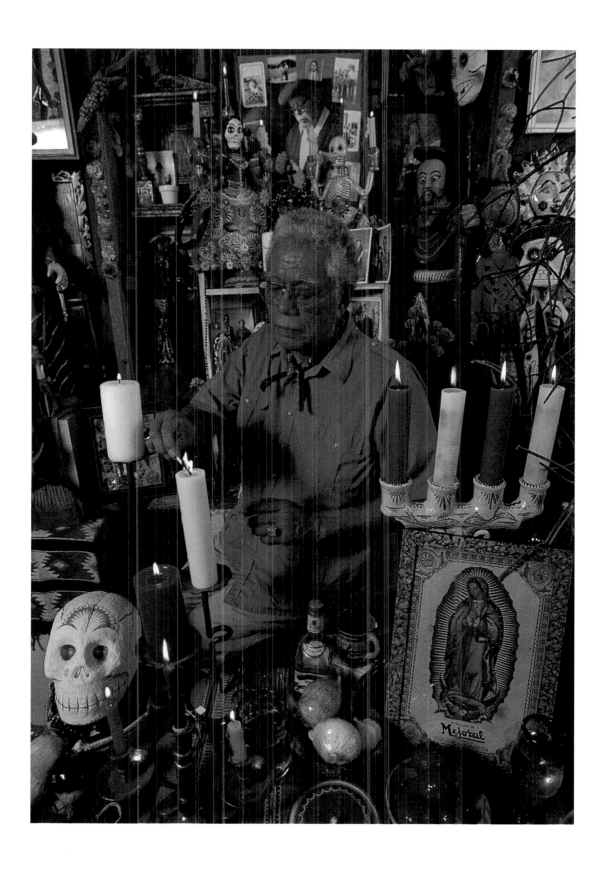

Opposite: Roadside cross, common in the
Southwest and México.
Yuma, Arizona
Photographer: Paul Pérez

Above: Macario Ramírez teaches the beautiful
tradition of building an *ofrenda*, or altar, in
Houston. This one celebrates and honors his
father, Jesús, and his ancestors.
Houston, Texas
Photographer: Carlos Rios

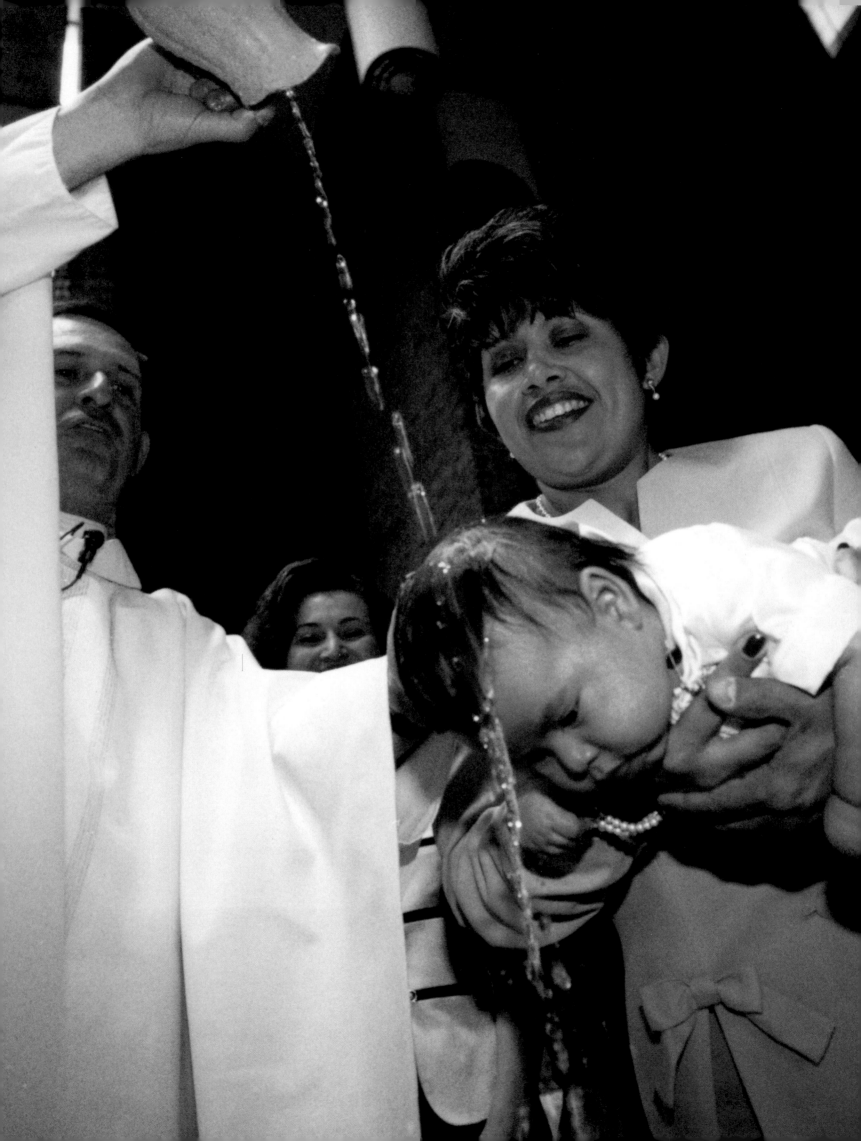

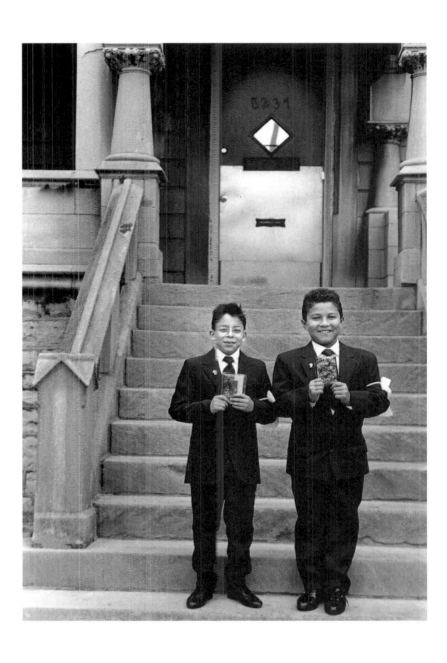

Left: Father Eugenio Hoyas celebrates a baptism at St. Anthony's Catholic Church.
Falls Church, Virginia
Photographer: Juana Arias

Above: First Holy Communion, St. Michael's Church.
Chicago, Illinois
Photographer: Antonio Pérez

Top: Emmanuel Presbyterian Church.
Cicero, Illinois
Photographer: Antonio Pérez
Bottom: The faithful come forward for special blessings at Emmanuel Presbyterian Church.
Cicero, Illinois
Photographer: Antonio Pérez
Opposite: Golden candlelight reveals altar server Ana Caridad Gómez's face as she and fellow parishioners observe the Jewish Passover celebration at Sacred Heart Catholic Church.
New Orleans, Louisiana
Photographer: Magdalena Zavala

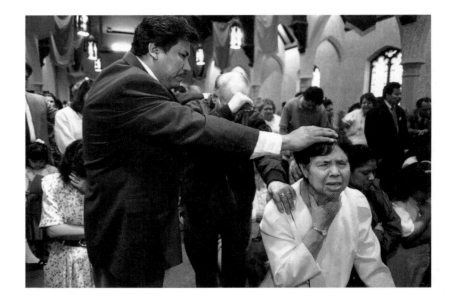

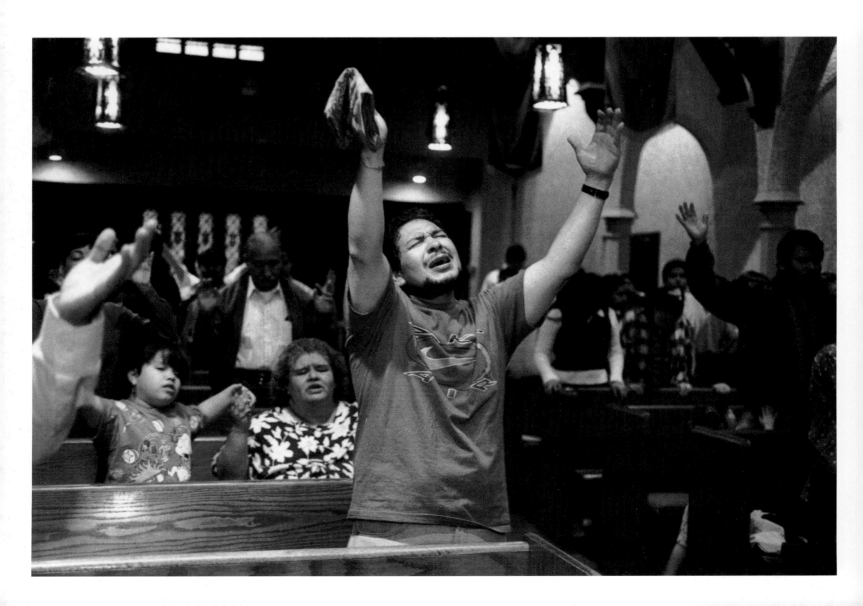

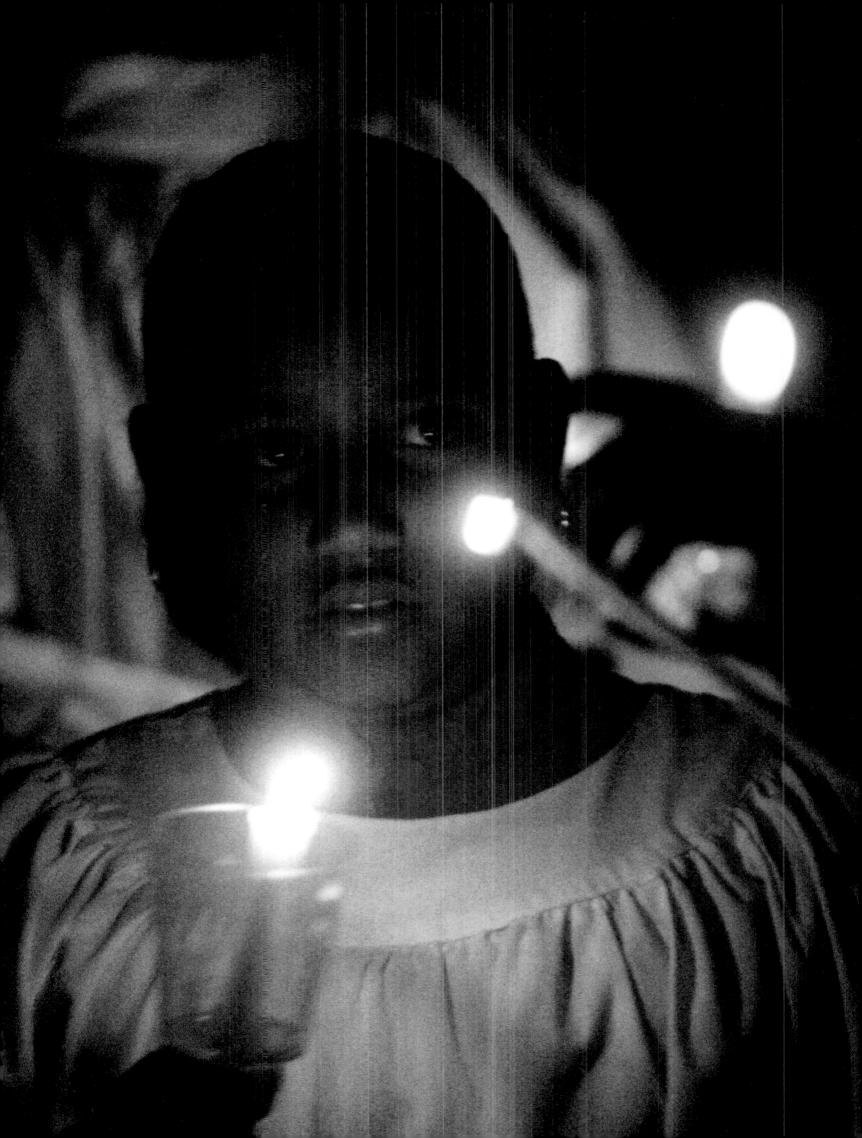

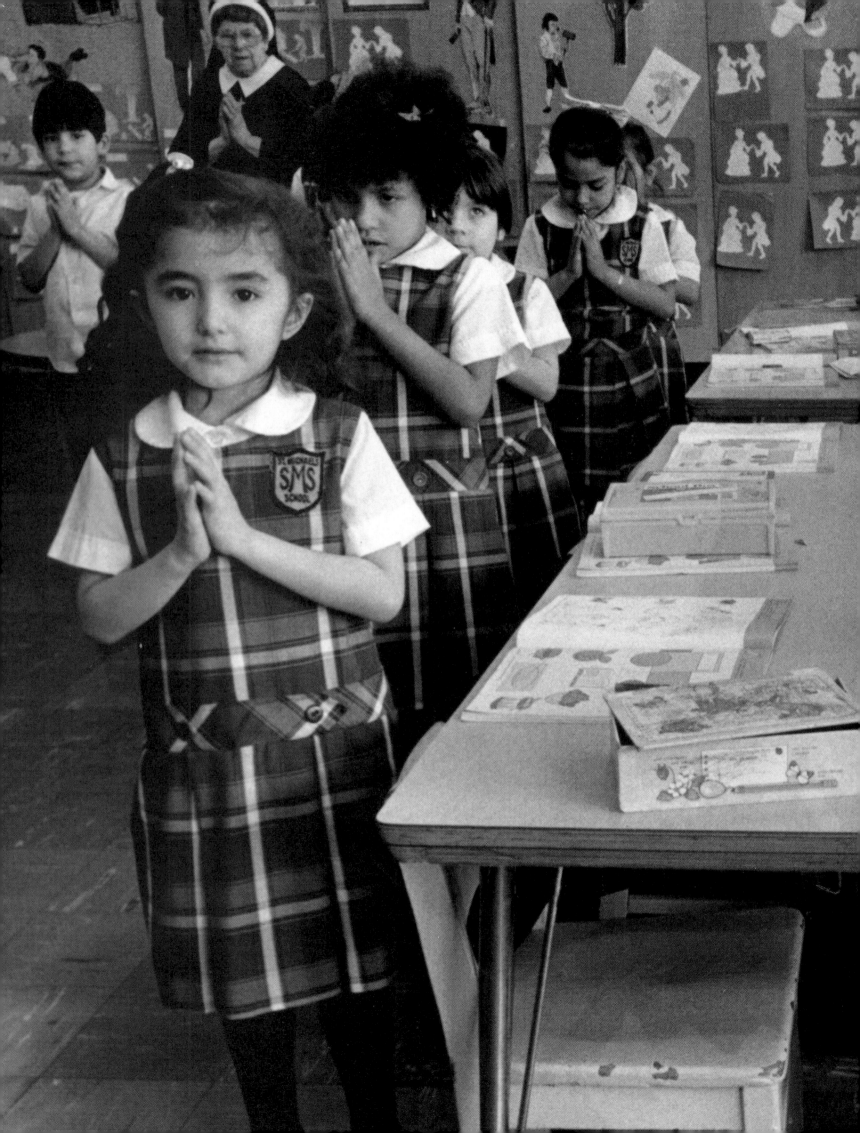

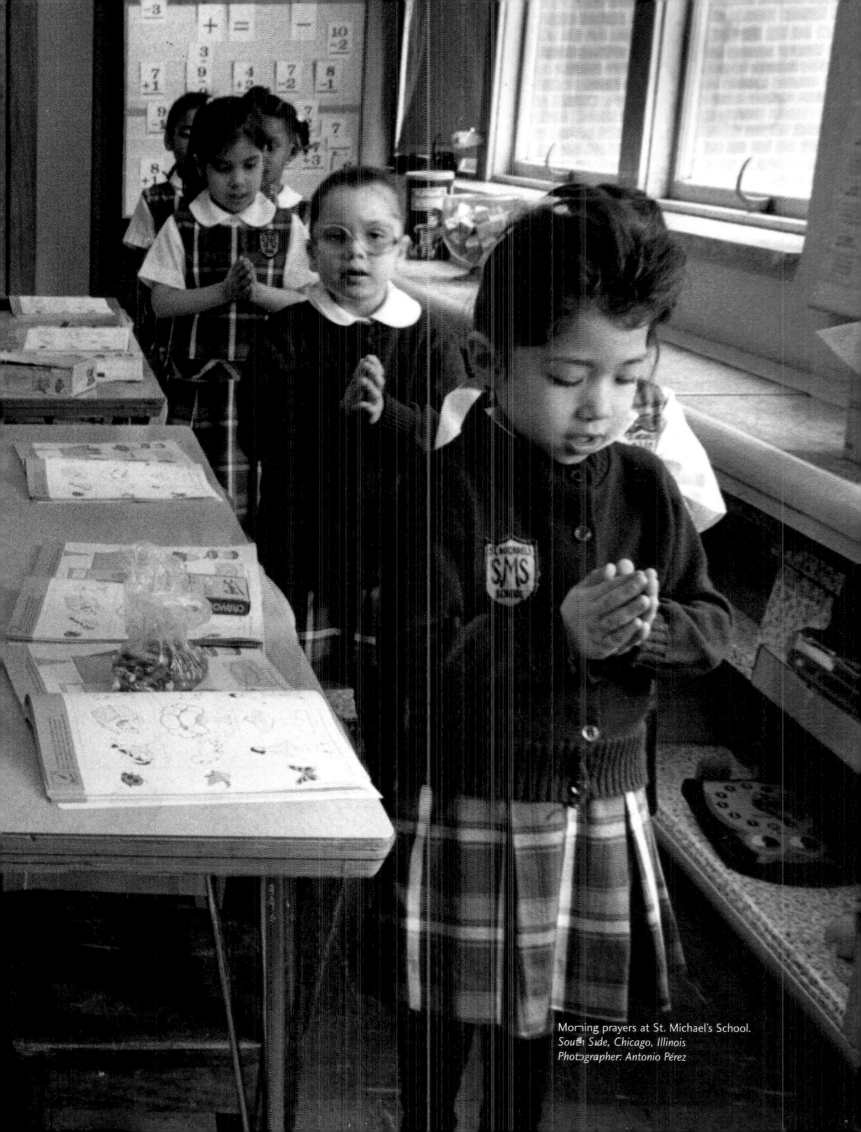

Morning prayers at St. Michael's School.
South Side, Chicago, Illinois
Photographer: Antonio Pérez

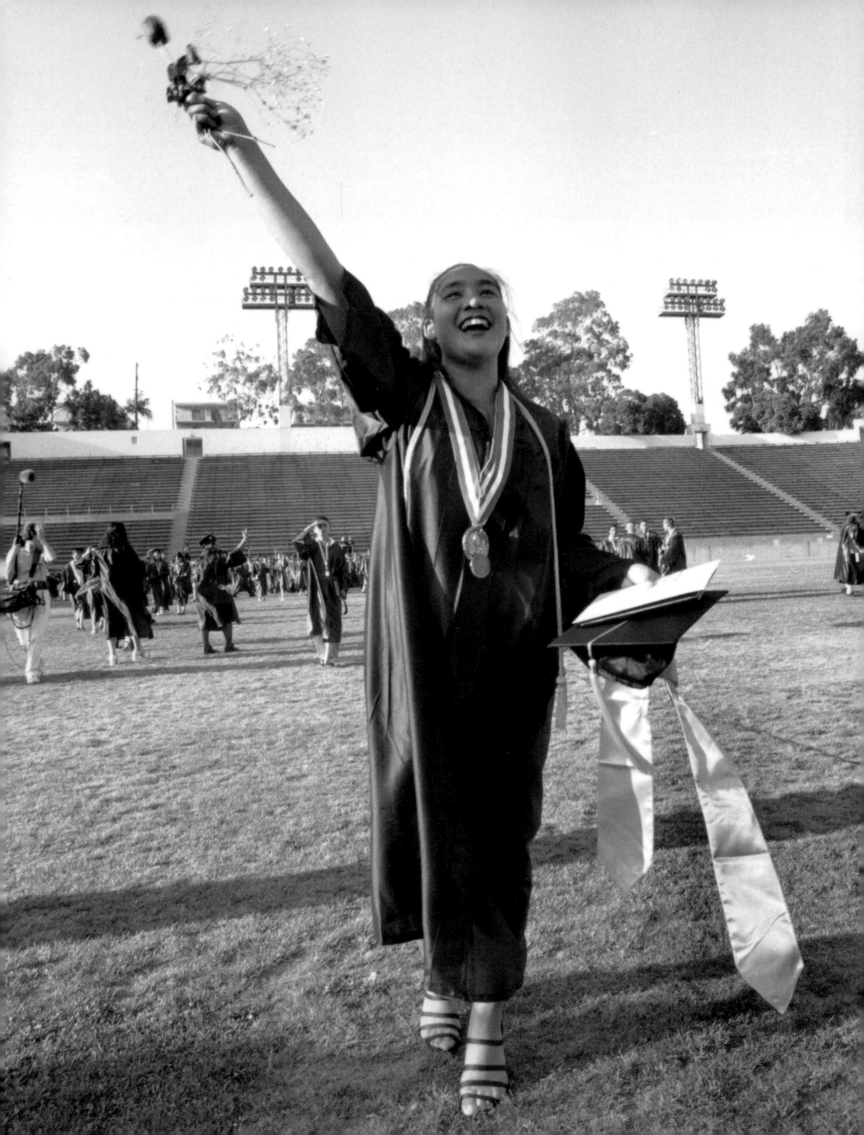

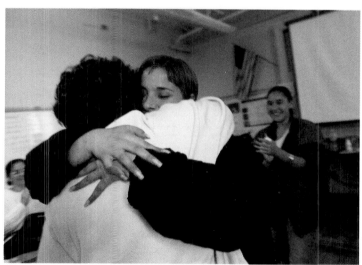

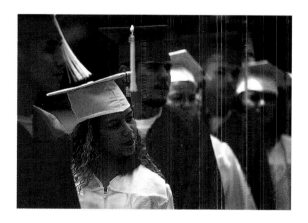

Opposite: Harvard-bound student Jennifer Bracamontes waves to her parents on graduation day at Garfield High School.
Los Ángeles, California
Photographer: Liliana Nieto del Río

Bottom left: Students at Pedro Albizu Campos High School pose for their graduation pictures.
Chicago, Illinois
Photographer: Antonio Pérez

Top: Garfield High School student Alejandra Velásquez has just been informed that she has been accepted to Yale University. Counselor Julie Nielson gives her the good news.
Los Ángeles, California
Photographer: Liliana Nieto del Río
Bottom right: Jennifer Bracamontes looks on as Garfield High School counselor Julie Nielson gives a congratulatory hug to Alejandra Velásquez.
Los Ángeles, California
Photographer: Liliana Nieto del Río

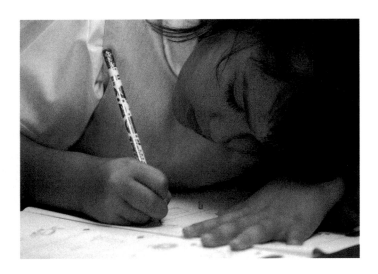

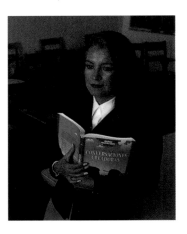

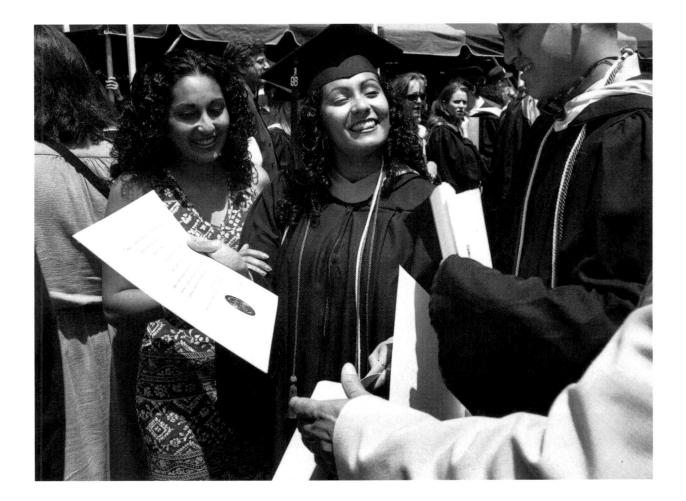

Top right: Emma Sepúlveda, a professor of
Spanish literature at the University of Nevada.
Reno, Nevada
Photographer: Andy Barron

Top left: An inspirational moment for a young
student in Miami.
Miami, Florida
Photographer: Al Díaz

Bottom: Princeton University graduate
celebrates the victory of achievement,
perseverance, and hard work.
Princeton, New Jersey
Photographer: Jules Allen

Opposite: Jaime Escalante, math instructor at
Hiram Johnson High School, in Sacramento, is
remembered most as the inspiration for the
film *Stand and Deliver,* where he was portrayed
by actor Edward James Olmos.
Sacramento, California
Photographer: José Luis Villegas

... IS ODD, THEN $\sqrt{a^n} = a$

HE TIME TO S

$+\left(-\dfrac{2v}{3}\right) + 10 = \qquad 2x\sqrt{7} + 3$

$\dfrac{2v}{3} + 10 = \qquad\qquad 2x\sqrt{7}$

$+ 10 =$

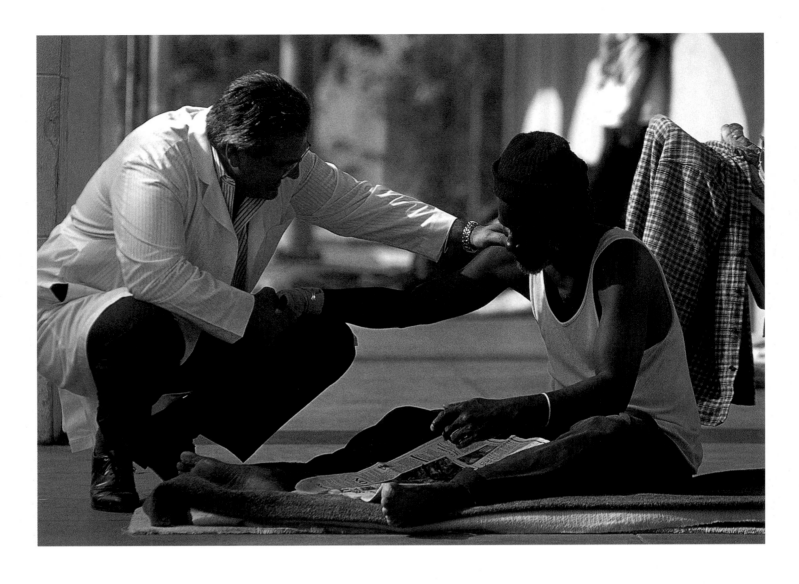

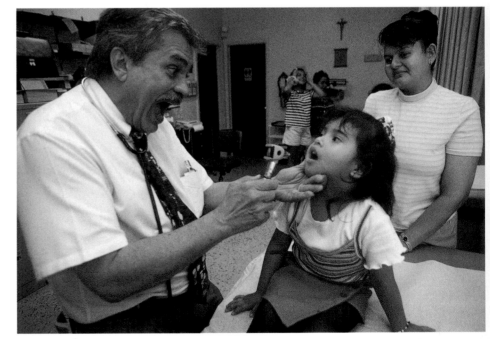

Top: Dr. Joe Greer started the Camillus Health
Clinic in Overtown. The clinic is known for its
outreach to the more than 10,000 homeless
men and women in the city.
Miami, Florida
Photographer: Al Díaz
Bottom: Dr. Carlos C. Vicaria at St. Juan Bosco
Clinic with Joseling Guatemala Obando, 3.
Miami, Florida
Photographer: Al Díaz
Opposite: Dr. Catalina García, anesthesiologist.
Dallas, Texas
Photographer: Beatriz Terrazas

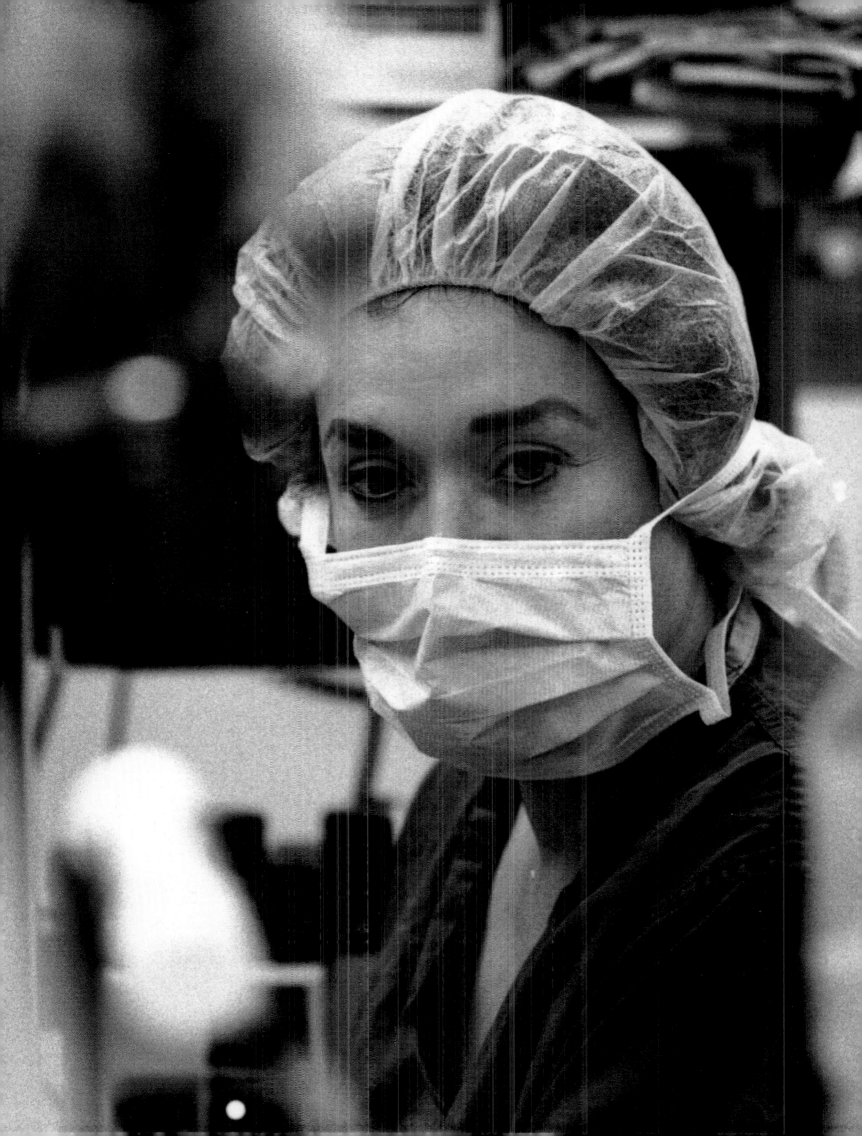

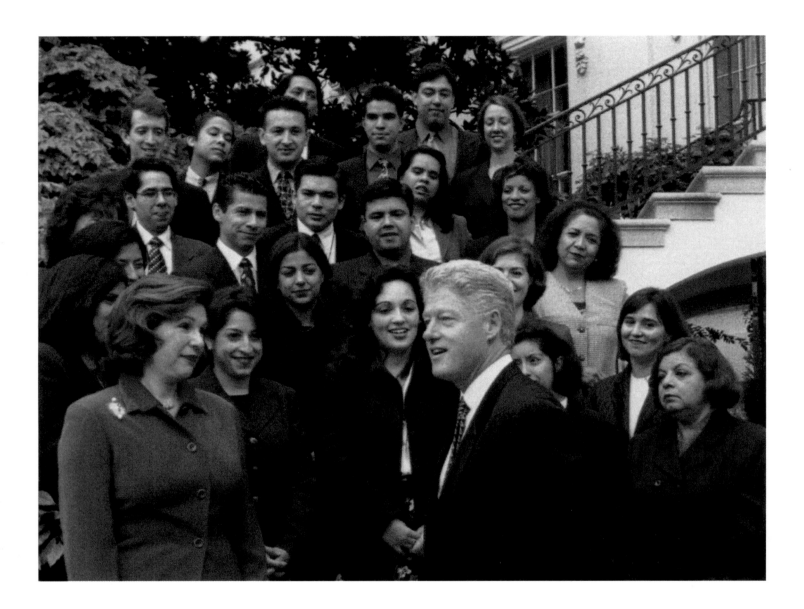

> "The end of all education should surely be service to others. We cannot seek achievement for ourselves and forget about the progress and prosperity for our community. Our ambitions must be broad enough to include the aspirations and needs of others for their sake and for our own."

∨
"El final en toda educación debe ser, sin duda alguna, el servicio a otros. No podemos procurar realizarnos nosotros mismos y olvidarnos del progreso y prosperidad de nuestra comunidad. Nuestras ambiciones deben ser suficientemente amplias para incluir las aspiraciones y necesidades de otros por su bienestar y por el propio."

César Chávez

Above: President Bill Clinton with Latino White House staff.
Washington, D.C.
Photographer: Héctor Emanuel

Opposite top: Astronauts Jeffrey A. Hoffman (left) and Franklin R. Chang-Díaz celebrate the fact that each has surpassed the one-thousand-hour mark in space. The two mission specialists joined three other astronauts and an international payload specialist for sixteen days of scientific research aboard the Space Shuttle *Columbia*. Chang-Díaz also participated in the first joint United States–Latin America effort in space.
Photograph: courtesy of NASA

Opposite bottom: Astronaut Ellen Ochoa, mission specialist, checks out a 35mm camera before making an exposure with it on Space Shuttle *Discovery*'s flight deck. Ochoa and four other NASA astronauts spent nine days in space supporting the Atlas-2 mission.
Johnson Space Center, Houston, Texas
Photograph: courtesy of NASA

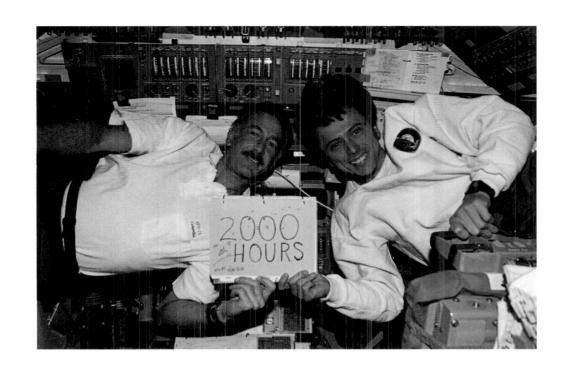

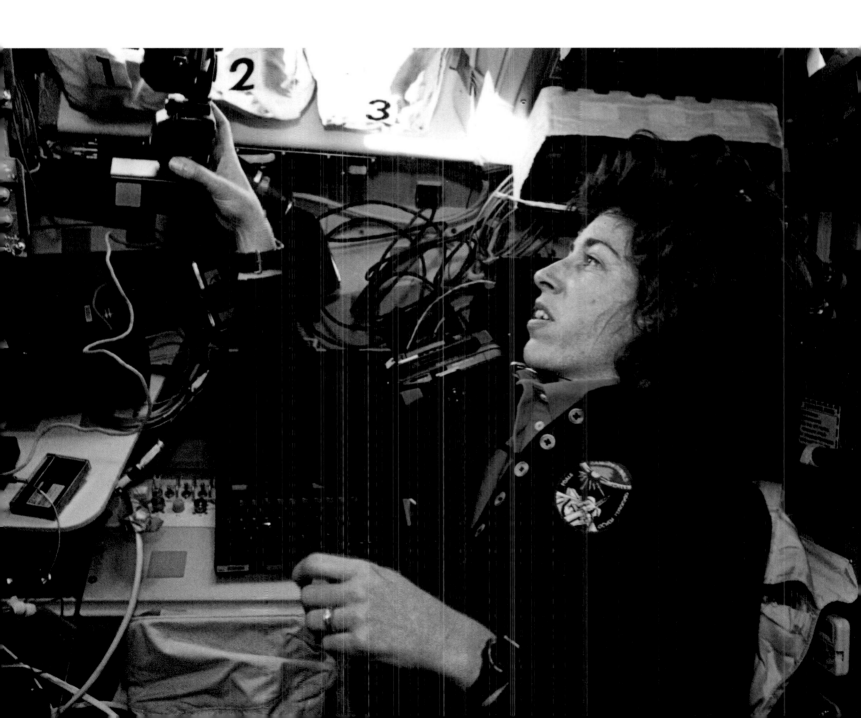

latino contributions

David Hayes-Bautista

contribuciones latinas

> Far from representing a threat to society, the Latino presence is strengthening the basic institutions of society: the family, work, and education. There are some who, ignoring the statistics relative to the strengthening of society by Latinos, think that the only form of Latino participation is found in total assimilation. The truth is that Latinos are not assimilating in the same manner as the European immigrants of the nineteenth century.

As demonstrated by the California Identity Project, we can see that Latinos continue being Latinos even until the third generation. There are some stable factors of Latino identity measured over three generations. These factors are

The Family. More than 96 percent of the state sample base their identity in the family. This factor does not change over three generations.

Culture. Culture is important to 84 percent of the sample. Included in this factor is the importance of being Mexican or Latino.

The Catholic religion. Seventy-eight percent of the sample identify themselves as Catholic.

Being Spanish speaking. This is the only factor that shows some variation. Nevertheless, it is very important to note that 67 percent of the third generation still identify themselves as being Spanish speaking.

In contrast to the European immigrants, Latinos continue to base their identity on the family, culture, religion, and language.

We would not say that Latinos have a double identity, rather that they have a complete identity that is at the same time Latino/Latina and American. What distinguishes the Latino from the Anglo-Saxon is that he is not first Anglo-Saxon, but American. According to this point of view, being American implies being Latino, speaking Spanish, and conserving the family.

Latinos in the United States do not turn their backs on Mexico or Latin America. They do not suffer from total assimilation nor from cultural amnesia. The preservation of a strong Latino identity, however, should not give rise to Anglo fears that there exists a disloyal group within the population. Latinos see themselves clearly as citizens of the United States and make their contributions to this country by strengthening the family, work, religion, and education.

V
Lejos de representar una amenaza para la sociedad, la presencia latina, de hecho, está fortaleciendo las instituciones básicas de la sociedad: la familia, el trabajo y la educación. Hay quienes, ignorando las estadísticas relativas al fortalecimiento de la sociedad por parte de los latinos, piensan que la única forma de participación latina se halla en la asimilación total. El hecho es que el latino no se está asimilando de igual manera que los inmigrantes europeos del siglo XIX.

Como muestra el Proyecto de Identidad de California, podemos ver que los latinos siguen siendo latinos aun hasta la tercera generación. Hay unos elementos estables de la identidad latina, medidos a lo largo de más de tres generaciones. Dichos elementos estables son:

La familia. Más de 96 por ciento de la muestra a nivel estatal halla su identidad en la familia. Este elemento no varía en tres generaciones.

La cultura. La cultura es importante para 84 por ciento de la muestra. Se incluye bajo el elemento de cultura la importancia de ser mexicano o hispano.

La religión católica. Un 78 por ciento de la muestra se identifica como católico.

Ser hispanoparlante. Éste es el único elemento que muestra alguna variación. Sin embargo, es importantísimo tomar nota de que 67 por ciento de la tercera generación todavía se identifica como hispanoparlante.

En contraste con los inmigrantes europeos, los latinos siguen basando su identidad en la familia, la cultura, la religión y el idioma.

No diríamos que los latinos tienen una identidad doble, sino que tienen una identidad amplia que es a la vez plenamente latina y americana. Lo que distingue al latino del anglosajón es que el primero no es anglosajón, sino americano: según su punto de vista, ser americano implica ser latino, hablar español y conservar la familia. Los latinos en los Estados Unidos no dan la espalda a México ni a América Latina. No sufren una asimilación total ni una amnesia cultural. La preservación de una fuerte identidad latina tampoco ha de ser la pesadilla anglosajona: la de que existe un grupo desleal dentro de la población. Los latinos se ven como plenos derecho habitantes de la sociedad estadounidense, y hacen su contribución a la misma al fortalecer la familia, el trabajo, la religión, la salud y la educación.

Opposite: Bernadine Mendoza sews a new American flag.
Houston, Texas
Photographer: Carlos Ríos

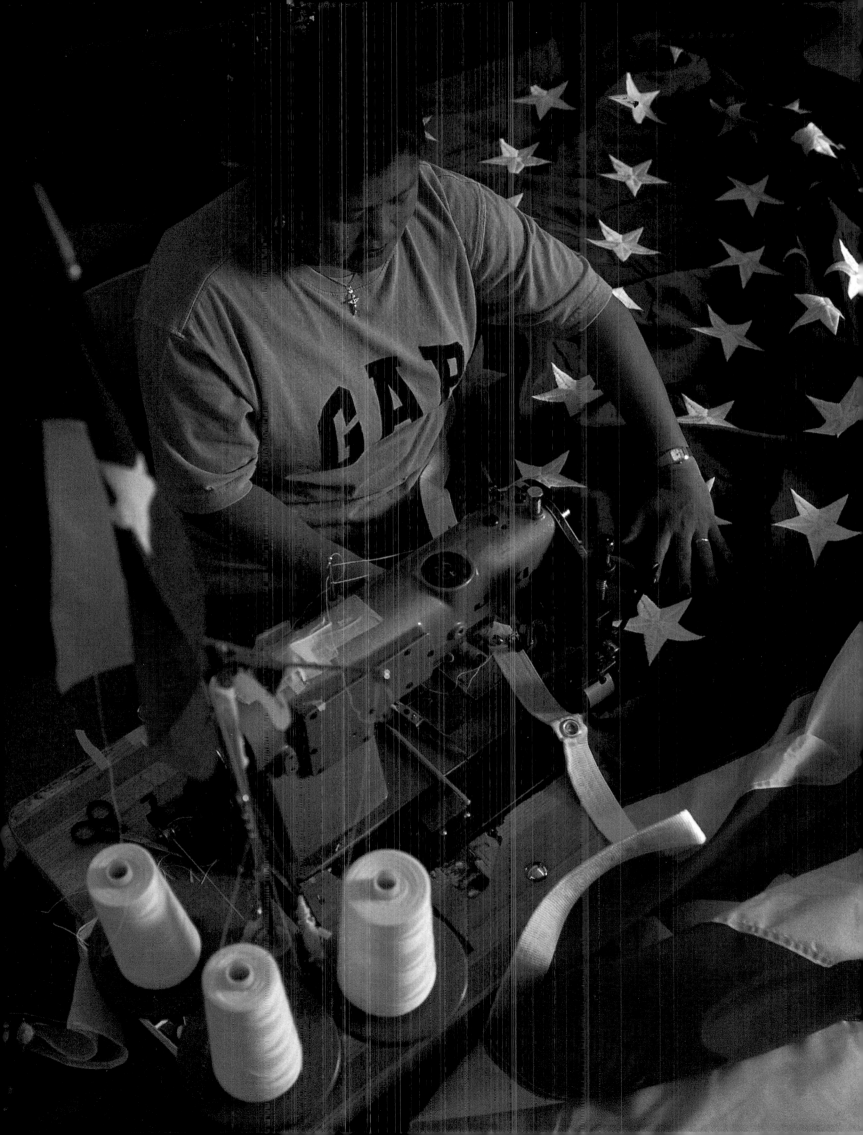

Below: Joel Luna, 19, lives with his family in Irrigon, Oregon. After a prayer the Luna family settles down on a Friday night with pizza and some movies. Joel, Catherine (his girlfriend), and his younger brother, León, 3, sit on the floor. His parents, Leo and Michelle, along with his grandfather, Leonides, sit on the sofa.
Irrigon, Oregon
Photographer: Timothy Gonzales

Below right: Joel works on replacing running lights on one of his family's trucks. He is assisted by his brother, León, 3.
Irrigon, Oregon
Photographer: Timothy Gonzales
Bottom: Joel, Catherine, and León.
Irrigon, Oregon
Photographer: Timothy Gonzales

Opposite: Joel received his truck, "El Gremlin," as a high school graduation present. His father and grandfather are also truckers.
Irrigon, Oregon
Photographer: Timothy Gonzales

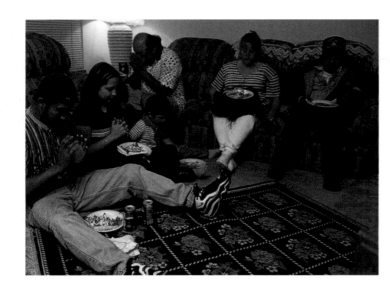

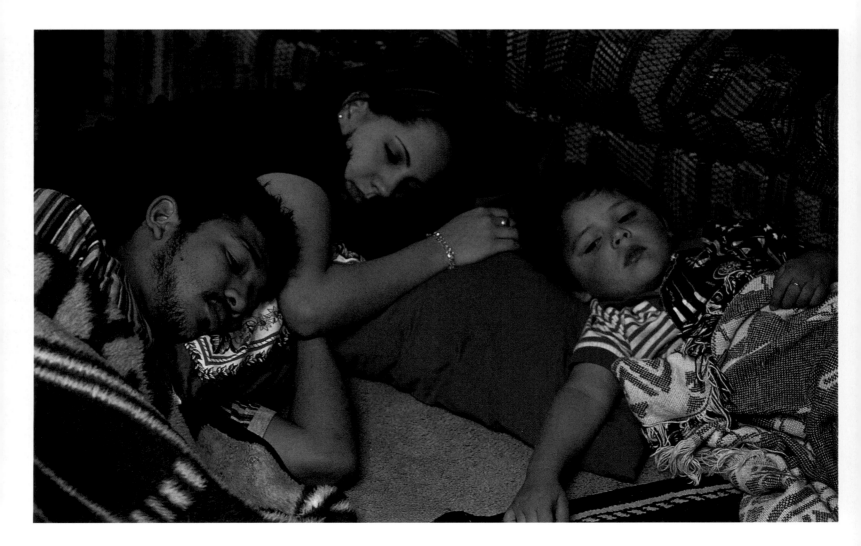

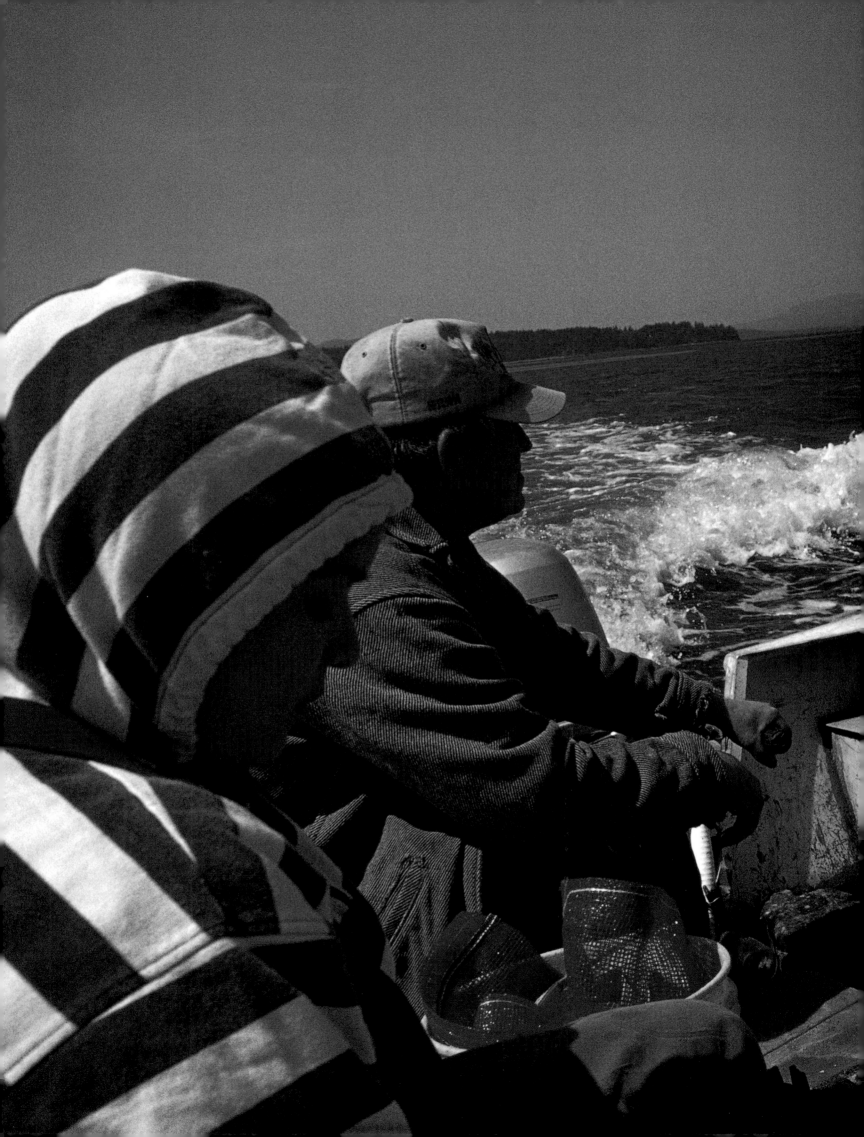

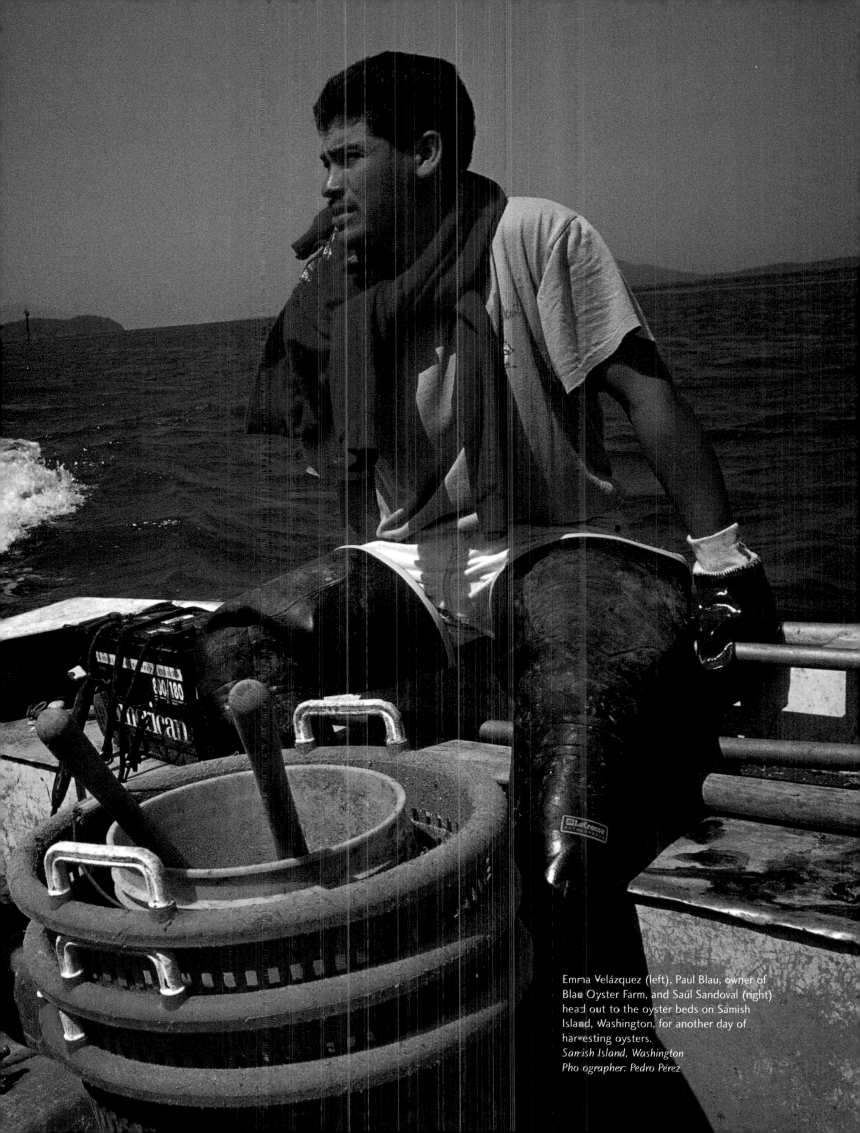

Emma Velázquez (left), Paul Blau, owner of
Blau Oyster Farm, and Saúl Sandoval (right)
head out to the oyster beds on Samish
Island, Washington, for another day of
harvesting oysters.
Samish Island, Washington
Photographer: Pedro Pérez

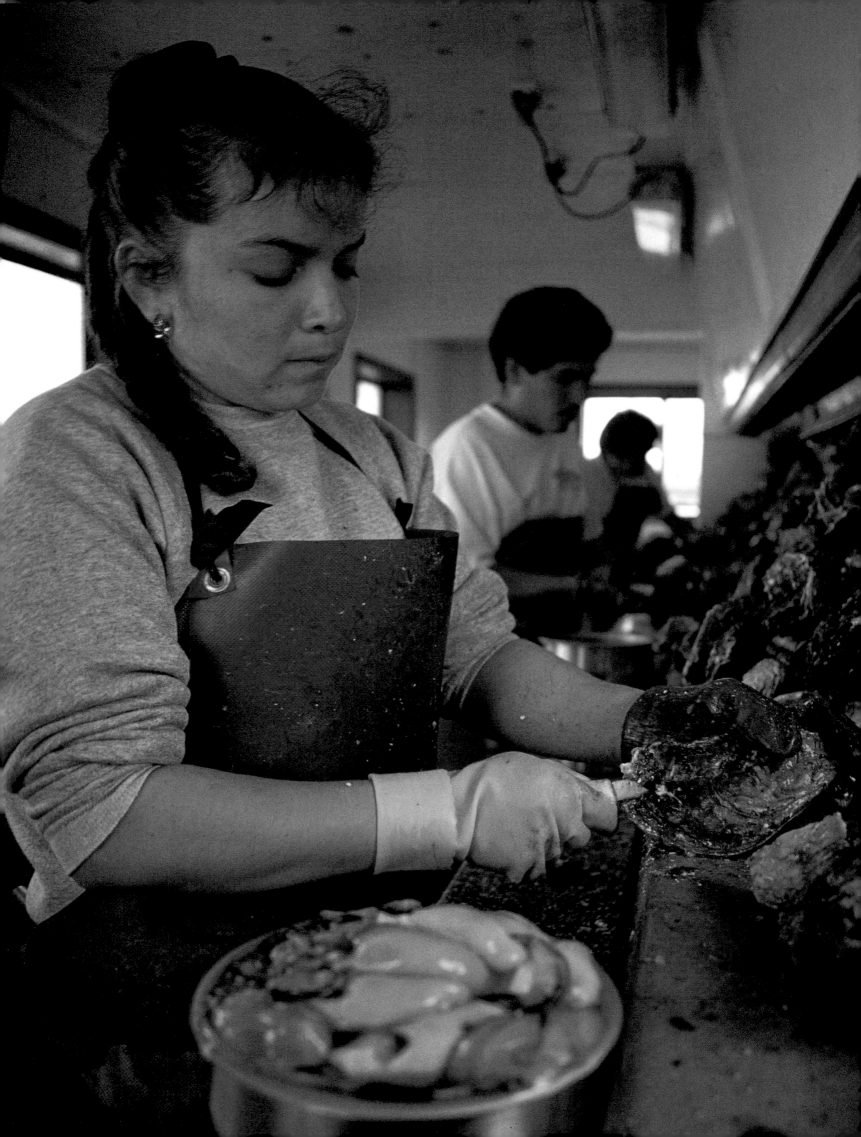

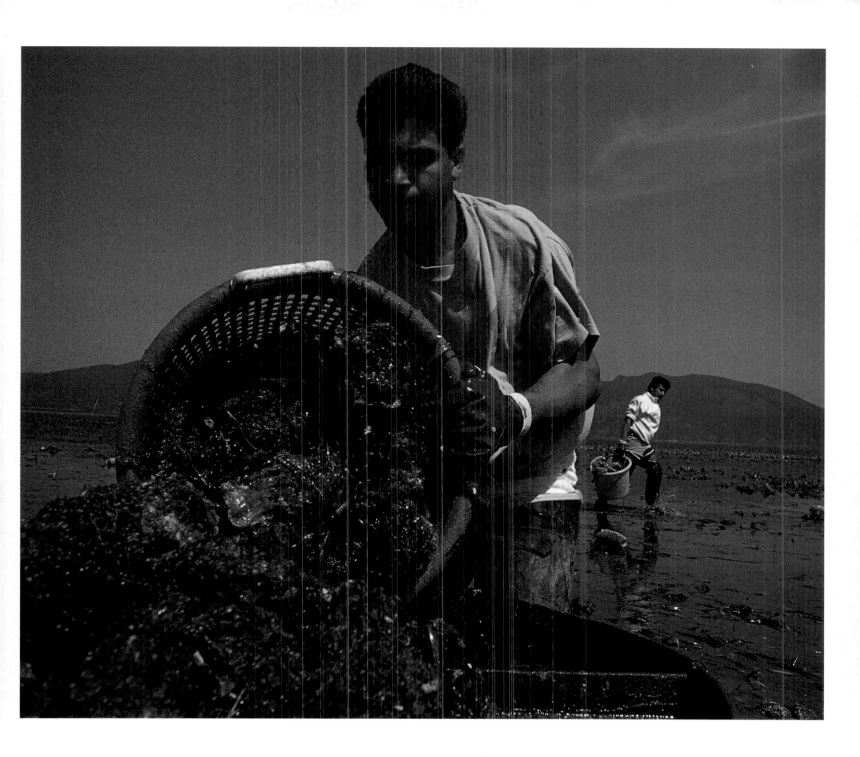

Opposite: Emma Velázquez, Saúl Sandoval, and Gerardo Rodarte shuck oysters.
Above: Saúl Sandoval empties a basket of oysters into a larger basket that will be picked up on a barge during high tide. Gerardo Rodarte carries a basket full of oysters that he picked up off the beds.
Samish Island, Washington
Photographer: Pedro Pérez
Right: Assistant executive chef José Barrera supervises about 250 employees at John Ascuaga's Nugget Casino Resort.
Sparks, Nevada
Photographer: Andy Barrón

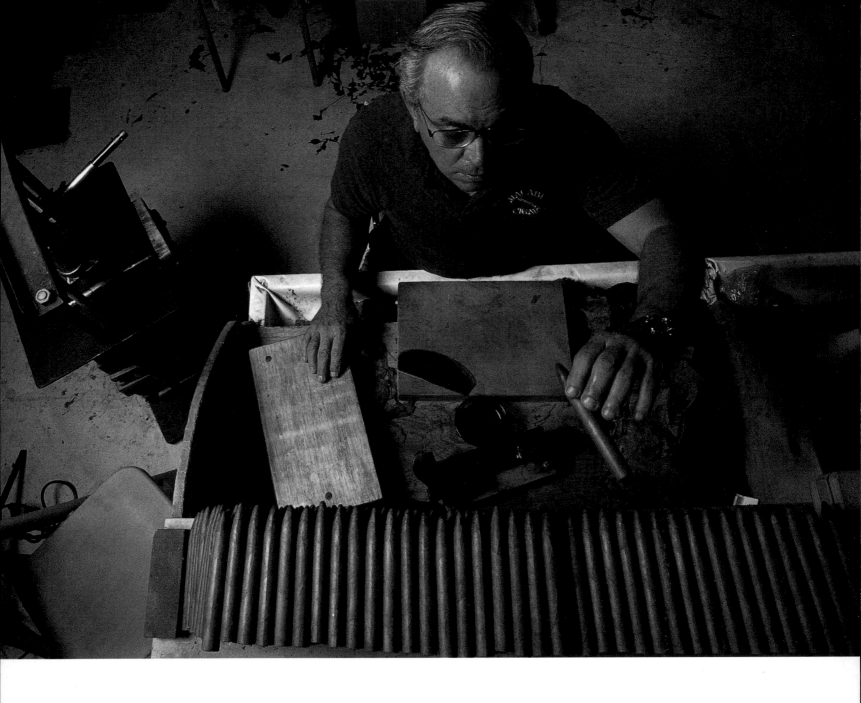

Top and opposite top: Armando Fonticiella
hand rolls cigars at the Macabi cigar factory in
Little Havana.
Miami, Florida
Photographer: Nuri Vallbona
Opposite bottom: Little Havana cigar factory,
downtown.
Chicago, Illinois
Photographer: John Castillo

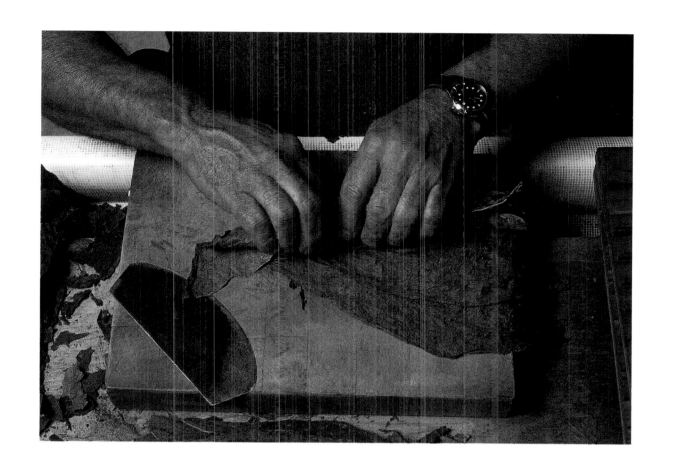
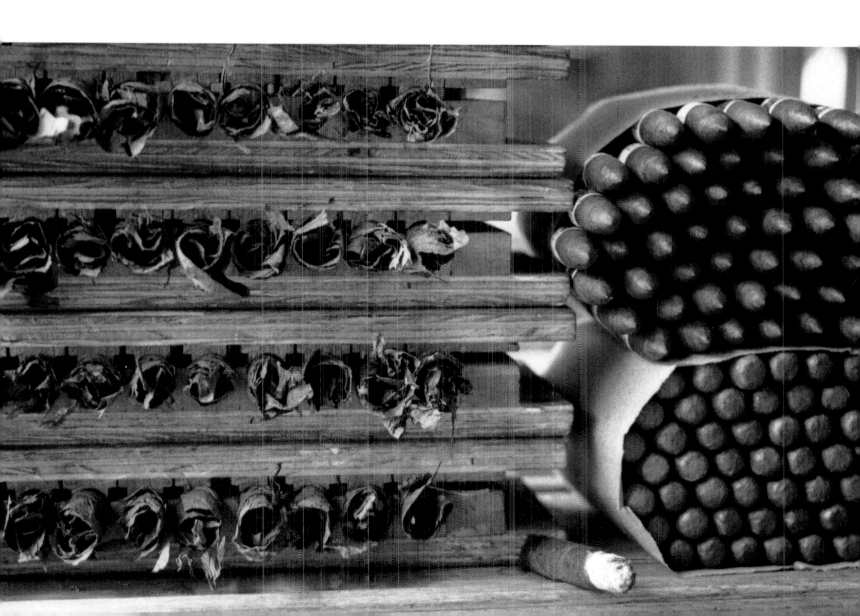

Below: Davil Aguilar, 26, a migrant farm worker, pulls yellow flowers from the field.
San Diego, California
Photographer: Jimmy Dorantes
Right: Rudy "Boy" Gómez, lifelong resident of Boyle Heights.
Los Ángeles, California
Photographer: Aurelio José Barrera

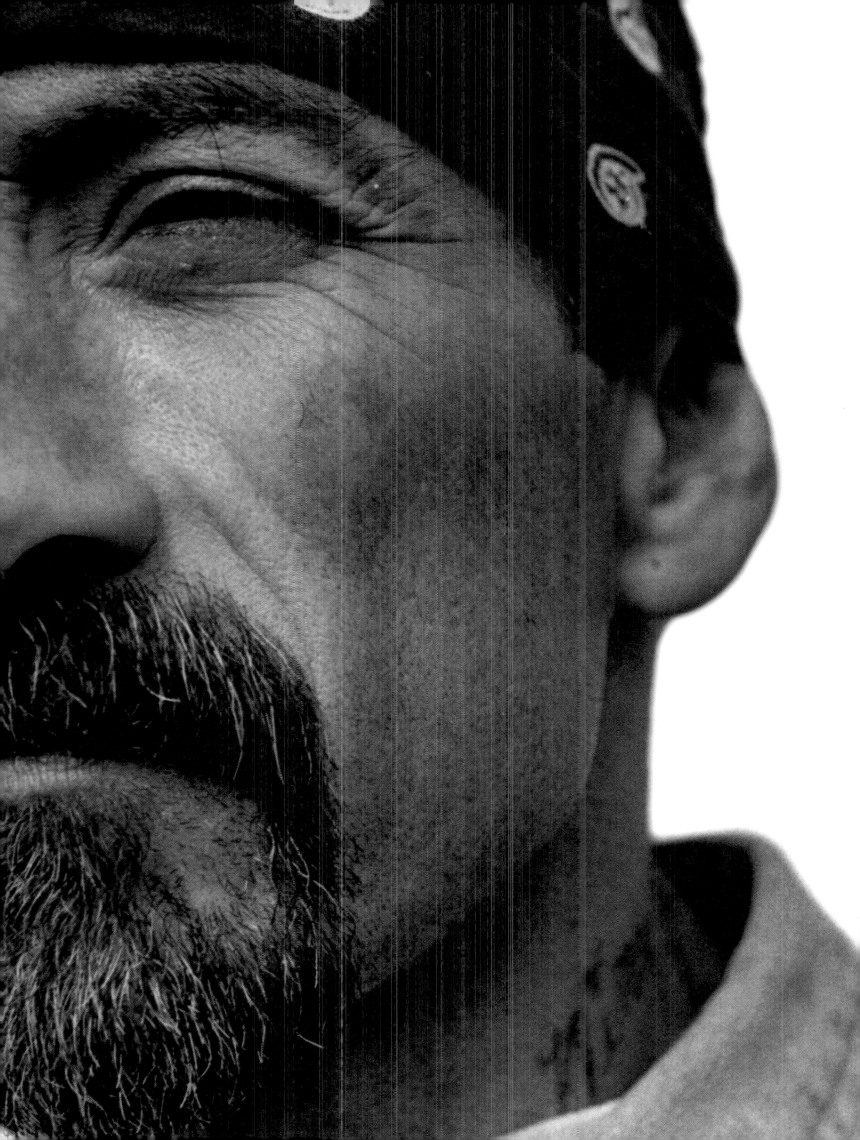

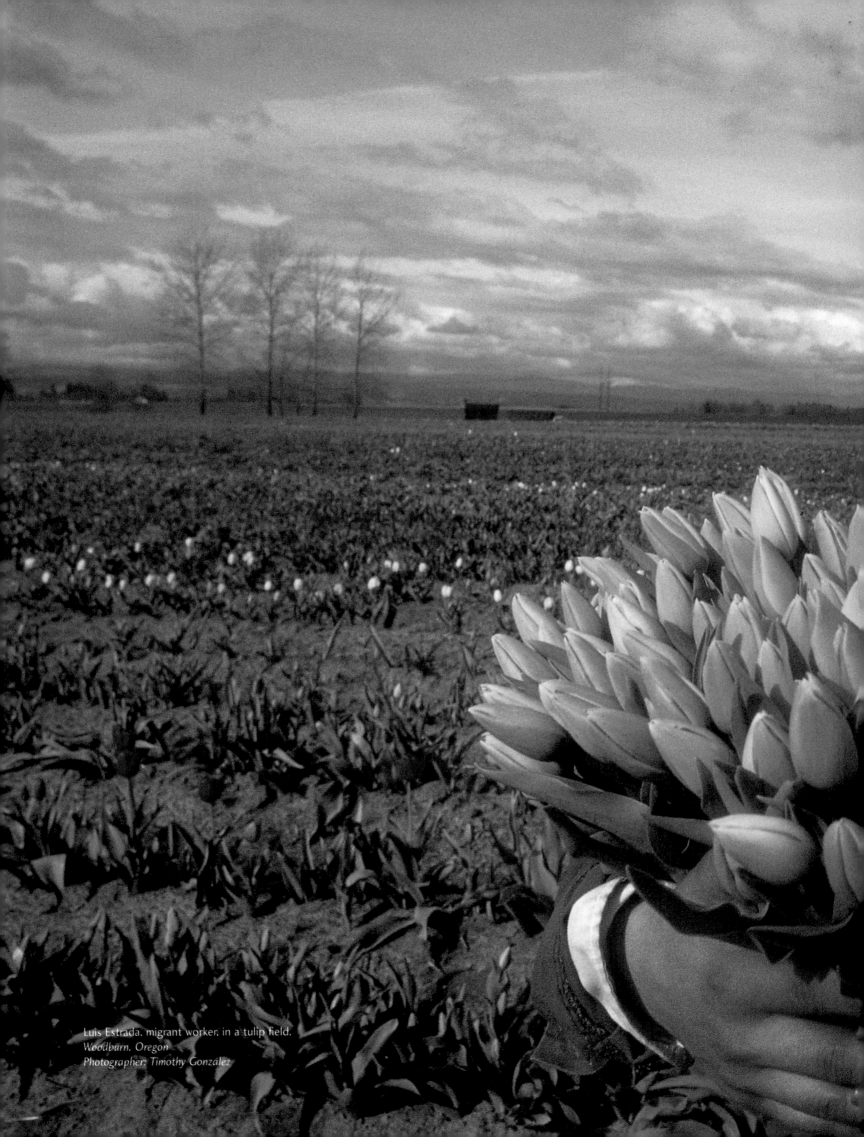

Luis Estrada, migrant worker, in a tulip field.
Woodburn, Oregon
Photographer: Timothy González

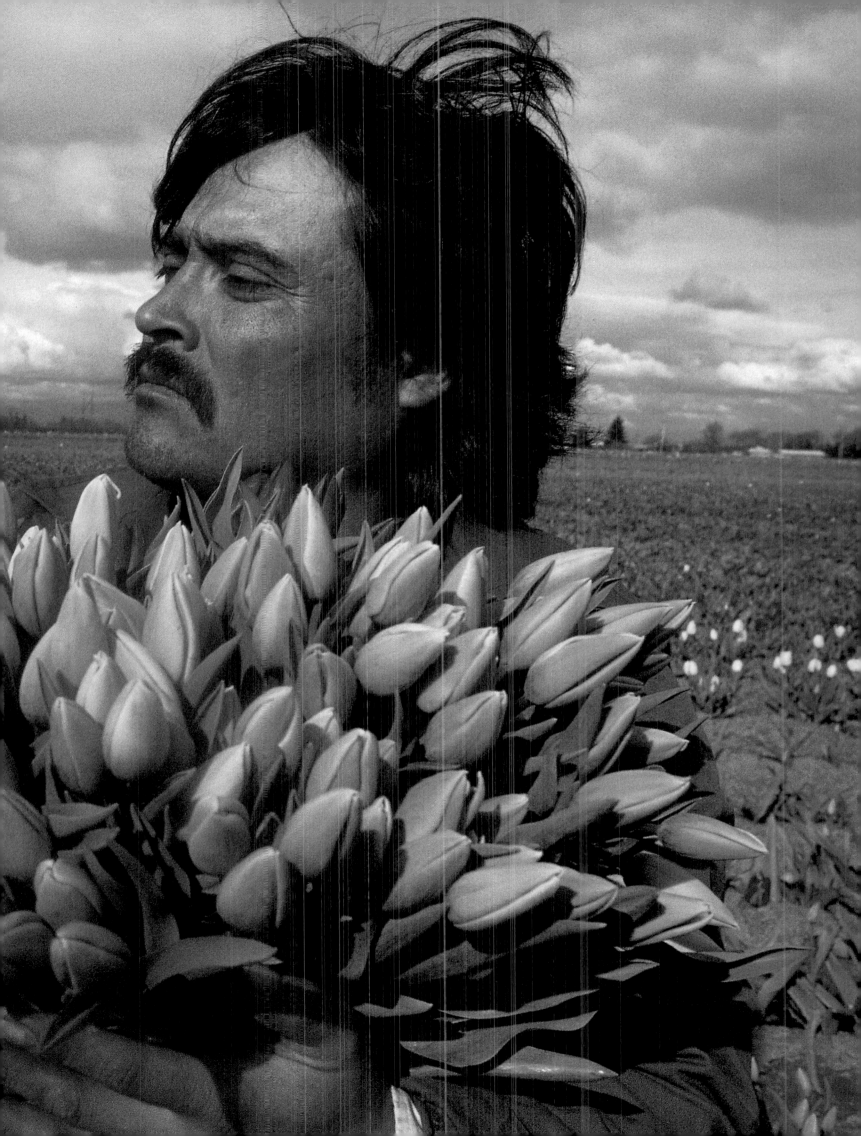

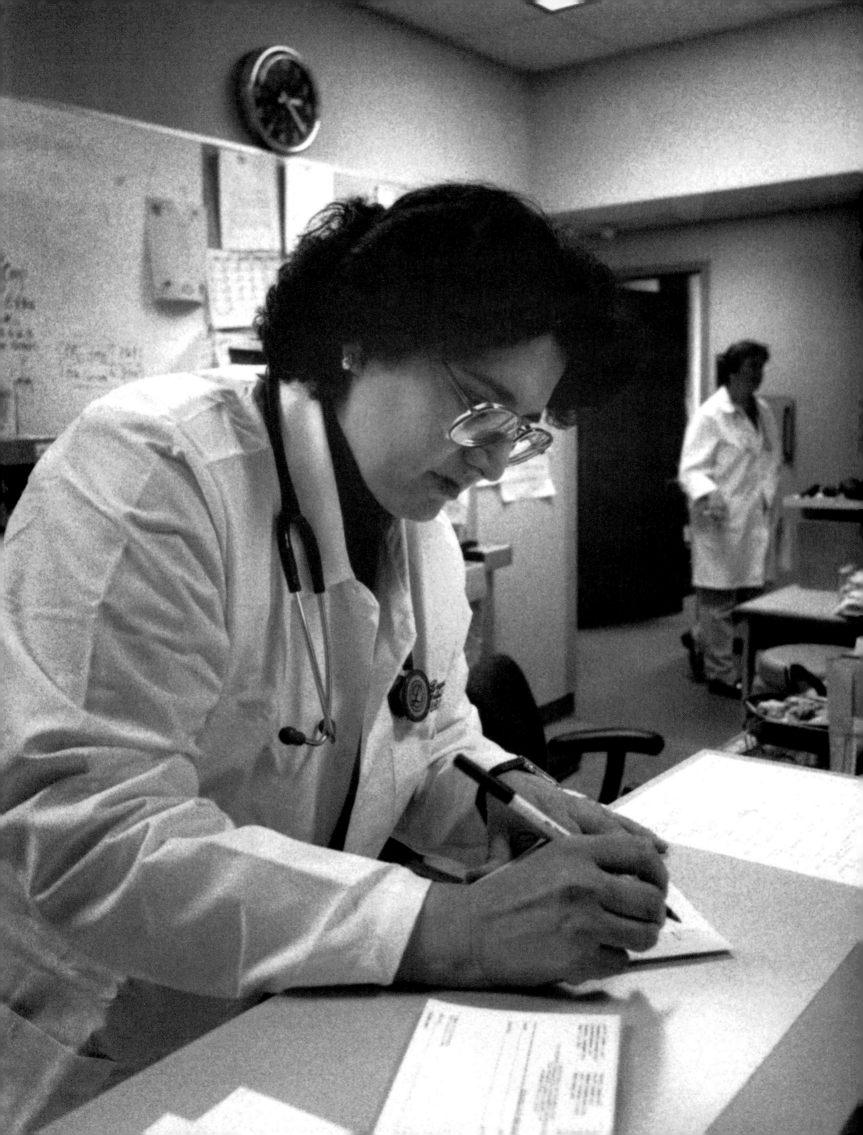

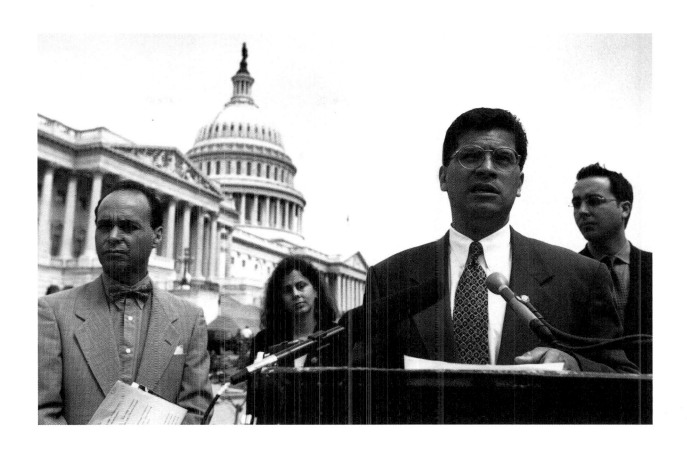

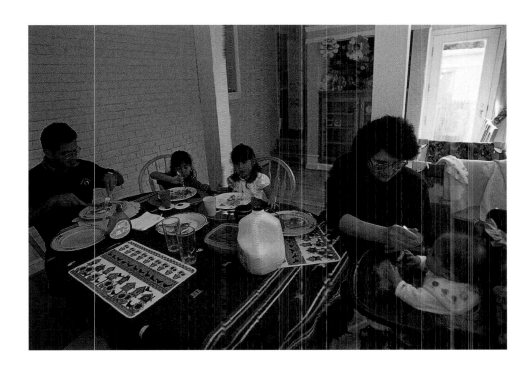

Opposite: Dr. Carolina Reyes, graduate of Harvard Medical School, is an assistant professor and physician at George Washington University.
Washington, D.C.
Photographer: Héctor Emanuel

Top: Xavier Becerra, graduate of Stanford University Law School, is an attorney and Democratic congressman from California. Standing with him are Luis Gutiérrez, Democratic congressman from Illinois (left), Cecilia Muñoz, from the National Council of La Raza, and Ambrosio Rodriguez from MALDEF.
Washington, D.C.
Photographer: Héctor Emanuel

Bottom: Congressman Xavier Becerra and his wife, Dr. Carolina Reyes, at home with their children, Clarisa, Olivia, and Natalia.
Washington, D.C.
Photographer: Héctor Emanuel

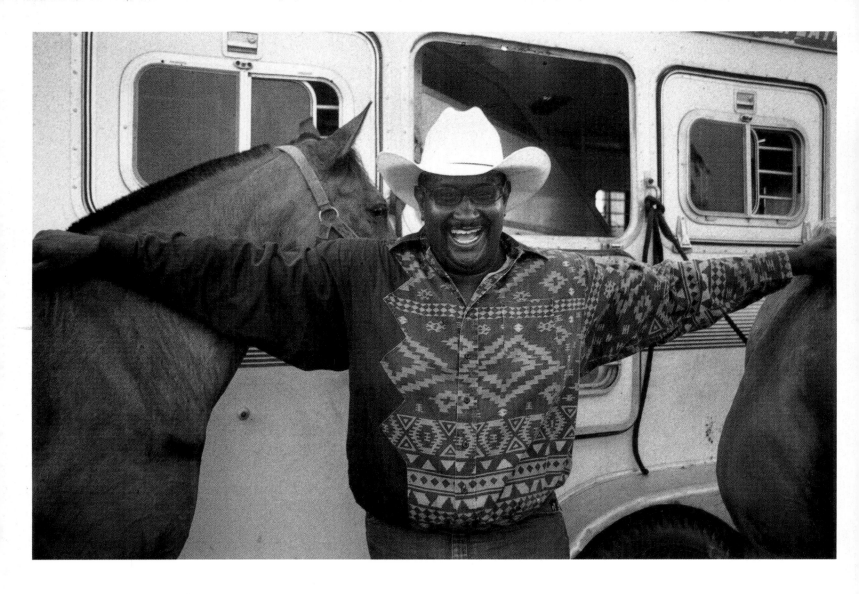

Top: Juan L. Hrobowski, Pembroke Rodeo cowboy, wins money for his ride.
Chicago, Illinois
Photographer: John Castillo
Bottom left and right: Fred Lozano has been a steel mill worker for thirty years.
Lorain, Ohio
Photographer: Ramón Mena Owens

Opposite top: Ramiro Silva, pictured with his pickup truck, works at a cattle ranch.
Welton, Arizona
Photographer: Paul Pérez
Opposite bottom: Arturo González trains and maintains several thoroughbred horses at Del Mar racetrack.
Del Mar, California
Photographer: Jimmy Dorantes

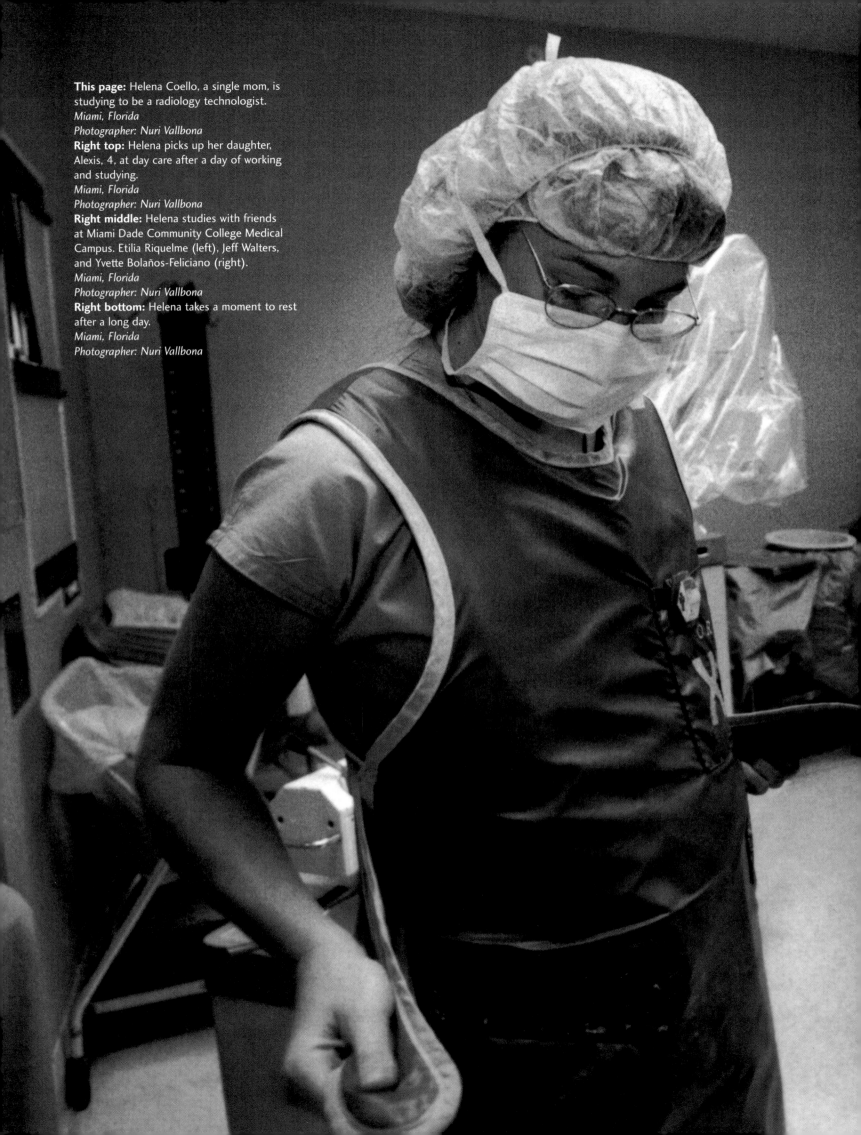

This page: Helena Coello, a single mom, is studying to be a radiology technologist.
Miami, Florida
Photographer: Nuri Vallbona
Right top: Helena picks up her daughter, Alexis, 4, at day care after a day of working and studying.
Miami, Florida
Photographer: Nuri Vallbona
Right middle: Helena studies with friends at Miami Dade Community College Medical Campus. Etilia Riquelme (left), Jeff Walters, and Yvette Bolaños-Feliciano (right).
Miami, Florida
Photographer: Nuri Vallbona
Right bottom: Helena takes a moment to rest after a long day.
Miami, Florida
Photographer: Nuri Vallbona

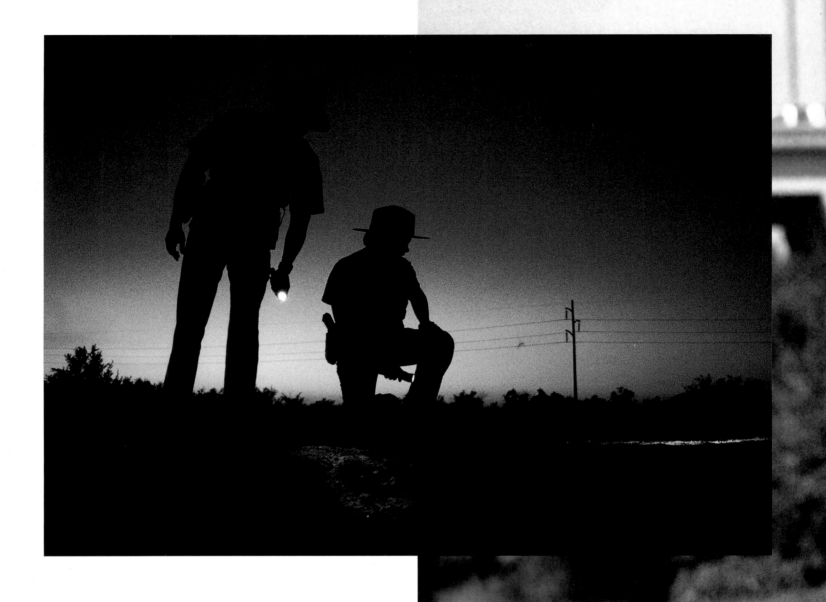

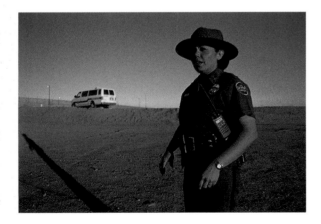

Top: U.S. Border Patrol agents.
El Centro, California
Photographer: Jimmy Dorantes
Above: U.S. Border Patrol agent Glicet
Gallegos Garvey.
El Centro, California
Photographer: Jimmy Dorantes

Opposite: A young couple crosses the Río
Grande into the United States.
Texas/México border
Photographer: Janet Jarman

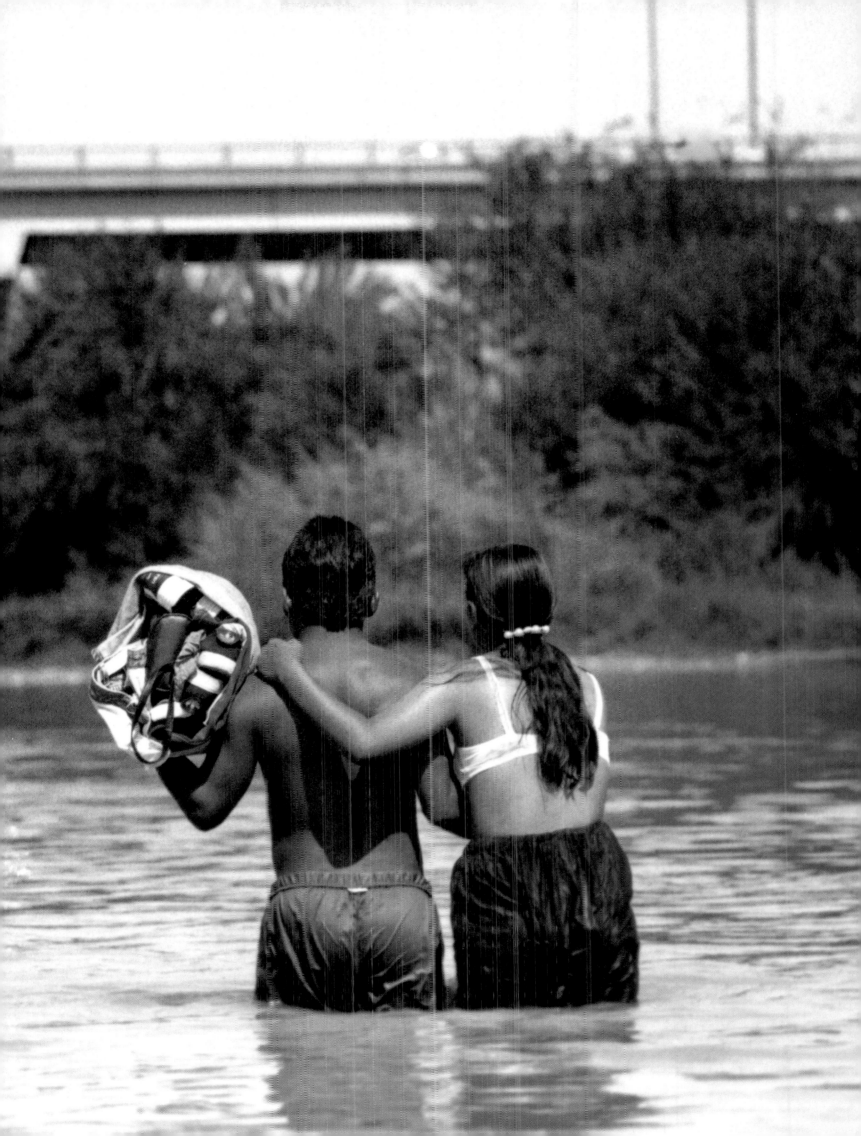

and nobody sees us *y nadie nos ve*

Humberto Ak'abal

The flame of our blood burns,
unextinguishable
in spite of the wind of centuries.

We do not speak,
our songs caught in our throats,
misery in spirit,
sadness inside fences.

Ay, I want to cry screaming!

The lands they leave for us
are the mountain slopes,
the steep hills:
little by little the rains wash them
and drag them to the valleys
that are no longer ours.

Here we are
standing on roadsides
with our sight broken by a tear.

And nobody sees us.

La llama de nuestra sangre arde,
inapagable
a pesar del viento de los siglos.

Callados,
canto ahogado,
miseria con alma,
tristeza acorralada.

¡Ay, quiero llorar a gritos!

Las tierras que nos dejan
son las laderas,
las pendientes:
los aguaceros poco a poco las lavan
y las arrastran a las planadas
que ya no son de nosotros.

Aquí estamos
parados a la orilla de los caminos
con la mirada rota por una lágrima.

Y nadie nos ve.

Marisol daydreams at dusk. Marisol has
made tremendous progress in school in
the United States, and wants to become a
computer teacher.
México
Photographer: Janet Jarman

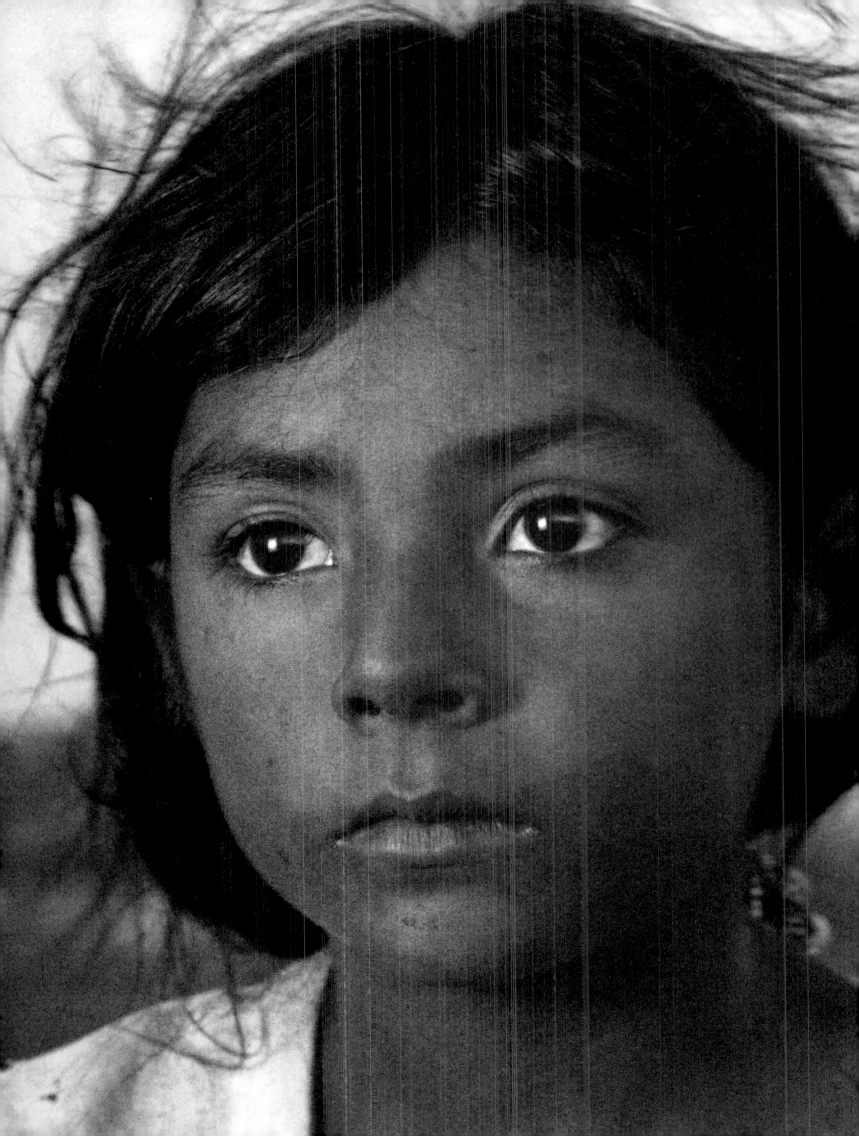

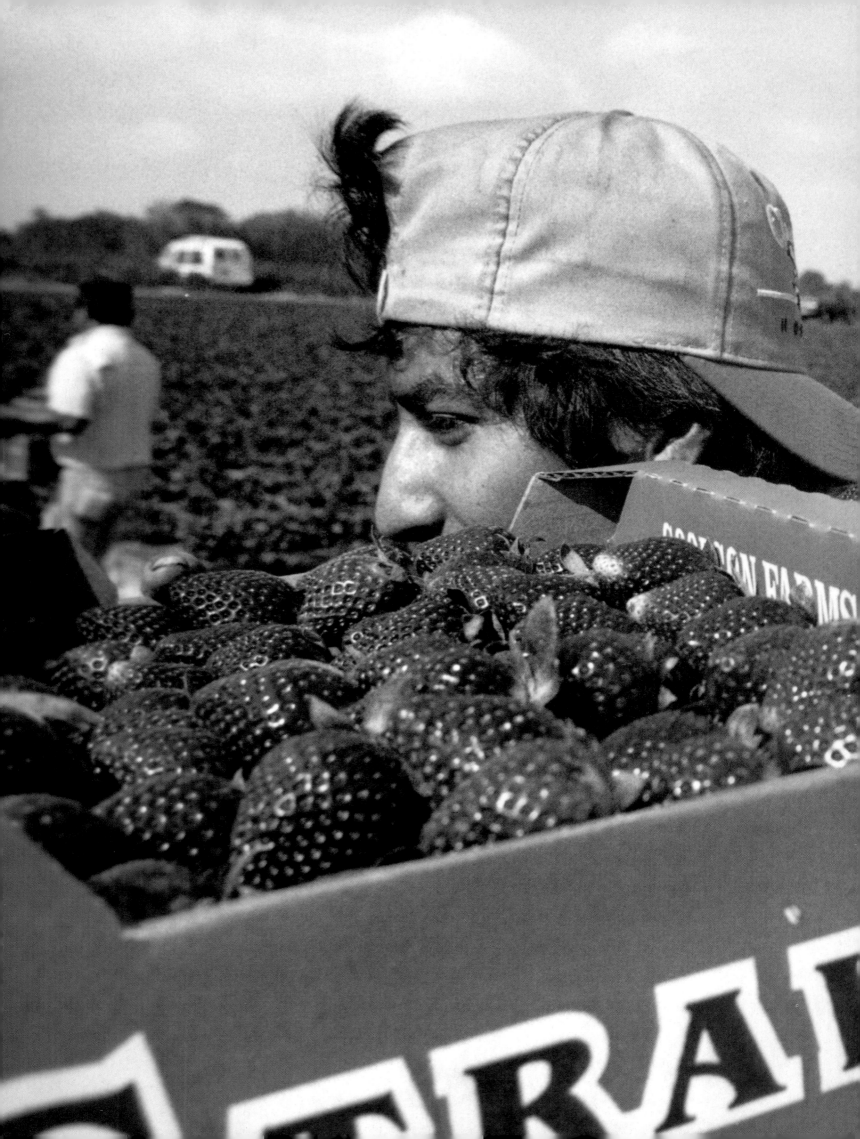

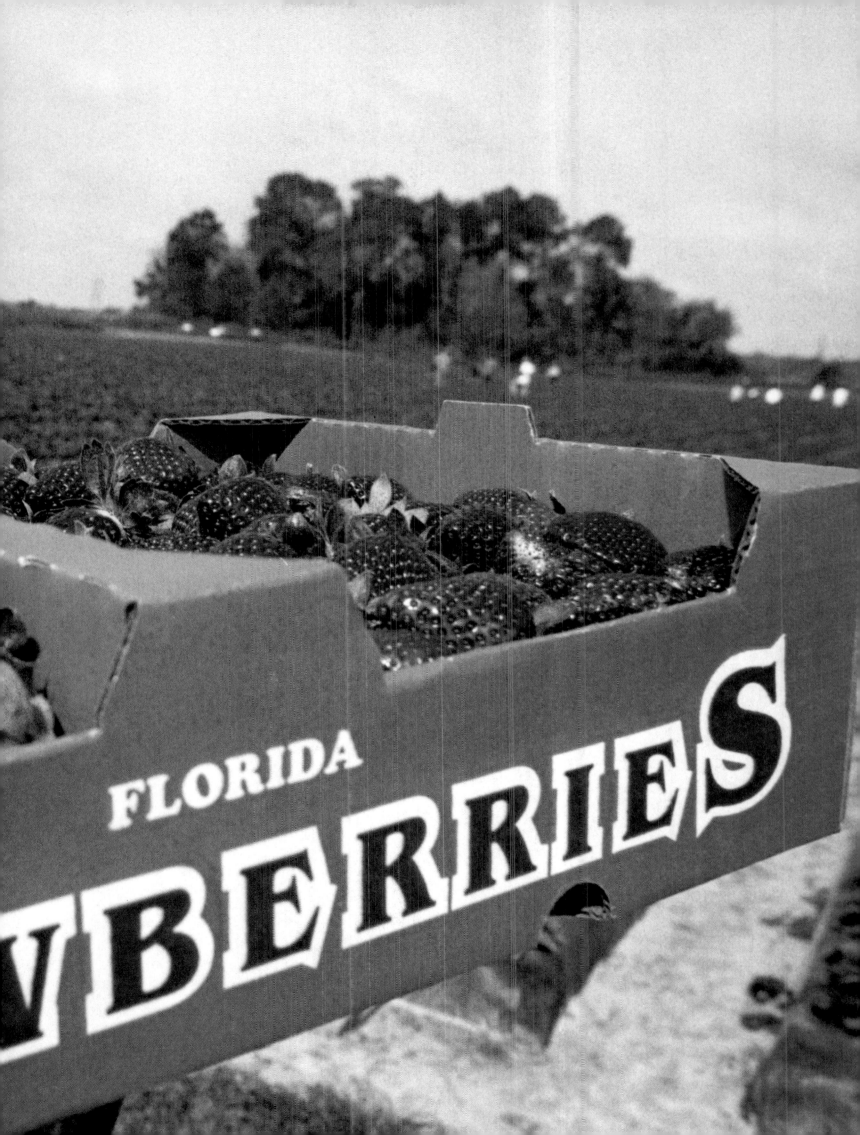

Previous page: Juan, Marisol's brother, carries a box full of strawberries ready to be inspected.
Florida
Photographer: Janet Jarman

Below: Eloísa, Marisol's mother, works at a factory in Texas.
Texas
Photographer: Janet Jarman
Bottom: Marisol waits outside with other classmates on her first day of school in the United States.
Florida
Photographer: Janet Jarman
Opposite: Marisol and her sisters, Kristina and Eloísa, take a bath outside their home.
México
Photographer: Janet Jarman

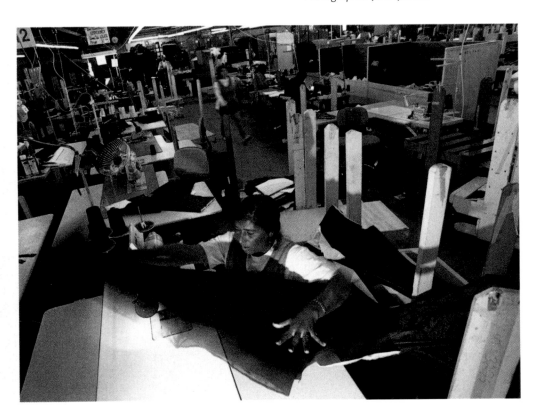

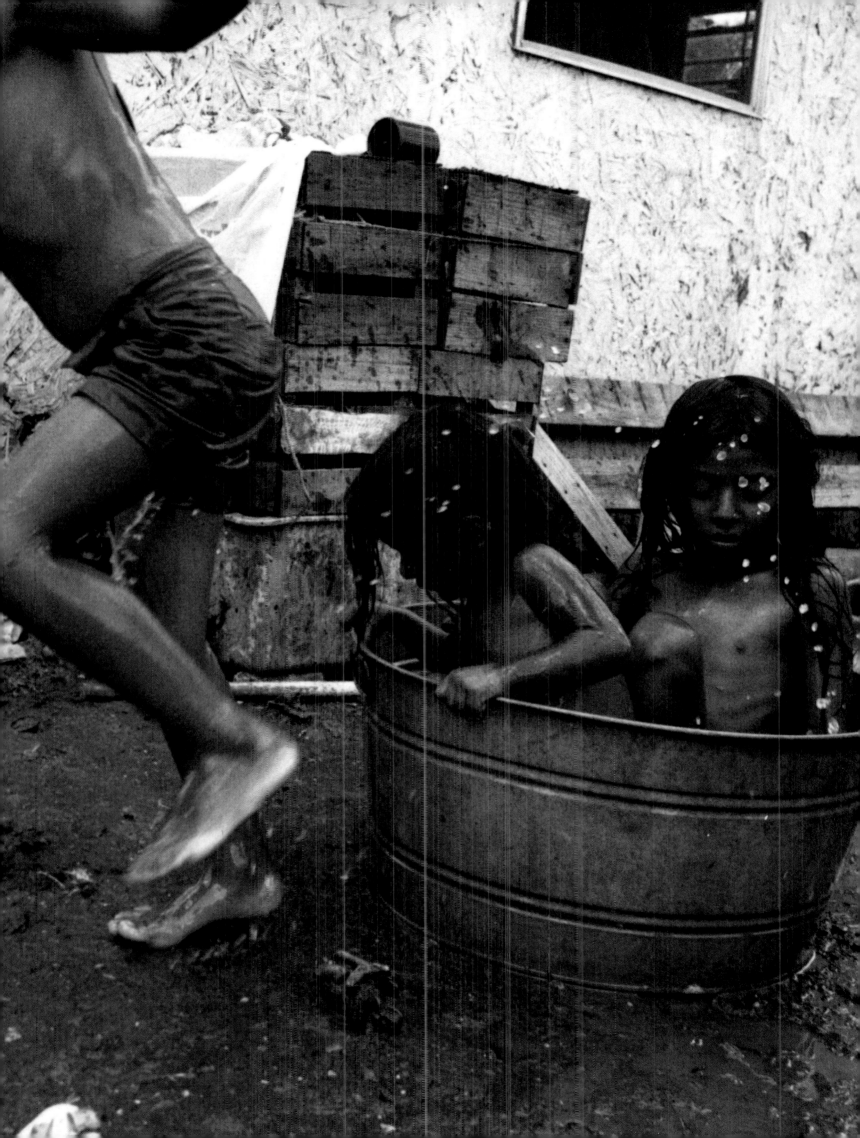

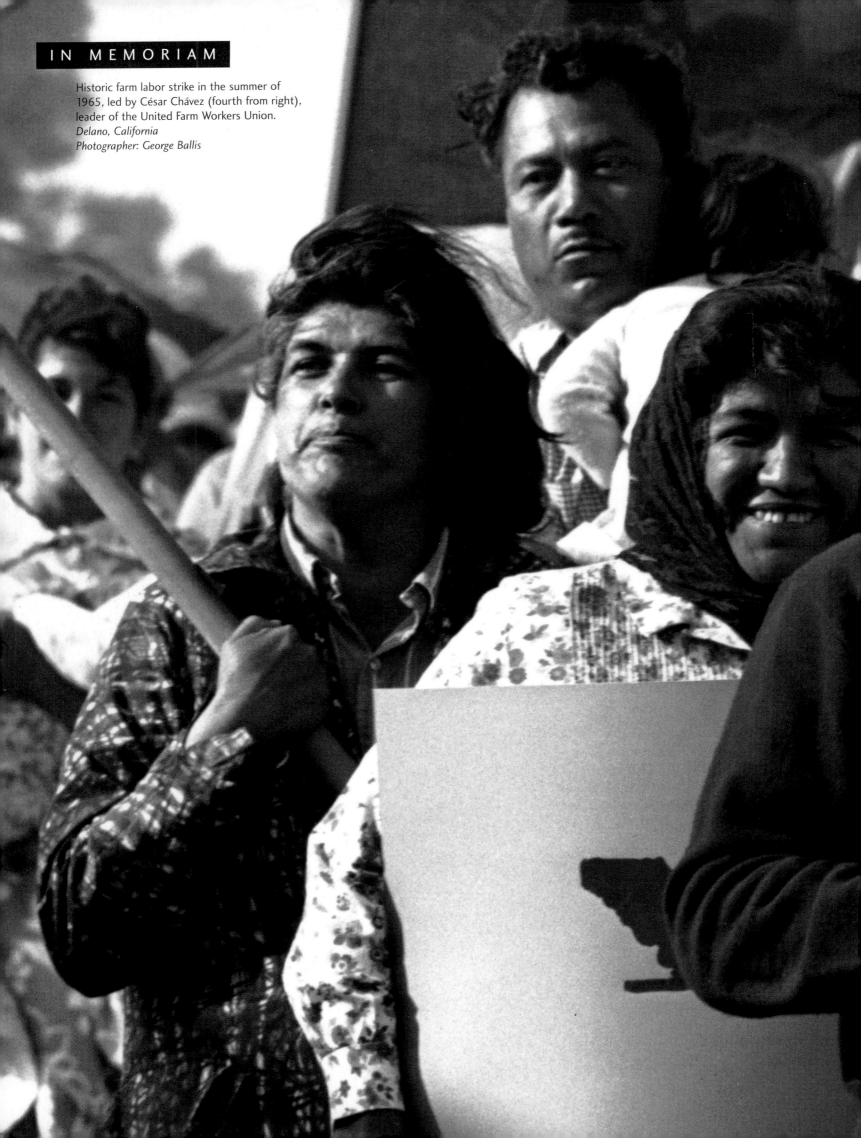

IN MEMORIAM

Historic farm labor strike in the summer of
1965, led by César Chávez (fourth from right),
leader of the United Farm Workers Union.
Delano, California
Photographer: George Ballis

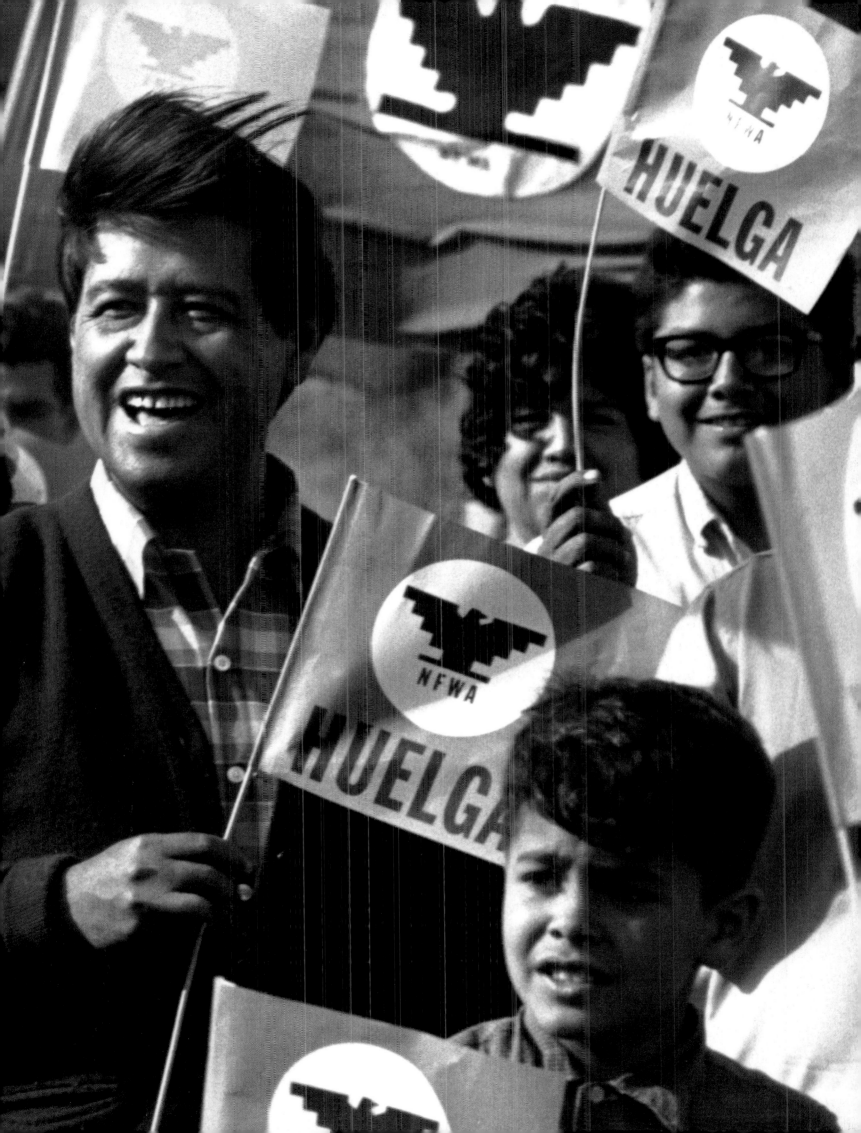

immigrant contributions
las contribuciones de los emigrantes

Julia E. Curry Rodríguez

> To go North, *ir al norte*, continues to be a beacon of hope for many who dare to explore immigrant life and its opportunities. The United States, land of pioneering spirit and opportunity for economic and social rewards, remains the goal for many of the earth's people.

Immigrants, both as families and as individuals, carry along with them their social values, skills, aspirations, and cultures as they travel and settle in new communities. The United States has continuously benefited from the contributions of immigrants, whether in terms of the seemingly mundane food on our tables, the care of our children, or the intellectual discoveries and musical contributions borne of the hands of our newer residents.

There are few places in the nation that have not been affected by immigrants, and vice versa. The East Coast has been home to Puerto Rican garment workers, Mexican mushroom pickers, and Costa Rican intellectuals. The Pacific Northwest has benefited from the entrepreneurial expertise of Mexican women, Nicaraguan food processors, and the poetic articulations of Chicano writers. The South has been host to temporary Caribbean sugarcane workers, and also to Cuban music and cultural development. The Midwest has evolved with the organizational skills of Latino community groups working for health services and educational rights. Iowa has been the home of poets trained at the Iowa writers' workshop, such as Cherrie Moraga and Ana Castillo. The Southwest, perhaps the most prolific home of Mexican-origin residents, has shared in the contributions made by immigrants. Texas with its political and social creativity became the home of the Raza Unida Party and was the place where Mexican labor activists Emma Tenayuca and Manuela Solis de Sanger united many in their quest for social justice. The people of Arizona and New Mexico, with their labor and political struggles and achievements, inspired many a child to dream of success. These are all part of the American spectrum. The nation is a matrix of its people — some newcomers, but all Americans, all contributors to this society.

The experiences of immigrant women are part and parcel of social change in America. They represent and symbolize change. Immigrant women have contributed to the feminization of the labor force and to the overall changes of conventional mores. Immigrants are important in society not merely because of the products of their labor. They also recast the way of life to which we are accustomed. They make us reflect and wonder. Immigrants are part of the future of our America, and they are important bearers of cultural norms treasured by us all.

As one revisits the accounts of immigrants, one is struck

V

El Norte sigue siendo una lámpara de esperanza para aquellos que se atreven a explorar la emigración y su promesa. En la imaginación de los emigrantes, Estados Unidos es un lugar con el espíritu pionero repleto de oportunidades y recompensas sociales. El Norte sigue siendo una meta para mucha gente del mundo.

Los emigrantes son miembros de familias, tanto como hombres y mujeres individuales, que se trasladan a los Estados Unidos estableciendo raíces en sus comunidades nuevas. Estas personas traen con ellas valores sociales, capacidades, aspiraciones, y normas culturales. Estados Unidos recibe beneficios de las contribuciones de los emigrantes. Estos beneficios incluyen labores mundanas como la comida en nuestras mesas, el cuidado de nuestros hijos, y su desarrollo intelectual y musical. Así es que los emigrantes nos dan los frutos de sus labores en múltiples áreas de nuestras vidas.

No hay ningún lugar en toda nuestra nación que no haya sido afectado por los emigrantes. La costa oriente del país ha sido hogar para costureras puertorriqueñas, y cosechadores mexicanos. En la costa norte del Pacífico encontramos empresarias mexicanas, procesadoras de comida nicaragüenses, y las articulaciones poéticas de escritores chicanos. El sur del país ha recibido a obreros de la caña procedentes del Caribe, y la música y cultura cubana. En las partes centrales del país, hemos visto el desarrollo de organizaciones entre grupos comunitarios que abogan por los servicios de salud y derechos educativos. Los estados de Iowa y Idaho han producido agricultores tanto como las finas escrituras de las poetisas chicanas Cherrie Moraga y Ana Castillo. Texas, con su creatividad política y social vio nacer al Partido de la Raza Unida. También fue donde nos beneficiamos con la labor sindicalista de Emma Tenayuca y Manuela Solís de Sanger, quienes galvanizaron a muchos en busca de justicia social. Arizona y Nuevo México con sus luchas políticas y laborales han inspirado a más de un niño a soñar que triunfa en su vida. Estos lugares, y estas personalidades, son parte del espectro americano. La nación refleja el paisaje cultural de su población — algunos recién llegados, pero todos americanos, todos contribuyentes a nuestra sociedad.

Las experiencias de las mujeres emigrantes son parte del cambio social de los Estados Unidos. Ellas representan y simbolizan cambio. Han contribuido a la femenización del mercado laboral y a los cambios de normas convencionales. Los emigrantes son importantes en cualquier sociedad no sólo por sus funciones laborales. También nos exhortan a recrear la cotidianidad de nuestras costumbres y convivencias. Nos hacen reflexionar y añorar el porvenir. Los emigrantes son

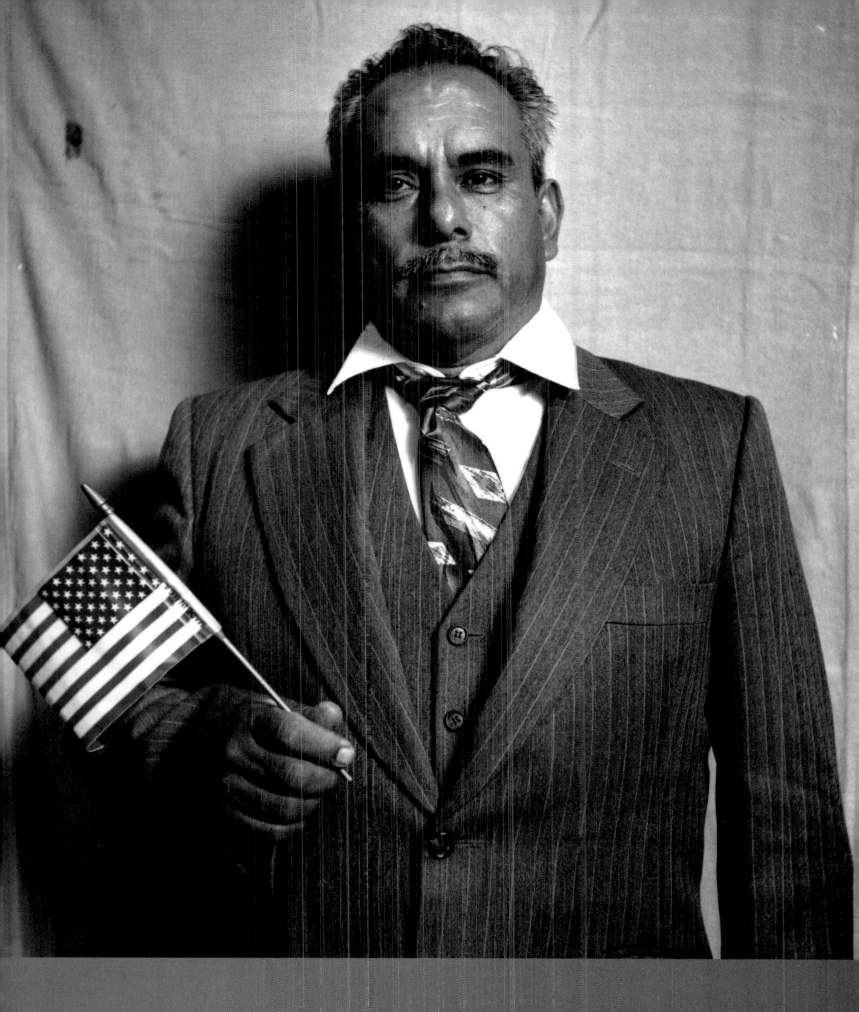

Carlos Aguas, after citizenship ceremony at
the Los Angeles Convention Center.
Los Ángeles, California
Photographer: José Galvez

by the familiarity of their stories. Listen to their powerful voices, those of women, men, and children. Know that in their unique experience lies the root of all humanity. After all, everyone in these United States except some native tribes came from somewhere else. Realize that all humanity is linked in experience by displacement and creativity. Immigrants come into new worlds to learn from people and cultures. We continue to make contributions to our host communities, now our communities, in ways we might never know.

Who is American today? A professor at California State University, Northridge, whose mother came to the United States in the 1930s to join the ranks of the garment industry. A Salvadoran family that fled the ravages of war, the eldest daughter making a migratory path. That daughter is currently a Spanish-language newscaster in the Los Angeles area. Her younger brother pursues a doctorate at the University of California at Berkeley, hoping to make contributions to the history of Latinos in the United States. A single mother of three in the San Gabriel valley teaching the newest Americans in a federally funded Head Start program how to create their first piece of art. Those are Americans, one and all. Keepers of the dreams of their parents, who brought them here or gave birth to them on U.S. soil. They nurture the dreams of people everywhere. These courageous people remind us to keep dreams alive, and to carry on with abiding hope.

parte del futuro de nuestra América y son los que nos traen la posibilidad de crear nuevas normas culturales que al fin nos definen como humanidad.

Mientras uno reflexiona sobre las experiencias de los emigrantes, tiene uno que sentir lo común con nuestras vidas, ya que sus historias son similares a las nuestras. Eschuchen sus voces poderosas: las voces de las mujeres, de los hombres y de los niños. Sepan que sus vidas son únicas, pero que también llevan en ellas la raíz de toda la humanidad. Después de todo, con excepción de las tribus indígenas, todos somos extranjeros en estas tierras. Dense cuenta que la humanidad esta íntimamente vinculada por la experiencia del desplazamiento geográfico y la creatividad de supervivencia. Los emigrantes vienen a tierras nuevas a aprender lo que el pueblo y la cultura les brinda. Seguimos contribuyendo a las comunidades que nos hospedan, o sea, nuestras comunidades, en formas que aún no hemos imaginado.

¿Quiénes somos los americanos en la actualidad? Una catedrática de la Universidad del estado de California en Northridge, hija de una mujer que viniera a los Estados Unidos durante los años treinta integrándose a la industria de la costura en Los Ángeles. Una familia salvadoreña que huye de la guerra civil después que una de sus hijas le forja el camino hacia el Norte. Esta hija hoy es reportera en Los Ángeles. Su hermano menor cursa estudios de posgrado en la Universidad de California en Berkeley con la esperanza de contribuir a la historia de los latinos en los Estados Unidos. Una madre de tres hijos, en el Valle de San Gabriel, quien enseña a los emigrantes pequeñitos a crear sus primeras obras de arte en el programa federal Headstart. Todos son americanos. Son los que conservan los sueños de sus padres, quienes los trajeron o procrearon en este país. Ellos promueven los sueños de gente en todas partes. Estas personas valientes nos enseñan a mantener nuestros sueños vivos y a vivir siempre con esperanza.

Yoo-mi Lee, from Argentina, is currently a graphic designer in Manhattan.
New York, New York
Photographer: Miriam Romais

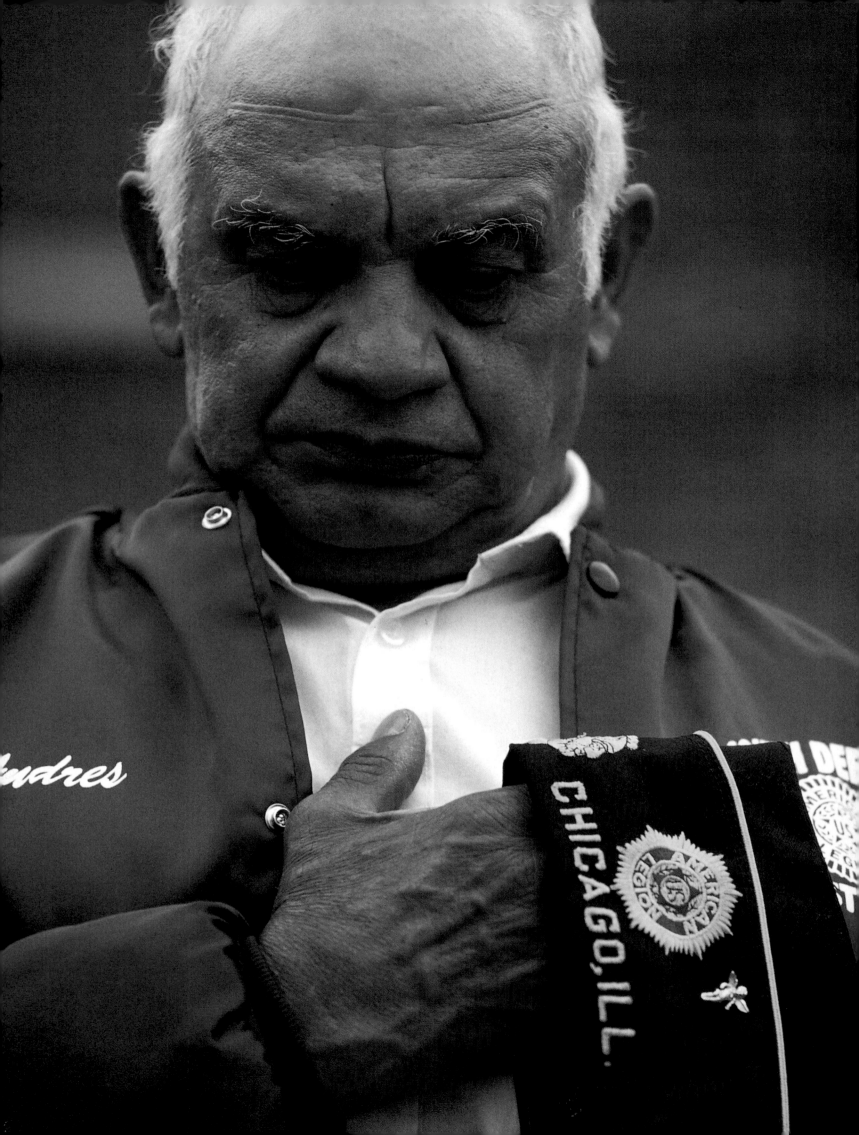

ANTONIO G. CHAVEZ JR.
1947 † 19 7
PETER RODR GUEZ
1949 † 8
JOSEPH A. IROZ
1944 †
ICHAEL S AND
1947 †

MEMORY

Previous page (left): A World War II veteran bows his head during the naming of those killed in Vietnam. Memorial Day services at Our Lady of Guadalupe Church in South Chicago.
Chicago, Illinois
Photographer: Antonio Pérez

Previous page (right): A marker honors twelve Latino men for giving their lives during the Vietnam War. Our Lady of Guadalupe Church.
Chicago, Illinois
Photographer: Antonio Pérez

Below: Antonio Chávez listens to Memorial Day services at Our Lady of Guadalupe Church. A veteran himself, he lost his son Antonio Chávez Jr. in Vietnam in 1968.
Chicago, Illinois
Photographer: Antonio Pérez

Right: Mary Lou Castro holds a photo of herself during her service in World War II.
Chicago, Illinois
Photographer: Antonio Pérez

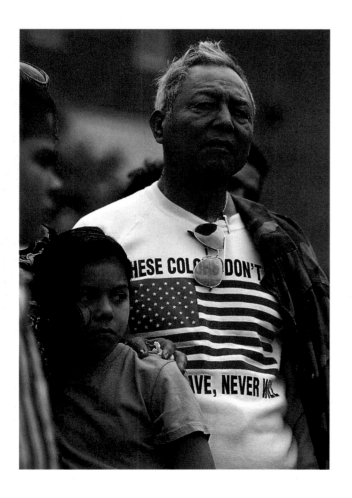

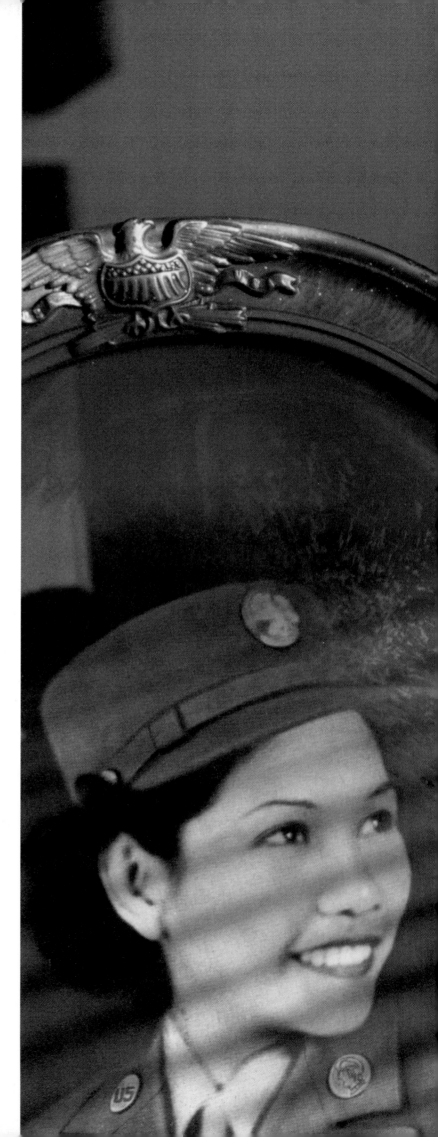

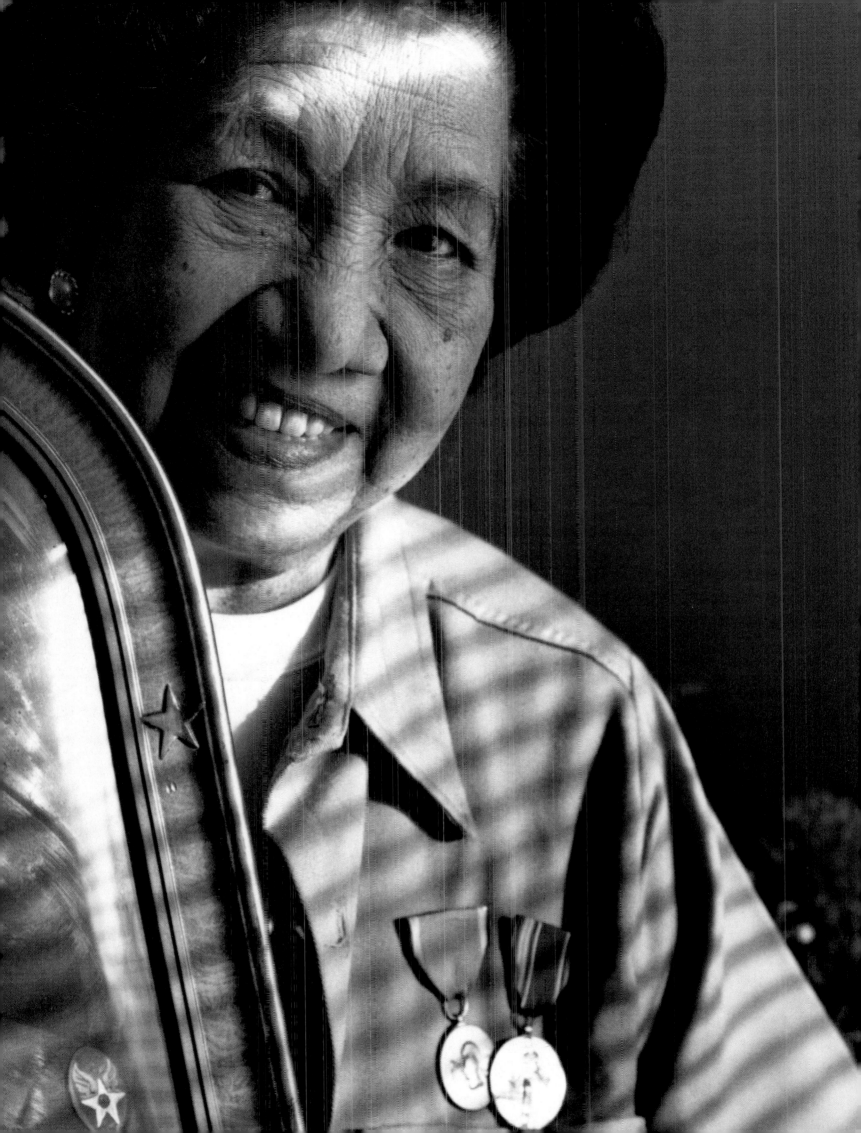

Right: Father Manuel and son Alberto Ortiz pose for a photo after services honoring those who lost their lives in Vietnam. Our Lady of Guadalupe Church.
Chicago, Illinois
Photographer: Antonio Pérez
Below: Humberto Rodríguez flies a helicopter for search-and-rescue missions.
Yuma, Arizona
Photographer: Paul Pérez

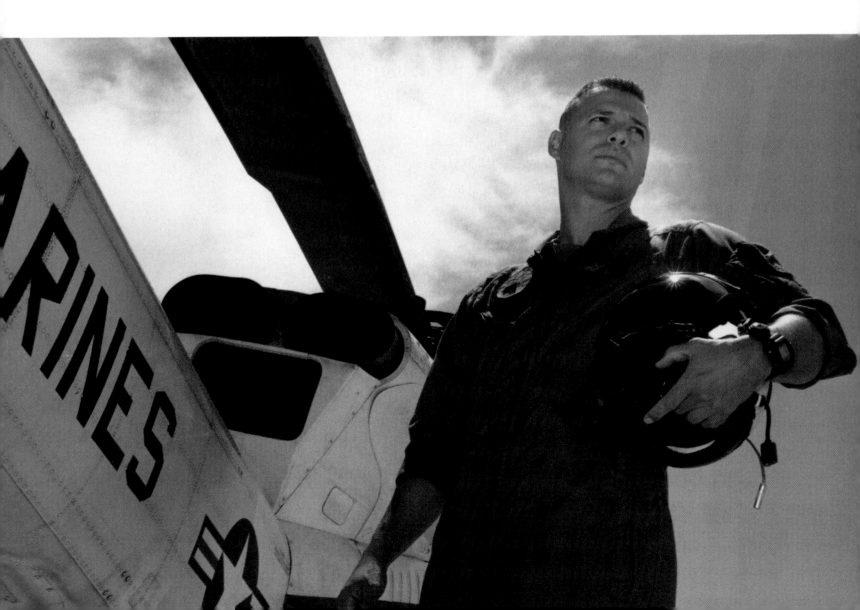

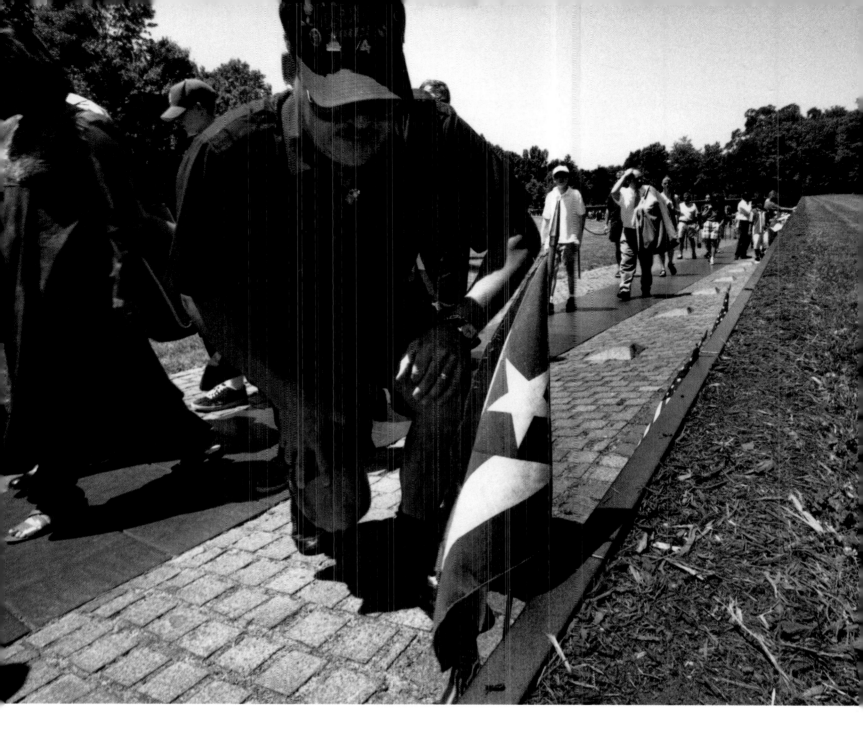

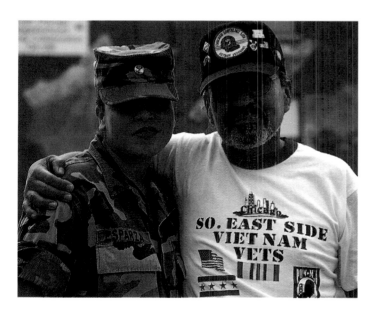

Above: Vietnam veteran José Meléndez visits the Vietnam Memorial.
Washington, D.C.
Photographer: Héctor Emanuel

Left: Vietnam veteran Manuel Esparza and his daughter, Irene Esparza, pose for a photo in South Chicago during annual Memorial Day services. The parish of Our Lady of Guadalupe lost more men in Vietnam than any other parish in the country.
Chicago, Illinois
Photographer: Antonio Pérez

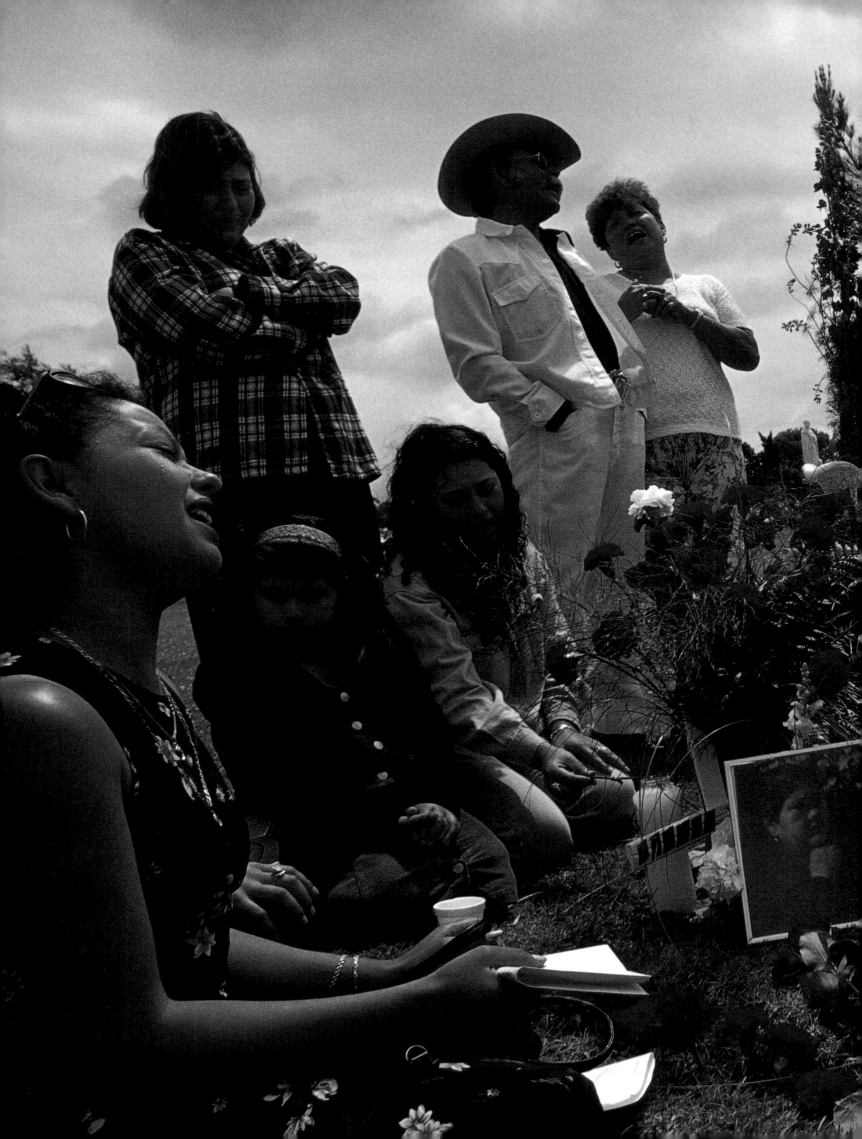

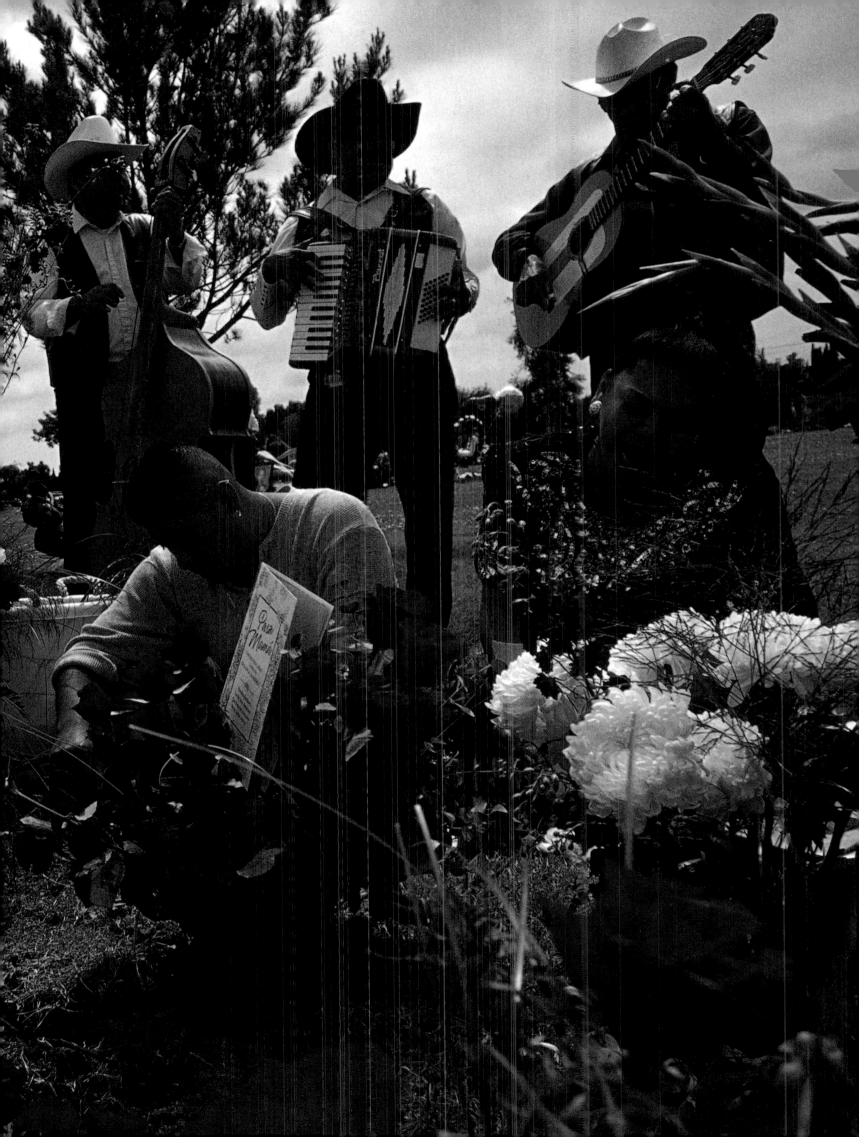

Previous page: Members of the Wence family mourn the loss of the family's matriarch, Leonor Wence, while music is played in her memory at Resurrection Cemetery.
Montebello, California
Photographer: Genaro Molina
Right: Luis Palacios, prepares *pollo asado* (grilled chicken) at El Zarape restaurant.
Yuma, Arizona
Photographer: Paul Pérez
Below right: Ramiro Silva holds corn freshly picked from the fields.
San Luis, Arizona
Photographer: Paul Pérez
Bottom: The hands of Socorro Torres pat a tortilla flat before she puts it on a griddle to cook.
Somerton, Arizona
Photographer: Paul Pérez

Opposite top: Robert Tamayo, owner of the Tamayo Bakery, specializes in Mexican pastries and breads.
El Centro, California
Photographer: Jimmy Dorantes
Opposite bottom: Mario Ramírez fills a bag with *pan dulce* for Teresa Villarreal at El Monterrey Panadería.
Houston, Texas
Photographer: Carlos Ríos

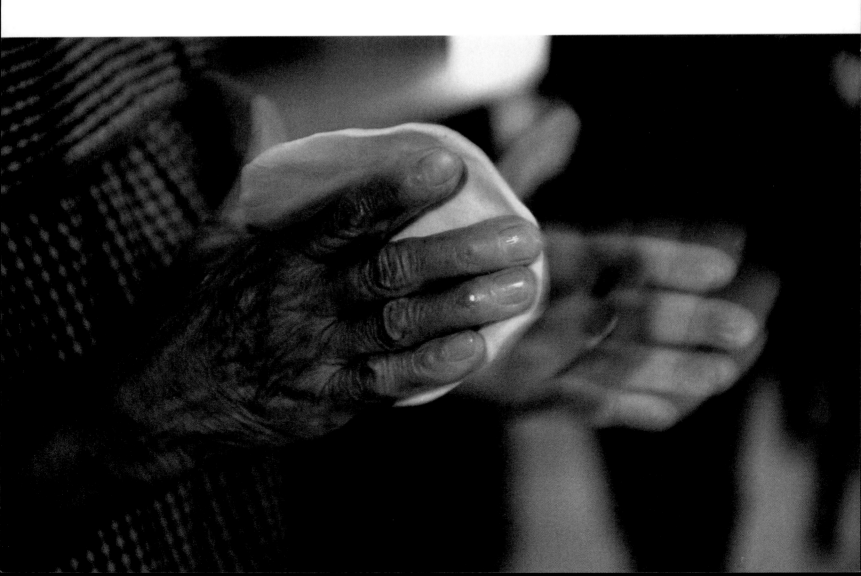

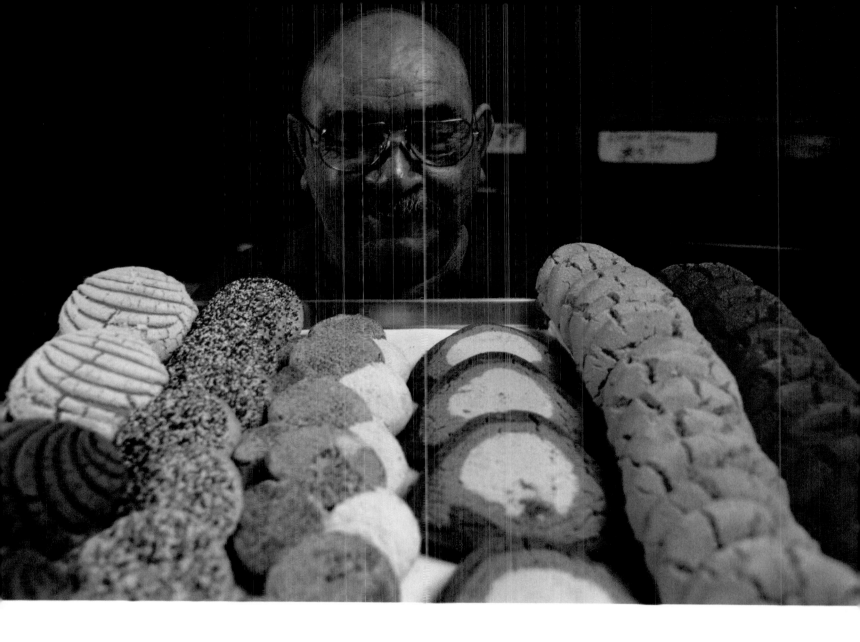

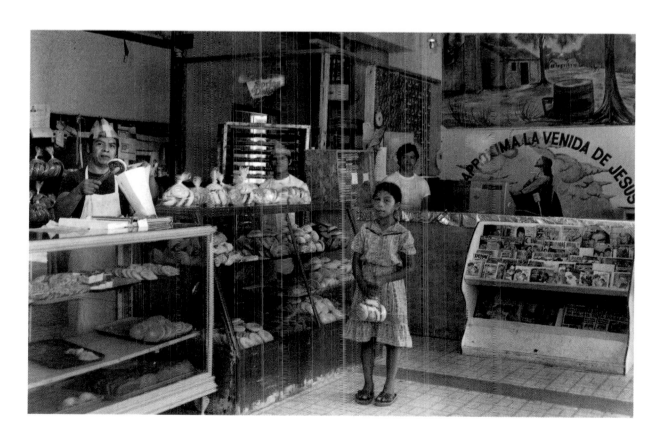

the family *la familia*

Lea Ybarra

> The very soul of the Latino experience is rooted in the family. *La familia* defines our experience at the moment of conception and throughout our lives, and also shapes our identity. Many Latinos were born in this country and have been here for generations. Others have come at different times, through different ports of entry, and under varying circumstances, fleeing poverty and hunger, persecution or revolution, or merely arriving with a dream of pursuing opportunity.

Despite our diversity, we are nonetheless bound together by a common search for a better life for ourselves and our children. Thus, our destiny has brought us to this country, whether it was generations ago or merely this morning.

What is the history of Latino families in the United States? Is it one of always wanting to return home or is it one of always considering the United States as home? Is it one of sorrow and sacrifice, or of joy and accomplishment? It is, undoubtedly, all of those.

A discussion of the Latino family is incomplete without recognition of the central role Latina women have played in both the family and the community. Despite the stereotypical portrayal of Latinas as passive women, they have always been a source of strength for family members. They maintain and nurture strong familial ties and loyalty. Historically, many Latina women also have been involved outside the family sphere in educational, community, and labor activities. As *Americanos* illustrates, Latinas are a diverse and dynamic group of women. Whether physicians, teachers, garment factory workers, astronauts, or students, they are an integral part of every aspect of American society and contribute daily to its strength and progress. As grandmothers, mothers, and daughters, single, divorced, or married, they are the cornerstones of family life.

We also must consider the role of the male in the Latino family. There are several definitions of machismo, but that of the macho as womanizer and abuser too often has been in the forefront. In *Americanos*, many Latino men are portrayed who exemplify the positive definition of a macho as one who works hard, values his family, and has valor, dignity, and honor. This is the definition we must embrace and provide for our young men.

Our families are the bridge between our past, our present, and our future. They help set our standards and our goals. We must maintain and strengthen the positive aspects of family life and continuously be role models for our children, so that when they are at the crossroads, they will know which path to take.

V

El alma misma de la vida latina está en la familia. La familia define nuestra experiencia desde el momento de ser concebidos y por el resto de nuestras vidas, y también define nuestra identidad. Muchos latinos nacieron aquí en este país y han vivido aquí por generaciones. Otros han llegado en diferentes ocasiones, por diferentes puertos de entrada, y bajo varias circunstancias, huyendo de la pobreza y del hambre, de la persecución o la revolución, o simplemente con el sueño de buscar nuevas oportunidades.

A pesar de nuestra diversidad, nosotros estamos atados juntos por nuestra búsqueda en pos de una vida mejor para nosotros y para nuestros hijos. De esa forma nuestro destino nos ha traído a este país, ya sea hace generaciones o simplemente esta mañana.

¿Cuál es la historia de las familias latinas en los Estados Unidos? ¿Es el querer siempre regresar a México o es el de considerar a los Estados Unidos como su casa? ¿Es el del dolor y sacrificio o el de la felicidad y la superación? Es sin duda alguna todo esto.

Un discurso de la familia latina no es completo sin reconocer la parte central que la mujer latina ha tenido en la familia y la comunidad. A pesar del estereotipo de las mujeres latinas como pasivas, siempre han sido un medio de fortaleza para los miembros de la familia. Han mantenido y han fomentado entre todos lealtad fuerte para la familia. Historicamente, muchas mujeres latinas han participado en actividades educacionales, laborales, y de la comunidad. Como *Americanos* ilustra, latinas son un grupo de mujeres diversas y dinámicas. Sean médicas, maestras, trabajadoras de fábricas, astronautas, o estudiantes, son una parte integral de todos los aspectos de la sociedad norteamericana y contribuyen a la fuerza y el progreso del país. Como abuelas, madres, y hijas, solteras, divorciadas, o casadas, son la fundación de la familia.

El papel del hombre entre la familia latina también se tiene que considerar. Hay diferentes definiciónes del machismo, pero la del macho como mujeriego y abusador, siempre se usa más. En *Americanos*, muchos hombres latinos que ejemplifican una definición positiva del macho como uno que trabaja duro, aprecia a su familia, y tiene valor, dignidad, y honor. Ésta es la definición que le tenemos que dar a nuestros jovenes.

Nuestras familias son el puente entre nuestro pasado, nuestro presente, y nuestro futuro. Nos ayudan a fijar nuestras metas y objetivos. Tenemos que mantener y fortalizar los aspectos positivos de la familia y ser buenos ejemplos para nuestros niños, para que cuando esten en el crucero, sepan cual camino tomar.

Above: Alberto and Marcela Prystupa and
their children, Andre, 7 months, and
Guadalupe, 2.
Van Nuys, California
Photographer: Jimmy Dorantes

Above: A boy listens for sounds of his new baby brother.
Plainfield, New Jersey
Photographer: Rita Rivera
Right: Kristi Padilla, 2, and Joe Padilla, 2, get the last drop of juice from their bottles at the South Dade Center, where their parents work at a plant nursery.
Homestead, Florida
Photographer: Nuri Vallbona

Opposite top: Isabel Vidales in her home in an East Side neighborhood of Chicago celebrates her seventy-fifth birthday with family, including grandchildren and great-grandchildren.
Chicago, Illinois
Photographer: Antonio Pérez
Opposite bottom: Family takes a stroll at Calumet Beach, an East Side neighborhood of Chicago.
Chicago, Illinois
Photographer: Antonio Pérez

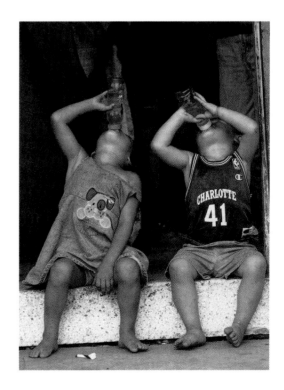

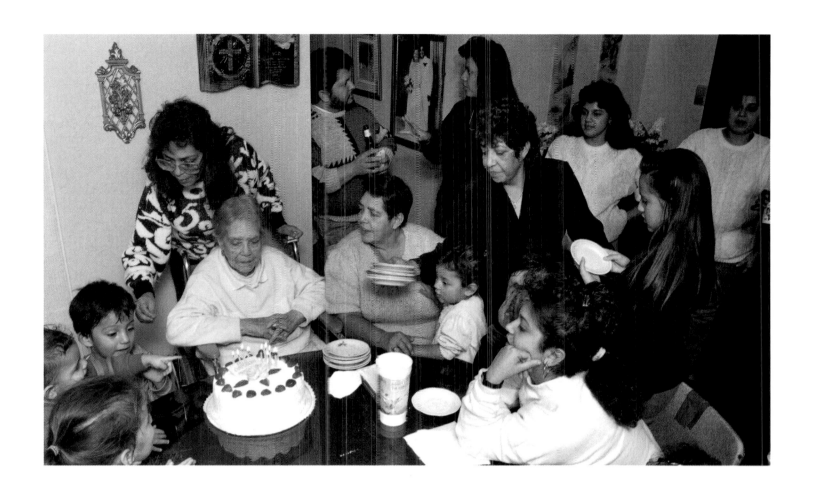
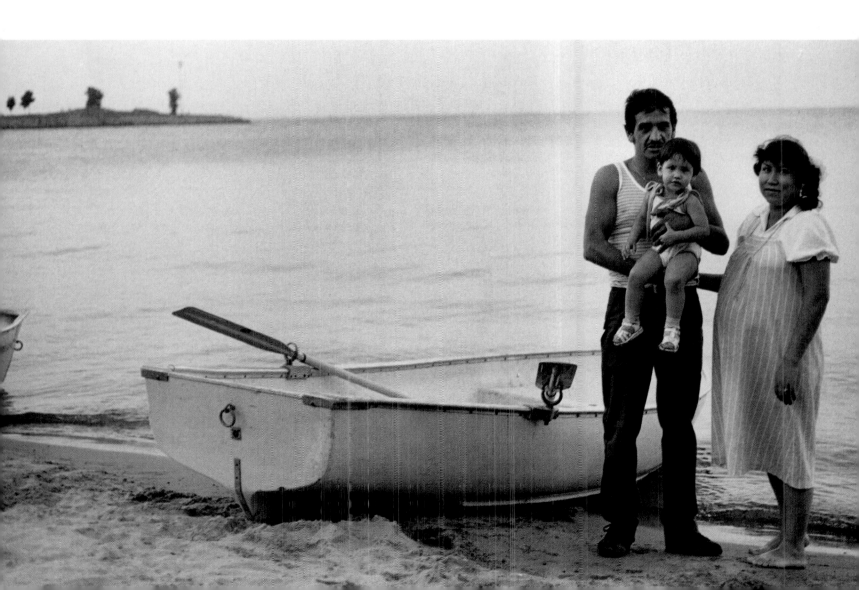

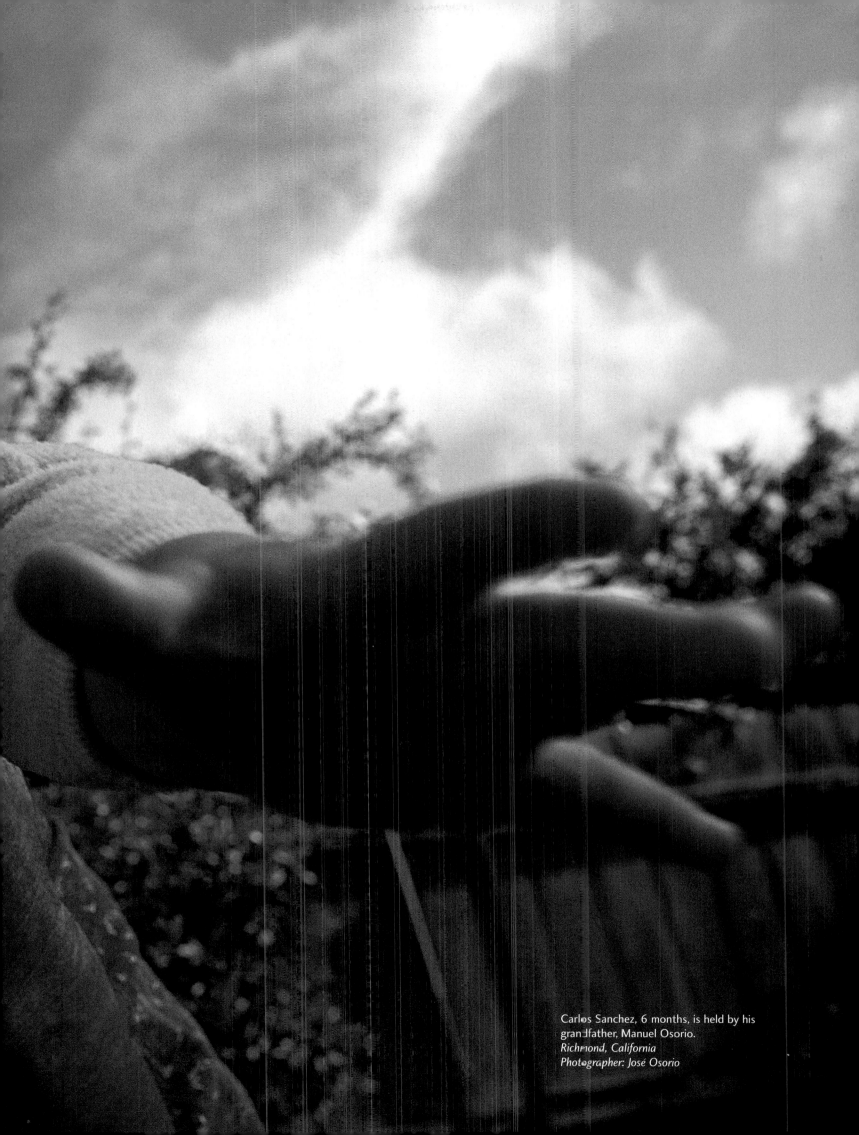

Carlos Sanchez, 6 months, is held by his
grandfather, Manuel Osorio.
Richmond, California
Photographer: José Osorio

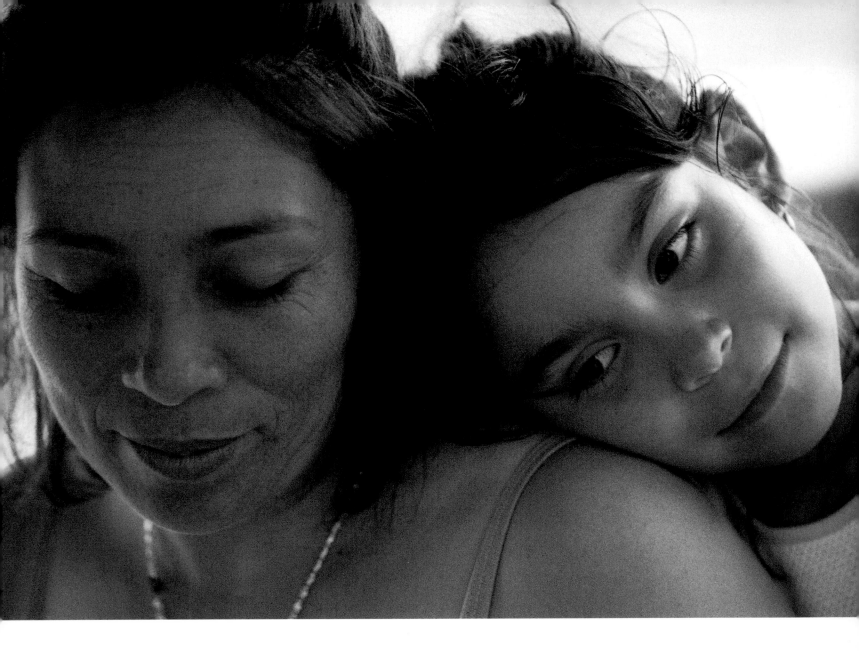

Top: Mother and daughter.
South Dade, Florida
Photographer: Nuri Vallbona
Right: Herminio Del Real and his daughter
Cristina in a rural oasis in back of their home
in South Chicago.
Chicago, Illinois
Photographer: Antonio Pérez
Opposite: Father and son resting after playing
ball.
Hunting Park, California
Photographer: José Gálvez

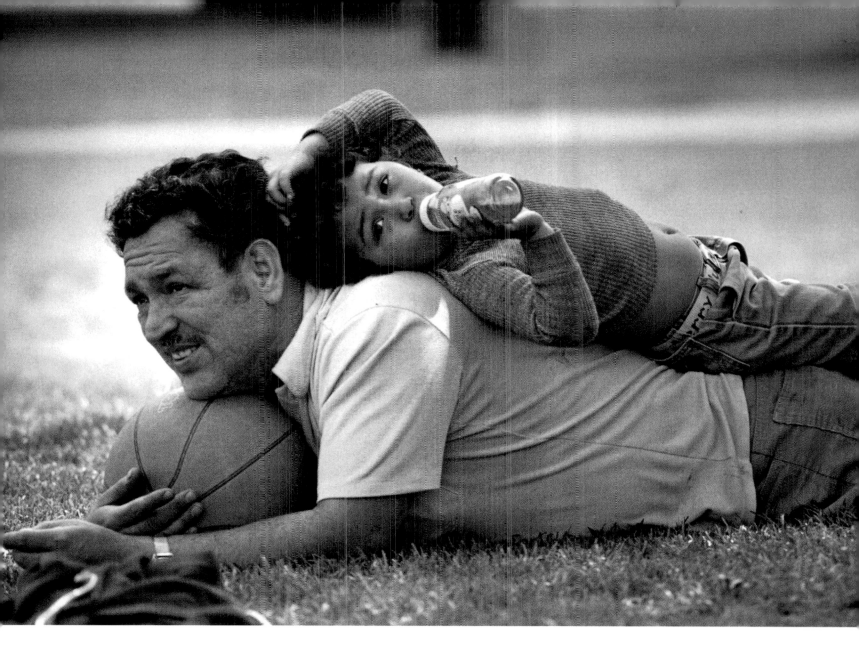

> We see the community as a vibrant entity — rich, complex, and profoundly historical, with roots and a heritage that are born from indigenous wisdom and from indigenous faces, from Spanish culture, from African sensibility; our evolution includes no end of creative people who migrated to our hearths and with whom we have loved, hated, fought, and learned.

We are both an accomplished and an unfinished people. We are a people with great potential. Democracy is in the process of hopeful developments, and Latinos are a vivid example of that hope. We have been here and we continue to come here to help sustain this country's eternal possibility. We help to sustain it every day in the small communities within our home and the larger communities outside our doors.

V

Nosotros vemos la comunidad como algo rico, complejo y profundamente histórico, con raíces y herencia que nacieron de la sabiduría indígena y de sus caras indígenas, de la cultura española, de la sensibilidad africana, así como su desarrollo incluye un sinfín de gente creativa, que se integró, hasta el fondo de nuestra cultura a los cuales hemos amado, odiado, peleado y de los cuales hemos aprendido.

Somos un pueblo que incluye tanto a los que han prosperado como a los que no se han abierto paso. Somos gente de gran potencial. La democracia está en un proceso de desarrollo, y los Latinos son un ejemplo claro de la esperanza de éste desarrollo. Hemos estado aquí y continuamos viniendo aquí para ayudar a alimentar esa eterna posibilidad. Nosotros ayudamos a alimentarla día a día en las comunidades pequeñas, dentro de nuestros hogares y las comunidades más grandes fuera de nuestras puertas.

David Carrasco

Top: Matt Hiddeman.
North Plainfield, New Jersey
Photographer: Rita Rivera

Above: Rodrigo Cruz, 21, and his nephew,
Brian Azael Cruz, 3, look over the scene at the
Ninth Annual Fiesta Broadway.
Los Ángeles, California
Photographer: Genaro Molina

Opposite: Ramona Sandoval, 80, spends a
light moment with her granddaughter, Jasmine
Zubia, in Boyle Heights.
Los Ángeles, California
Photographer: Genaro Molina

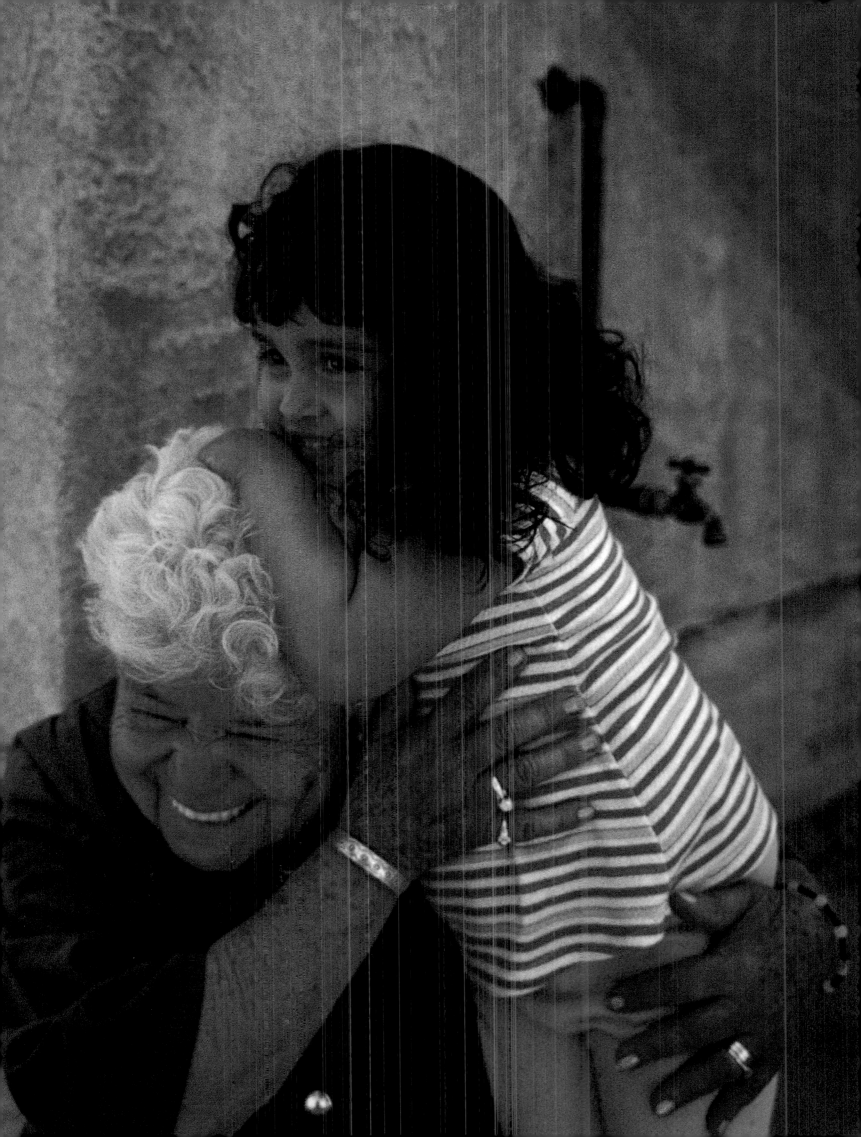

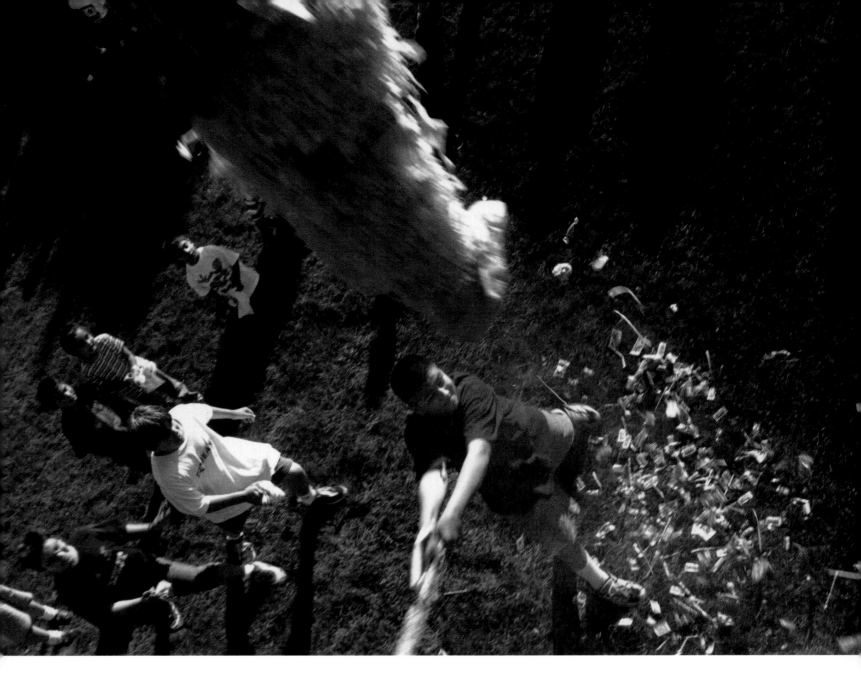

Above: Piñata bust.
Yuma, Arizona
Photographer: Paul Pérez
Right: Three brothers, David (left), Paul (center), and Richard Carrillo, share a laugh.
Escondido, California
Photographer: Jimmy Dorantes
Opposite top: Arel'j Villegas, 8, and her sister Jessica Villegas, 6, at the Ninth Annual Fiesta Broadway.
Los Ángeles, California
Photographer: Genaro Molina

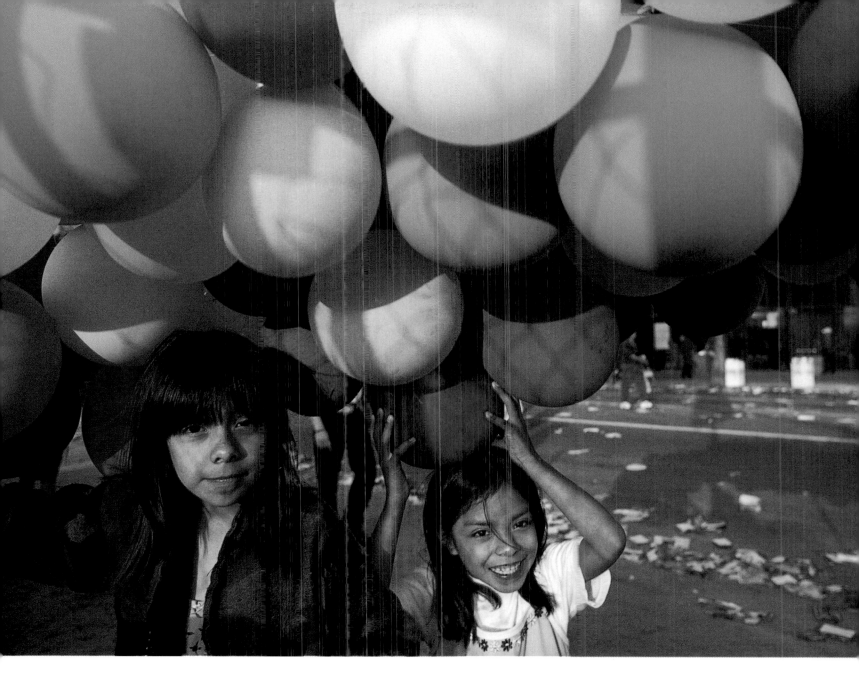

> Fiesta, music, dance, food, drink, celebration! I used to be amazed at the ability of grassroots Latinas to organize a fiesta in the midst of even the most difficult circumstances. At times I wondered what it was that they were rejoicing about, for all I could see was harshness and pain. Then I realized that fiestas provide for us the opportunity to be together, to draw strength from each other, to fight despair, to forge hope. Fiestas encourage us to struggle ahead; fiestas are part of our searching for the good life. For us, *la vida buena es la que se goza*, the good life is the one we enjoy. Our struggle is for joy and delight, for shared good fortune, for fullness of life — that is why we celebrate. *Qué siga la fiesta!*

V

¡Fiesta, música, comida, bebida, celebración! Me quedaba asombrada de la habilidad de las latinas para organizar una fiesta aun en medio de las circunstancias más difíciles. Algunas veces me preguntaba cuál era el motivo por el que celebraban, ya que todo lo que yo veía eran momentos difíciles y dolor. Entonces me enteré de que las fiestas proveían la oportunidad para que nosotros estuviéramos juntos, para fortalecernos unos a otros, para combatir la desesperación, para crear la esperanza. Fiestas que nos animan a seguir luchando; fiestas que son parte de nuestra búsqueda por una vida buena. Para nosotros, la vida buena es la que se goza. Nuestra lucha es por sentir alegría, deleitarnos, y compartir nuestra buena suerte, por tener una vida plena — por eso celebramos. ¡Qué siga la fiesta!

Ada María Isasi-Díaz

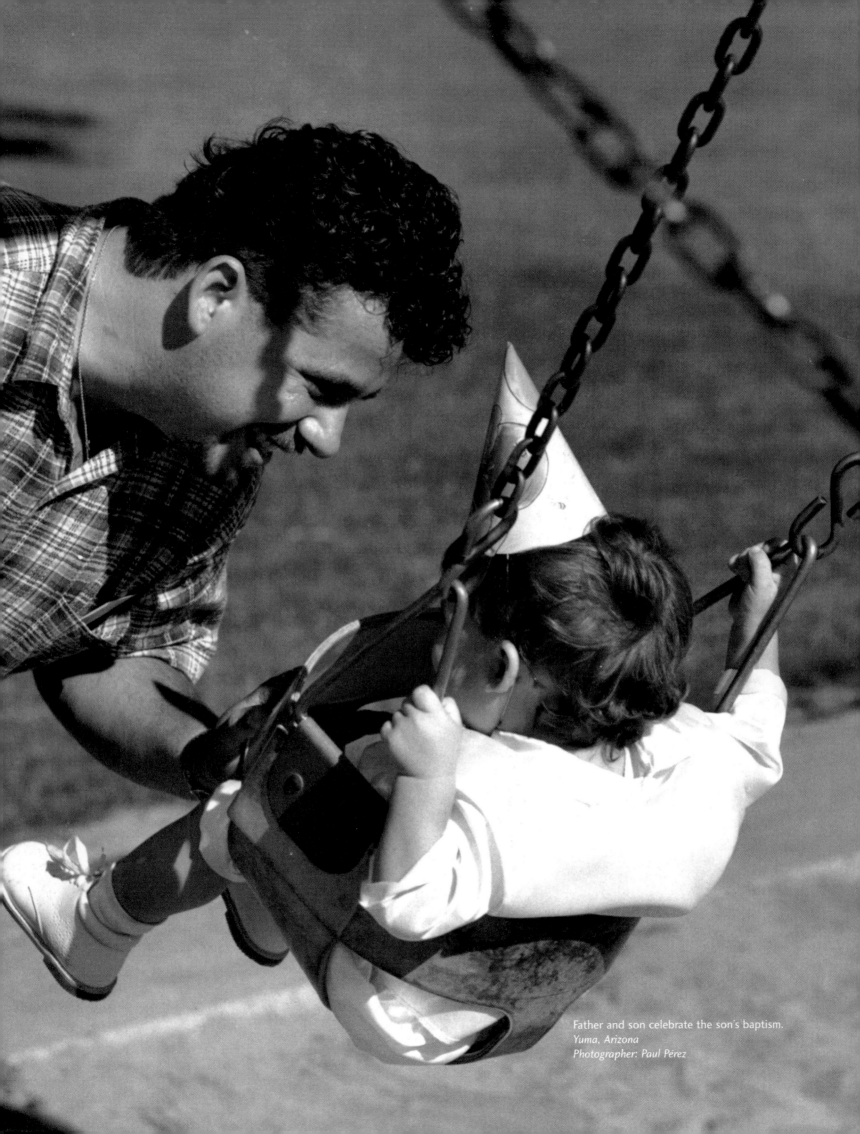

Father and son celebrate the son's baptism.
Yuma, Arizona
Photographer: Paul Pérez

Father swinging his daughter.
Tucson, Arizona
Photographer: José Gálvez

> I asked my grandfather what *macho* meant
he laughed and sat me down next to him
 It means being strong enough to be kind and gentle
I don't understand grandfather
what about those guys who treat people mean?
 Oh Juanito
 they're just not strong enough yet.

V
Yo le pregunté a mi abuelo lo que quiere decir "macho"
Él se rió, me sentó a su lado
 Y me dijo que quiere decir ser lo bastante fuerte para
 ser bueno y gentil
Yo no comprendo abuelo
¿y qué de esos que tratan mal a la gente?
 Ah, Juanito
 Ésos no son suficientemente fuertes todavía.

Juan Carlos Heredia

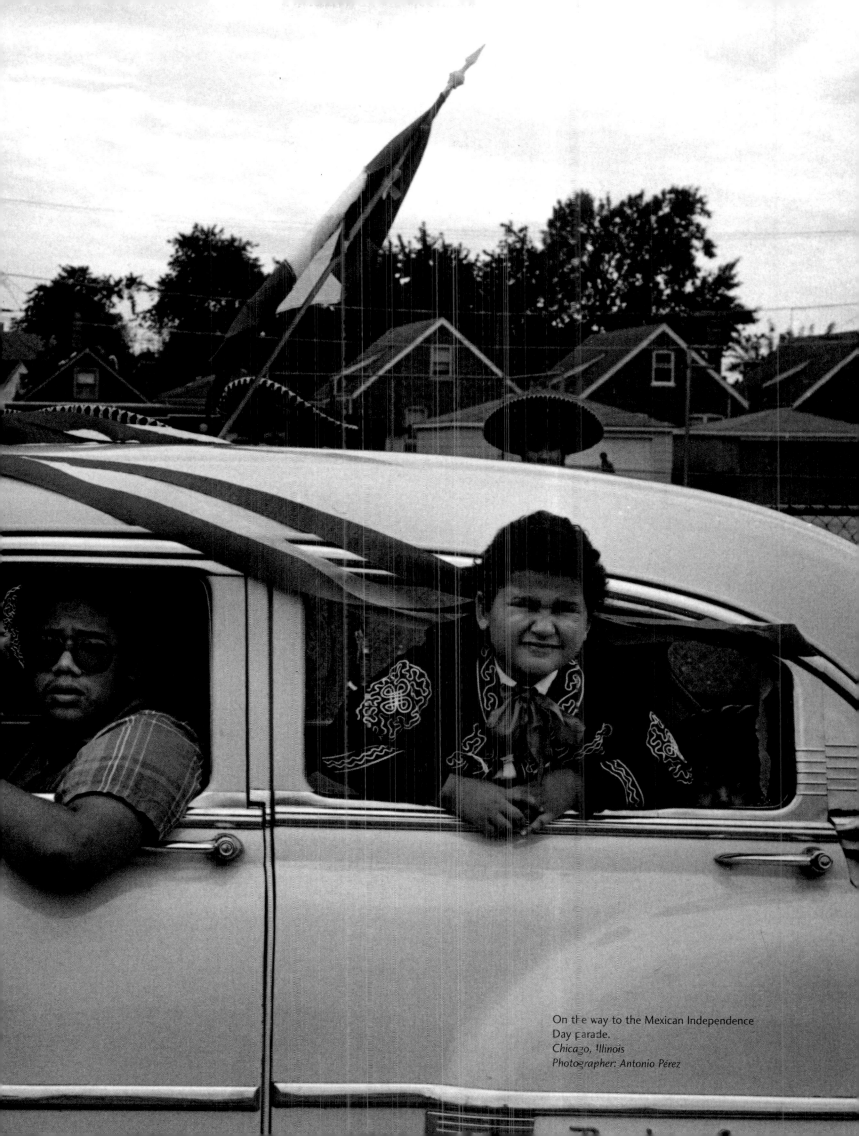

On the way to the Mexican Independence
Day parade.
Chicago, Illinois
Photographer: Antonio Pérez

colors *colores*

Ada María Isasi-Díaz

> Latinas sitting on a stage, presiding at a conference — how beautiful is the rainbow of colors of their skins! How rich the diversity of races and cultural strands they represent. How blessed the *mestizaje* and *mulatez* that run through our veins and are stamped on our skin. Diversity and differences: our blessing and our challenge. They are a gift from our ancestors, a gift we want to pass on to our children. Living in the midst of institutionalized prejudices, however, the challenge is no small matter; it is a *lucha* we have to embrace if we want to remain faithful to who we are as Latinas, as children of Europeans, Amerindians, and Africans.

No matter how different we are, there are many ways in which we are the same or similar and that is precisely what makes relationships and dialogue possible. If there were no differences and diversity, our world would be so poor, so limited, so *aburrido*. We need differences; that is what it means to be social beings. And since our sociality is intrinsic to who we are as persons, to reject differences and diversity is to negate ourselves.

To value those who are different we have to know them, we have to deal with them, we have to make them our friends; we have to welcome people of different nationalities and cultures, of different gender and orientation, of different political leanings, with different degrees of schooling. If we embrace those who are different we will soon realize there are similarities among us and that we can learn from them because who they are and how they face life is valuable and important for all.

V

Latinas sentadas en el escenario dirigiendo una conferencia — ¡qué bonito es el arco iris del color de sus pieles! Qué rica es la diversidad de razas y las diferentes líneas de cultura que ellas representan. Qué bendito es el mestizaje y mulatez que corre en nuestras venas y está estampado en nuestras pieles. Diversidad y diferencia: nuestra bendición y desafío. Son el regalo de nuestros antepasados a nuestros hijos. Viviendo en medio de un prejuicio establecido, sin embargo, el desafío no es un asunto pequeño, es una lucha que tenemos que abrazar si queremos ser fieles a lo que somos, como latinas, como hijas de europeos, indígenas americanos y africanos.

No importa que tan diferente seamos, hay muchas maneras en las cuales somos iguales o similares y eso es precisamente lo que hace posible la amistad y la comunicación. Si no hubiera diversidad y diferencia, nuestro mundo sería tan pobre, tan limitado, tan aburrido. Nosotros necesitamos las diferencias — eso significa que somos seres sociables. Y ya que socializarse es algo intrínseco a lo que nosotros somos como personas, rechazar las diferencias y diversidades es como negarnos a nosotros mismos.

Para valorizar a aquellos que son diferentes tenemos que conocerlos, tenemos que tratarlos, tenemos que hacernos sus amigos. Nosotros tenemos que aceptar con agrado las gentes con diferentes nacionalidades y culturas, de diferente sexo e inclinación, de diferentes enseñanzas políticas, con diferentes grados de educación. Si nosotros aceptamos a aquellos que son diferentes, muy pronto caemos en cuenta que hay similaridades entre nosotros y que podemos aprender de ellos porque lo que ellos son y cómo enfrentan la vida es valioso e importante para todos.

Opposite: Rosa Rodríguez (left) and Melissa Pozotrigo at the Cuban Day parade.
New York, New York
Photographer: Alexis Rodríguez-Duarte

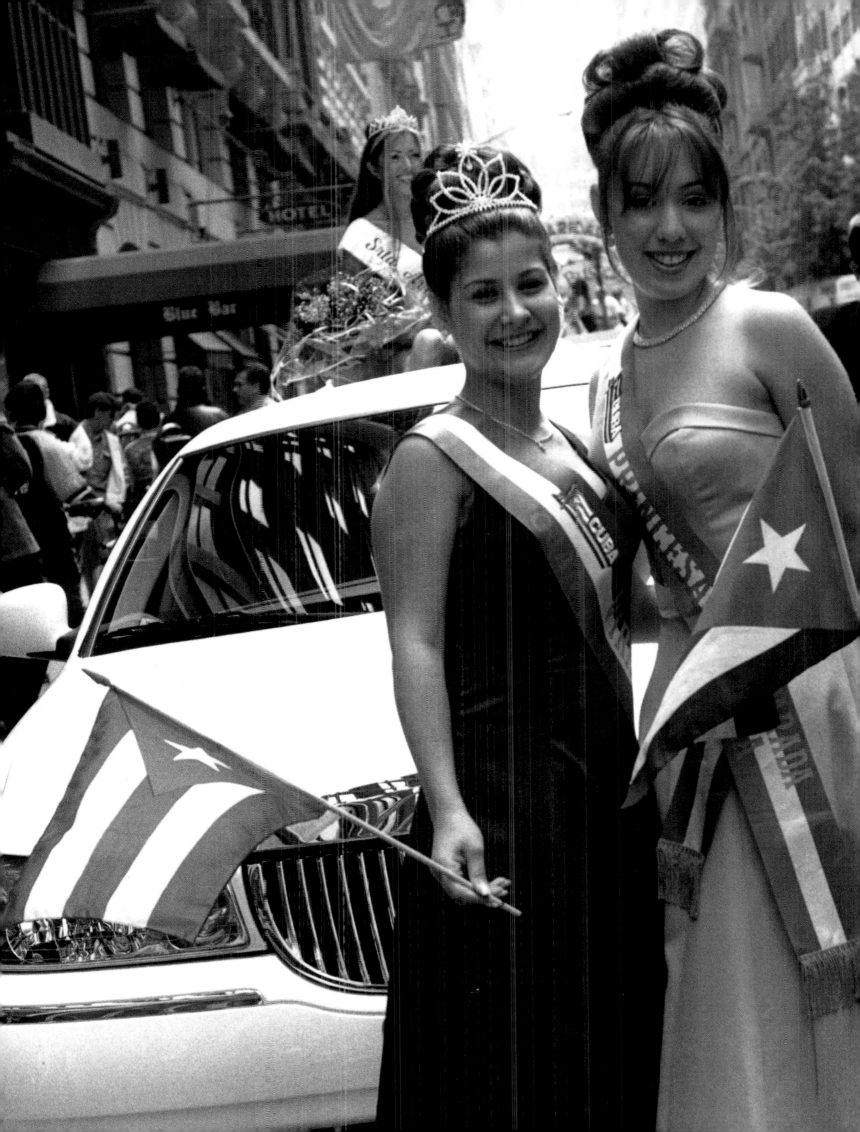

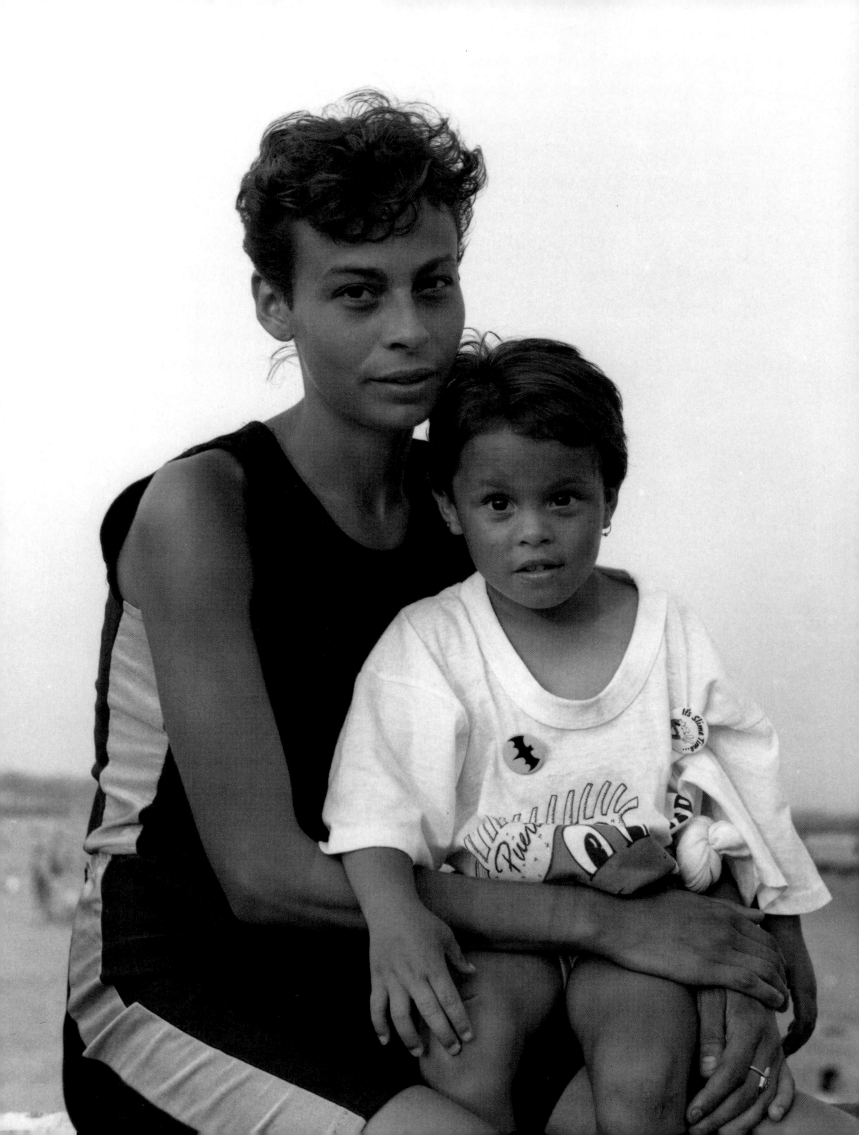

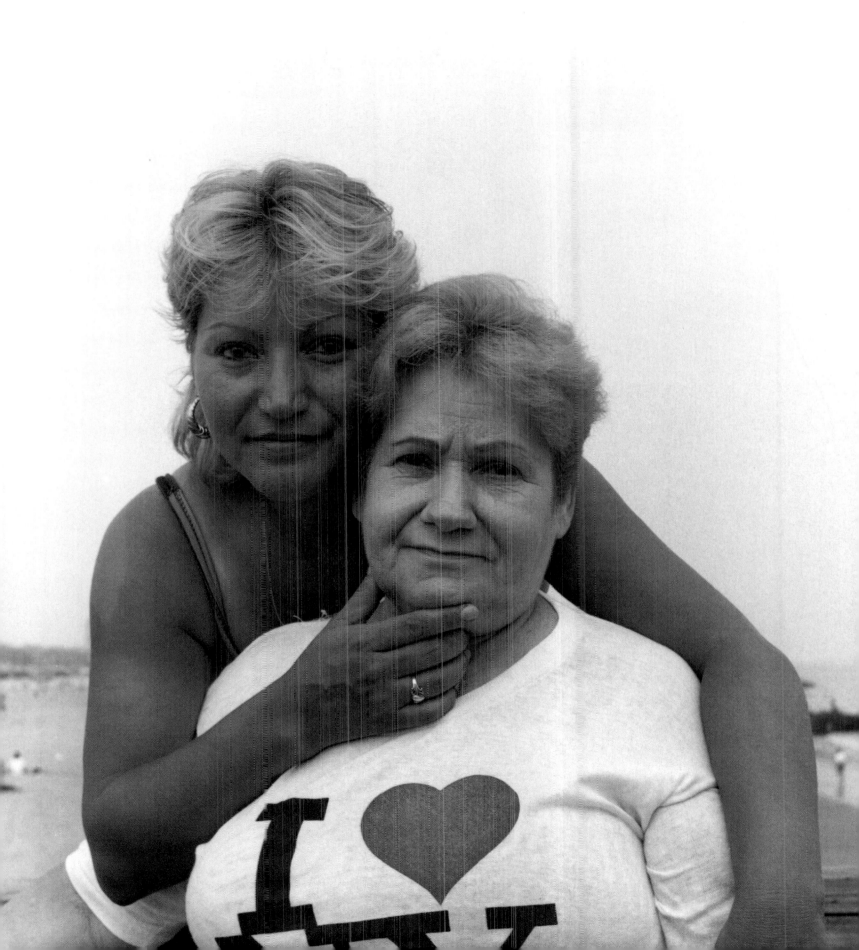

Opposite: Mother and child at Coney Island.
New York, New York
Photographer: Rita Rivera
This page: Mother and daughter at Coney Island.
New York, New York
Photographer: Rita Rivera

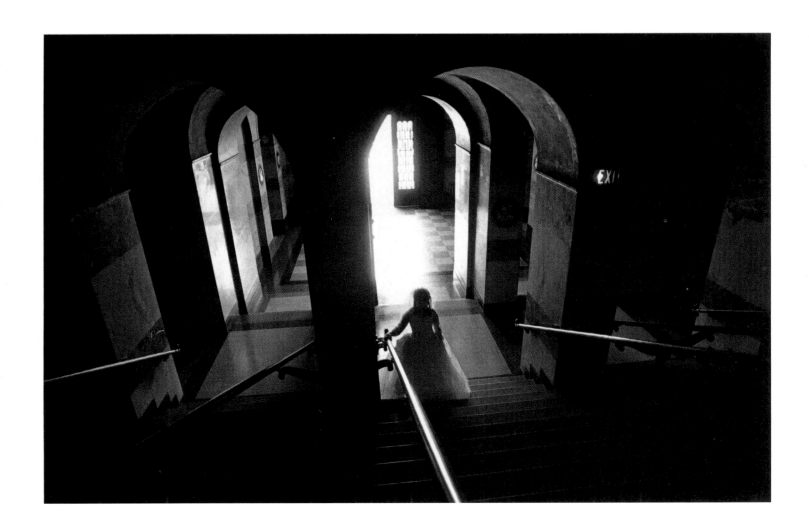

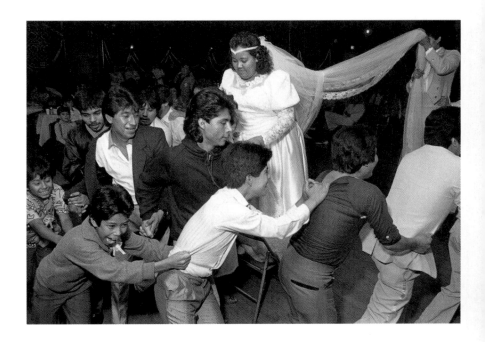

Top: A ten-year-old girl on her Communion day at an East Los Angeles chapel.
Los Ángeles, California
Photographer: Aurelio José Barrera
Right: Gladys (Calderón) Romero and her husband, Ciro Romero, stand on chairs, as their wedding guests swing around during the "snake dance."
Chicago, Illinois
Photographer: Antonio Pérez
Opposite top: A *quinceañera*, a fifteenth birthday celebration, at La Placita Roman Catholic Church.
Los Ángeles, California
Photographer: Liliana Nieto del Río
Opposite bottom: Vintage cars at Memorial Day picnic.
Santa Fe Spring, California
Photographer: Aurelio José Barrera

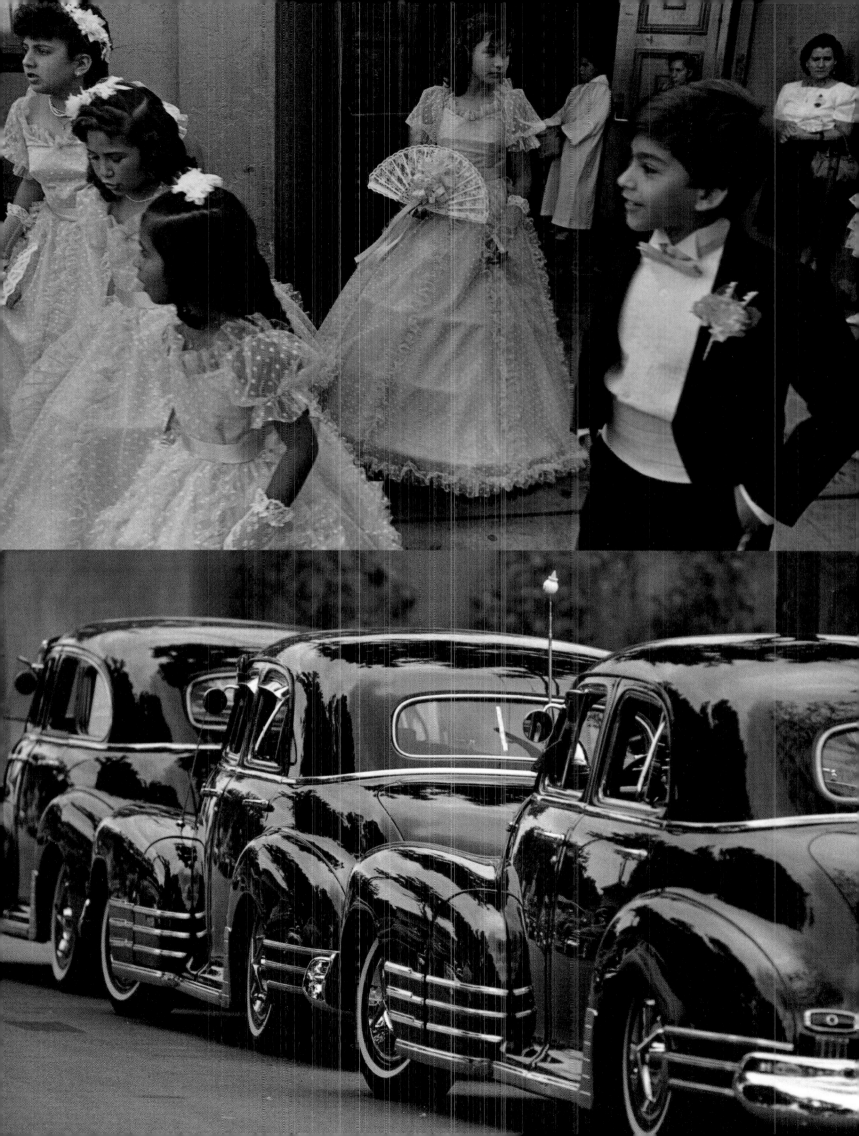

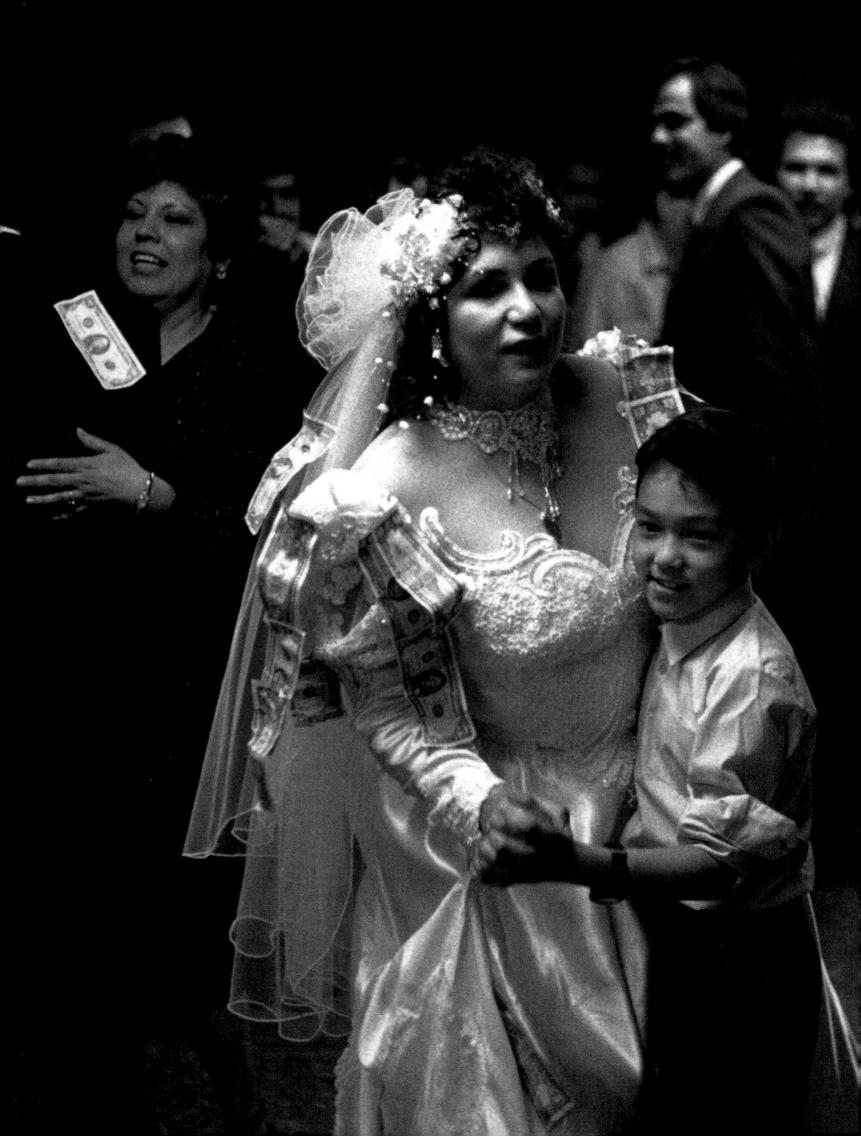

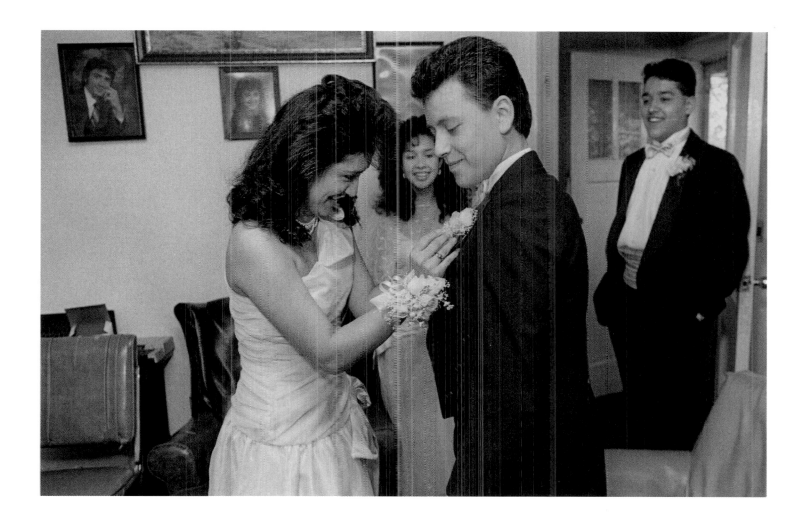

> As Latinos in America we have continued our everyday practices and special celebrations that mark the values and beliefs we share. Our *quinceañeras*, our *bailes*, our *bodas*, our *pastorelas*, our *fiestas patrias*, our foods, our music, and our arts are all part of the cultural contributions we have made to the vibrant life of the United States. The scholar Renato Rosaldo describes those contributions as a cultural citizenship through which we have claimed our identities, our space, and our rights. In such a time of growing xenophobia it is important to affirm for ourselves and for others the myriad ways in which we have enriched this country, from our historic beginnings as ancient people to our contemporary lives. We must make visible and understood the Latino vernacular within public life. From the *vendedores* to the murals, from the yard shrines of the Virgen de Guadalupe to the Web sites of Chicano activists, we have transformed the cultural landscape of North America.

Opposite: Bride Sandra Velázquez and Jesse Vidales dance the "dollar dance."
Chicago, Illinois
Photographer: Antonio Pérez
Above: Prom day for Josefina Álvarez and friends in a South Chicago neighborhood.
Chicago, Illinois
Photographer: Antonio Pérez

V
"Como latinos en América nosotros hemos continuado nuestra rutina diaria y nuestras celebraciones especiales que marcan los valores y creencias que compartimos. Nuestras quinceañeras, nuestros bailes, nuestras bodas, nuestras pastorelas, nuestras fiestas patrias, nuestra comida, nuestra música y nuestro arte son todos parte de las contribuciones culturales que hemos otorgado a la vibrante vida de los Estados Unidos. El pedagogo Renato Rosaldo describe estas contribuciones como una ciudadanía cultural por la cual hemos establecido nuestra identidad, nuestro espacio y nuestros derechos. En esta época de gran miedo a los extranjeros es bien importante que nos afirmemos a nosotros mismos y a los demás el sinfín de maneras en las cuales hemos enriquecido a este país desde nuestros históricos comienzos como pueblo antiguo hasta la vida contemporánea. Tenemos que hacer visible y demostrar lo vernacular del latino dentro de la vida pública. Desde los vendedores hasta los muralistas, desde los altares a la virgen de Guadalupe en los patios y en frente de las casas hasta los anuncios en el "website" de los activistas chicanos, hemos transformado el panorama cultural de Norteamérica."

Amalia Mesa-Bains

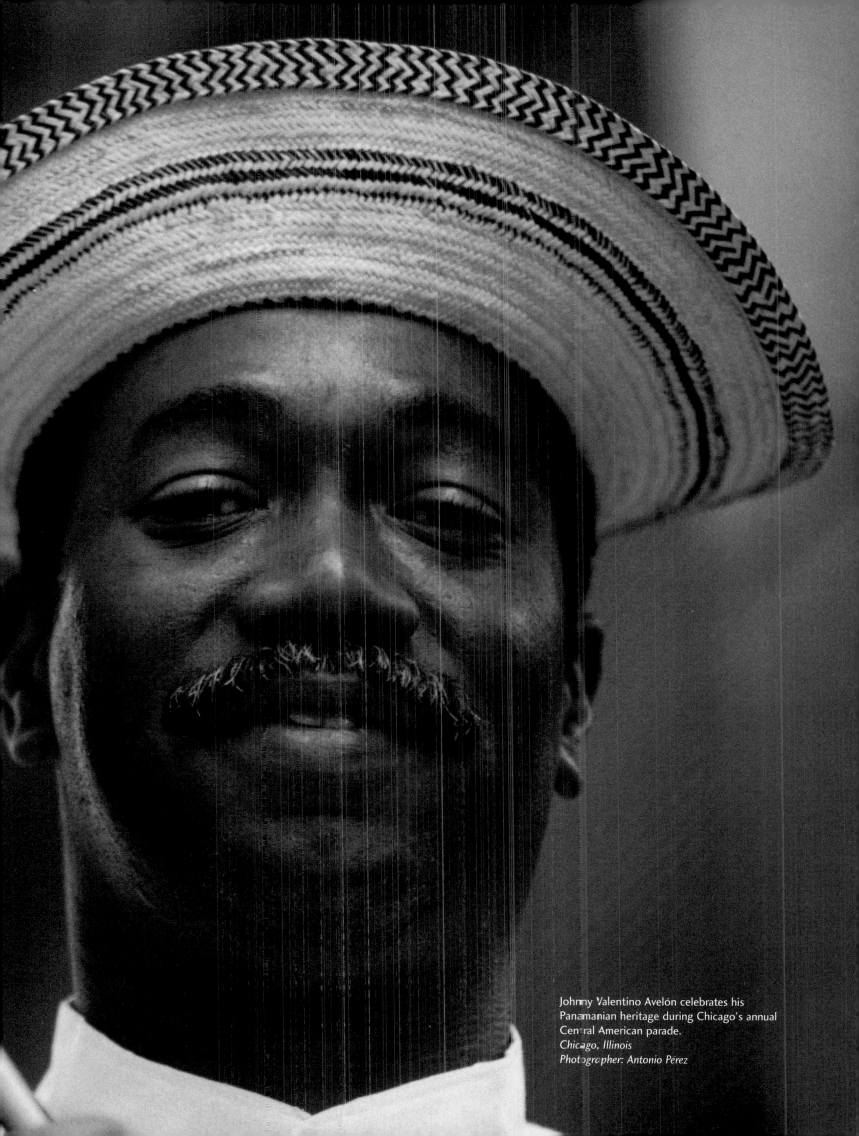

Johnny Valentino Avelón celebrates his
Panamanian heritage during Chicago's annual
Central American parade.
Chicago, Illinois
Photographer: Antonio Perez

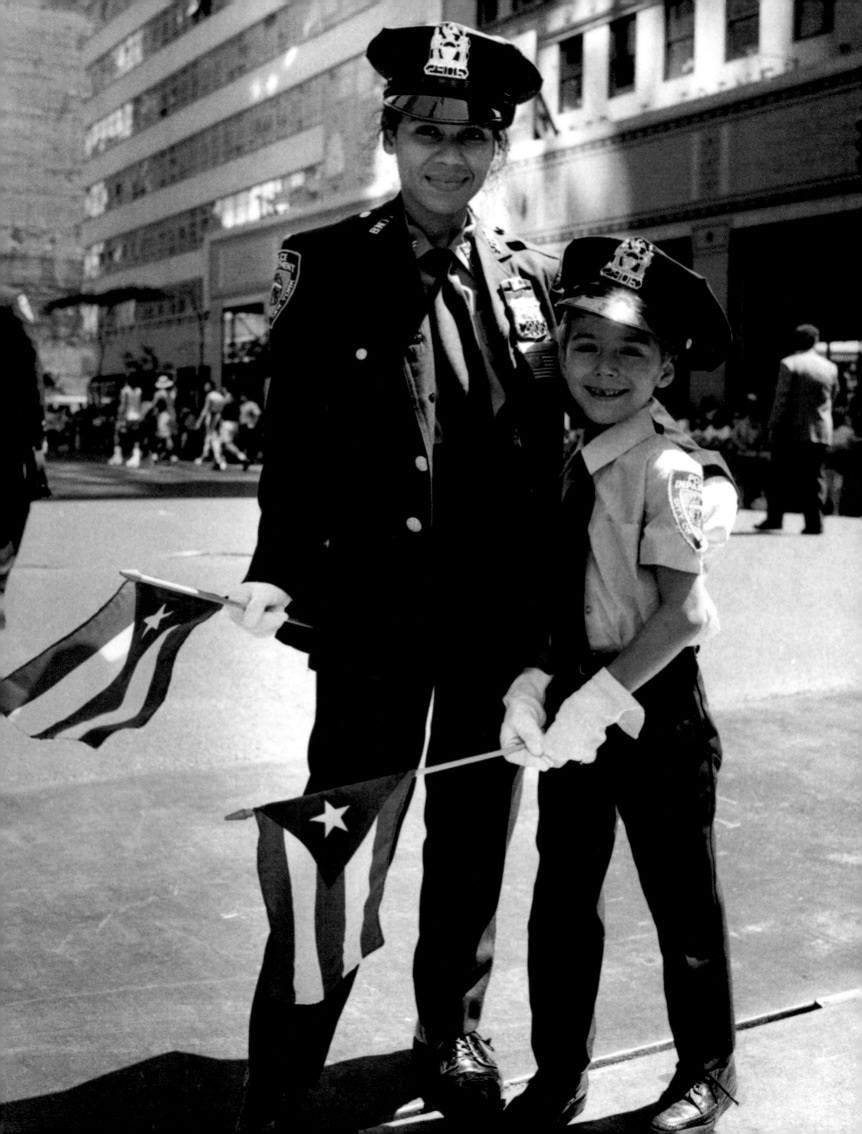

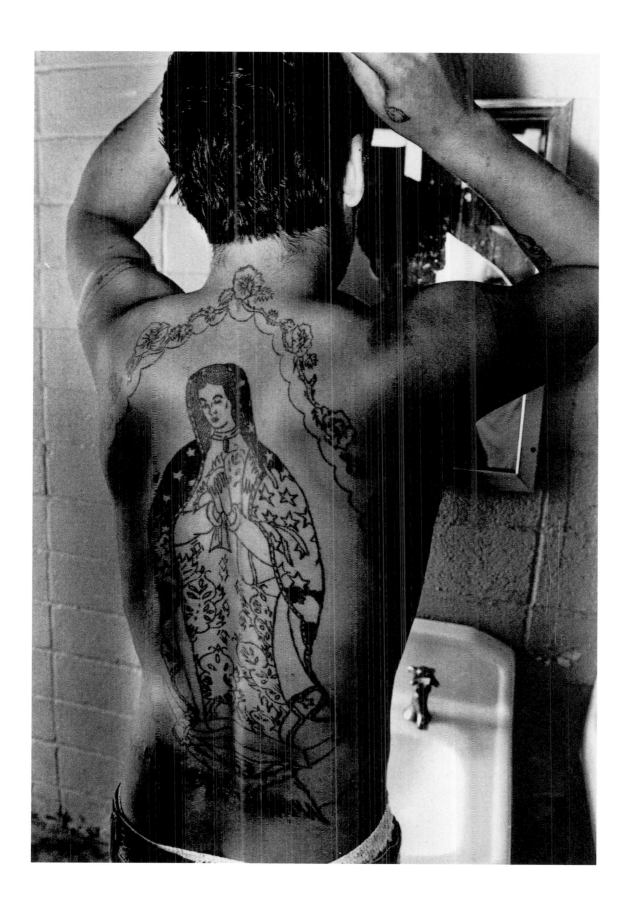

Opposite: Police Officer Lisa Demetriou and her son at the Puerto Rican Day parade.
New York, New York
Photographer: Rita Rivera

Above: Joe Cruz with the religious icon of Our Lady of Guadalupe on his back.
Houston, Texas
Photographer: Carlos Ríos

This page: Yolanda Tafolla holds a No Drugs sign at an antiviolence march and rally. More than six hundred children and parents in Pilsen protest against gangs, drugs, and violence.
Chicago, Illinois
Photographer: Antonio Pérez
Opposite: Carlo Hernández hugs his sister Samantha Hernández with a No Violence sign.
Chicago, Illinois
Photographer: Antonio Pérez

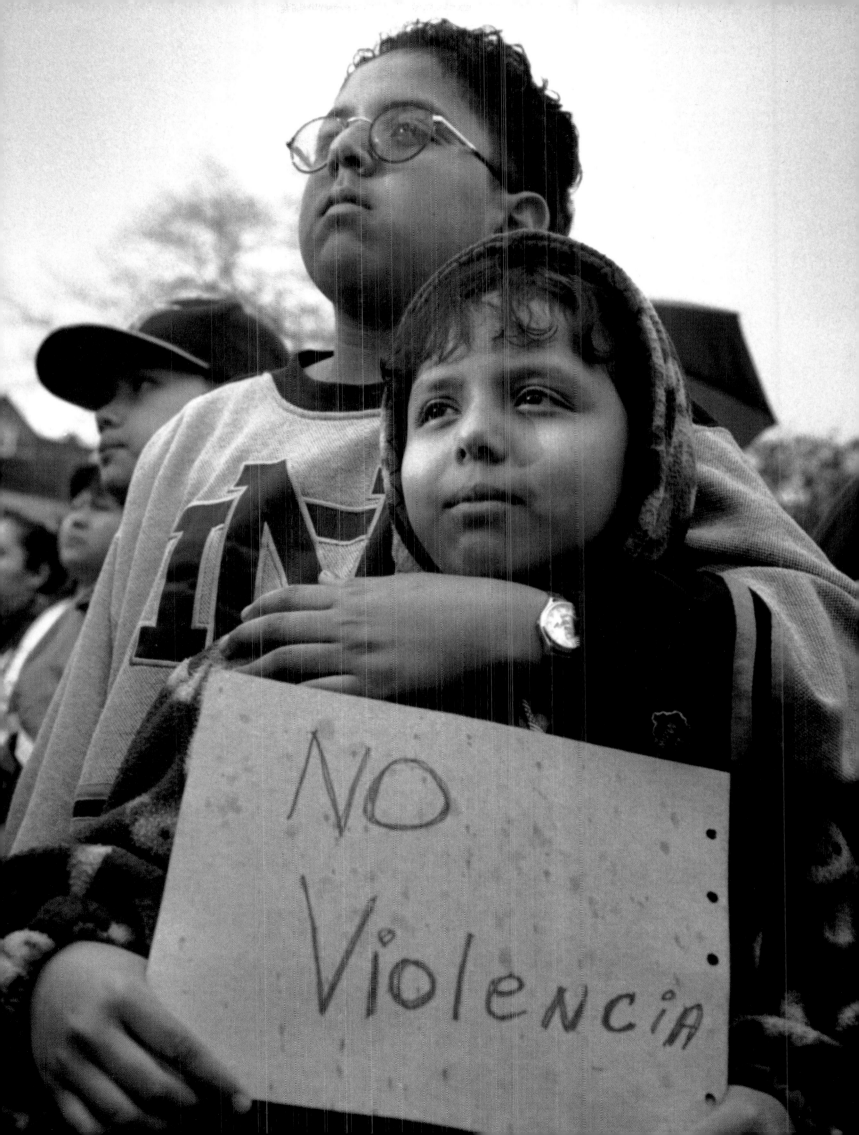

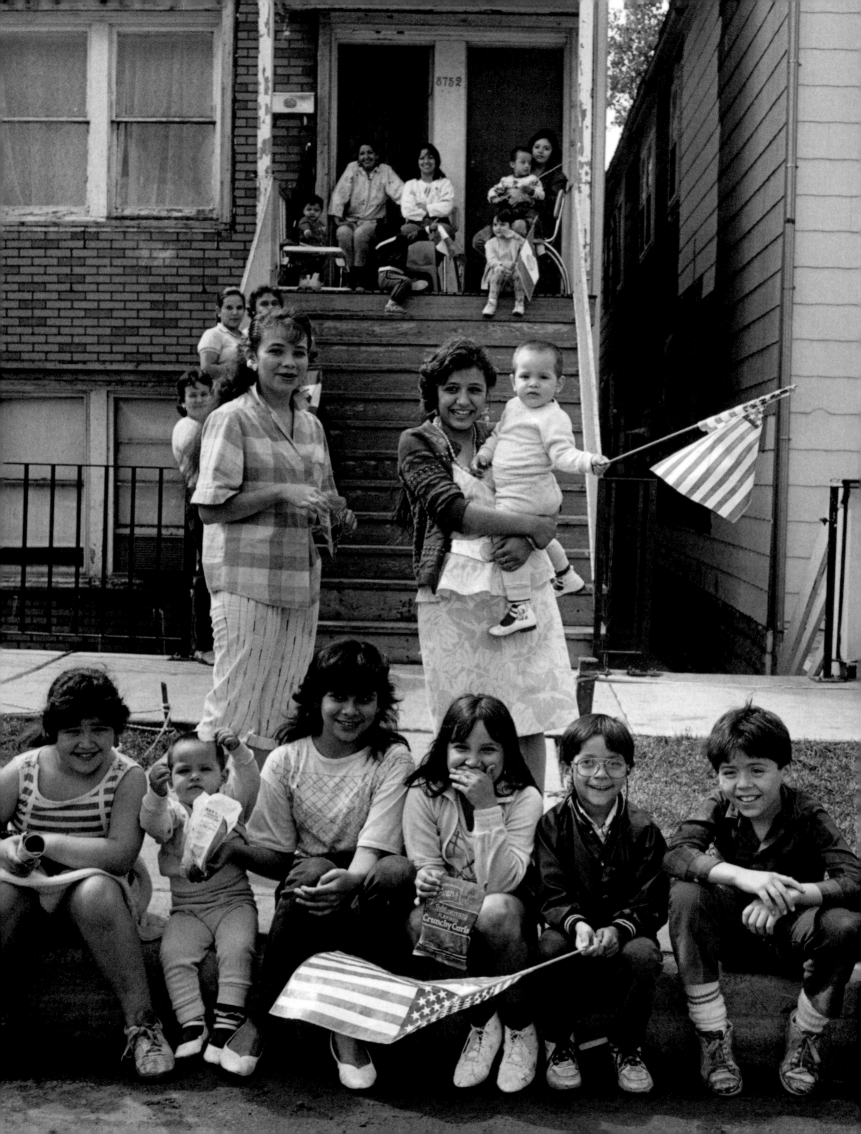

Opposite: Community residents of a South Chicago neighborhood watch the Mexican Independence Day parade.
Chicago, Illinois
Photographer: Antonio Pérez
Top: Young Latinos at a local barber shop.
New York, New York
Photographer: Jules Allen
Bottom: Four kids pose in front of the renovation of vaulted sidewalks in South Chicago.
Cnicago, Illinois
Photographer: Antonio Pérez

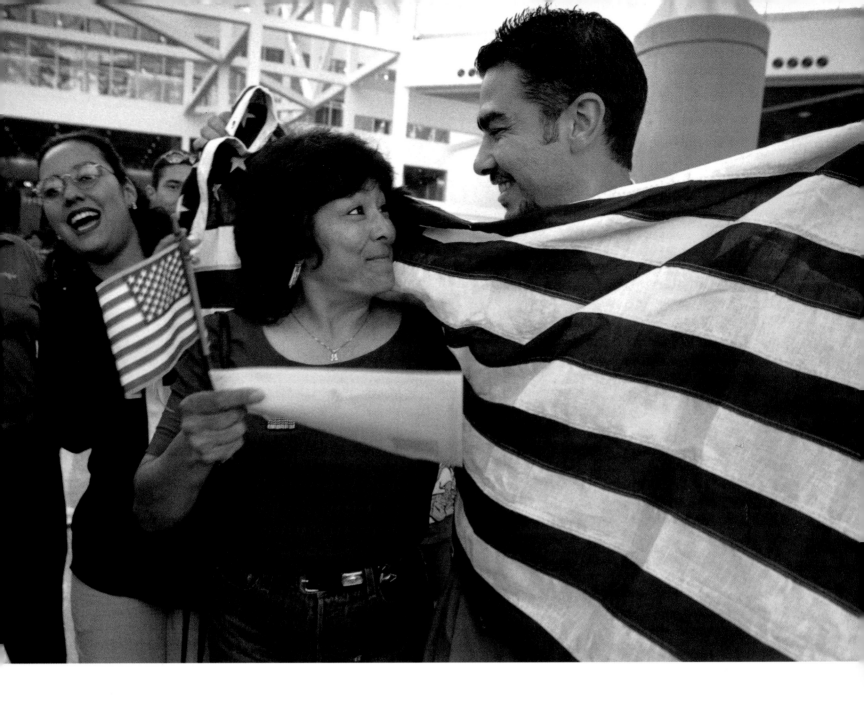

Above: Oscar Cordero, 26, greets his mother, Maria Cordero, with a large U.S. flag as she emerges from the Los Angeles Convention Center holding her naturalization certificate. She has just been sworn in as a U.S. citizen.
Los Ángeles, California
Photographer: Liliana Nieto del Río
Right: Jason Lara, Apache Chicano.
Riverside, California
Photographer: Jimmy Dorantes

rr in spanish =
 errrrrrrr rrrrrr con errrrrrrrrrrre means
 that everytime you have 2 r's together
 your tongue curls under
 arching and rolling (read trilling)
 like cigar smoke coiling
 around and up, lingering a little
in spanish 2 r's, like cars race off
 toward the
 horizon or like railroad ties running
 on and on, fast, faster

 sometimes 2 r's ring a barrel, securely
 ... and r barril
 rapidly run the cars on the railroad...
it loses something in the translation
going from español to inglés
 english to spanish
 and every-in-between
you might hear the rr of chicharrónes ricos,
or the r of las malditas cucarachas
the r of mi tierra aquí y allá
or the soft one in cara of so

 so many faces.

rr in spanish = rr en español
Cecilia Rodríguez Milanes

Above: Eduardo Barada, owner of the Habana
Village Niteclub.
Washington, D.C.
Photographer: Héctor Emanuel

Previous page: Players from the Ixtlan and the Tateposco soccer teams belong to the Hispano Soccer League.
Chicago, Illinois
Photographer: José Osorio
Above: The Rubén Gómez softball league, Humboldt Park.
Chicago, Illinois
Photographer: José Osorio
Right: John Maldonado rides his skateboard.
Yuma, Arizona
Photographer: Paul Pérez
Opposite top: Mixteco farmworkers play basketball at a local school playground.
Madera, California
Photographer: Héctor Amezcua
Opposite bottom: Capoeira is a Brazilian form of martial arts brought to the country by African slaves.
New York, New York
Photographer: Miriam Romais

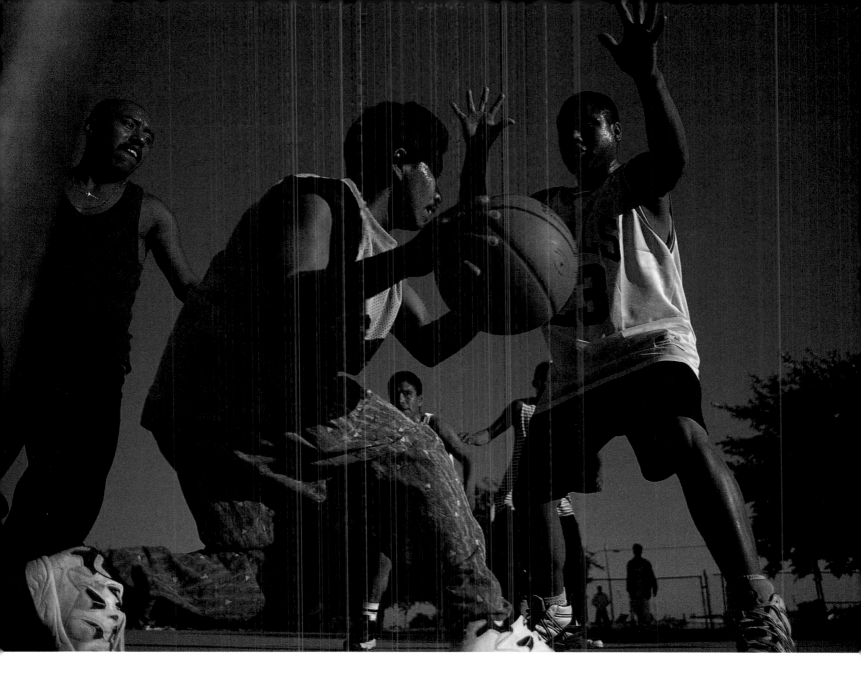

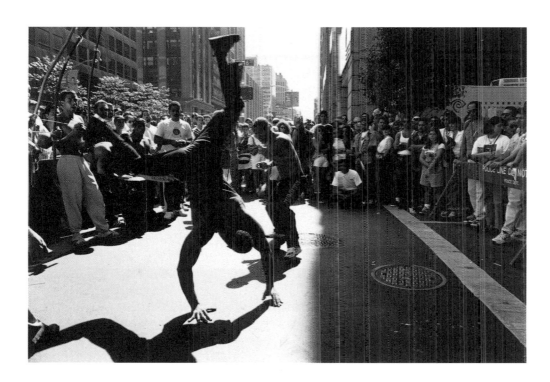

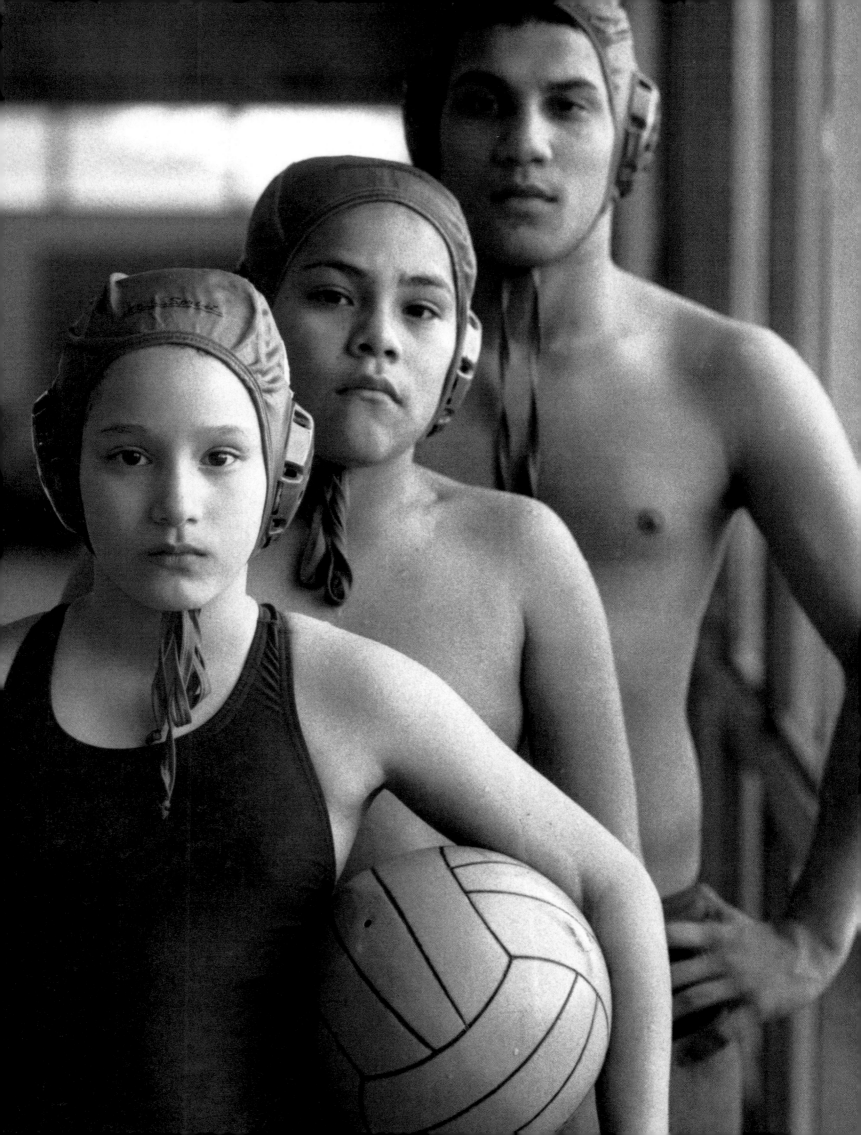

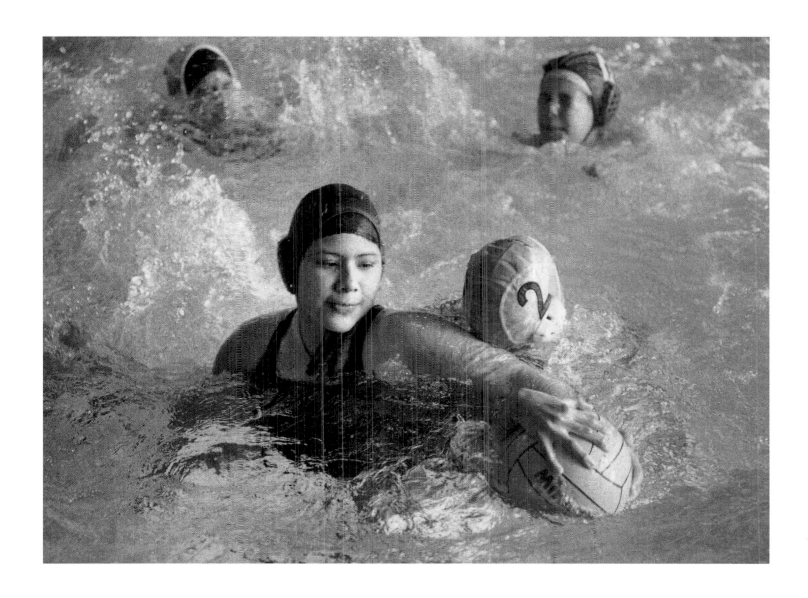

Opposite: The Piranas water polo team in Pilsen.
Chicago, Illinois
Photographer: Antonio Pérez
Top: Silfred Cruz of the Piranas water polo team, which practices daily in Harrison Park in Pilsen.
Chicago, Illinois
Photographer: Antonio Pérez
Right: Gabriel Torres, surfer, has been surfing for ten years. His parents emigrated from Argentina thirty-five years ago.
Newport Beach, California
Photographer: John Castillo

Above: Young chess club member.
Pilsen, Chicago, Illinois
Photographer: Antonio Pérez

Opposite: Carolina Bernal, 8, of the Knight Moves Chess Club ponders her next move.
Pilsen, Chicago, Illinois
Photographer: Antonio Pérez

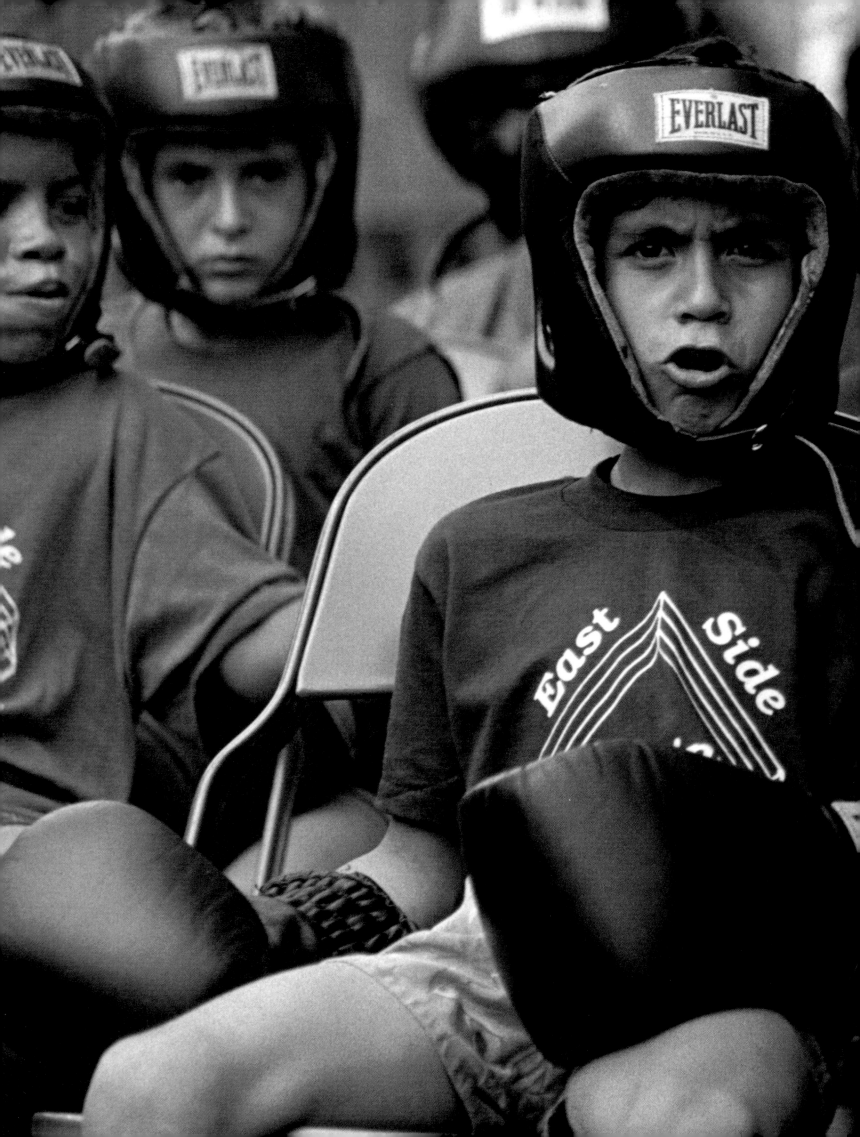

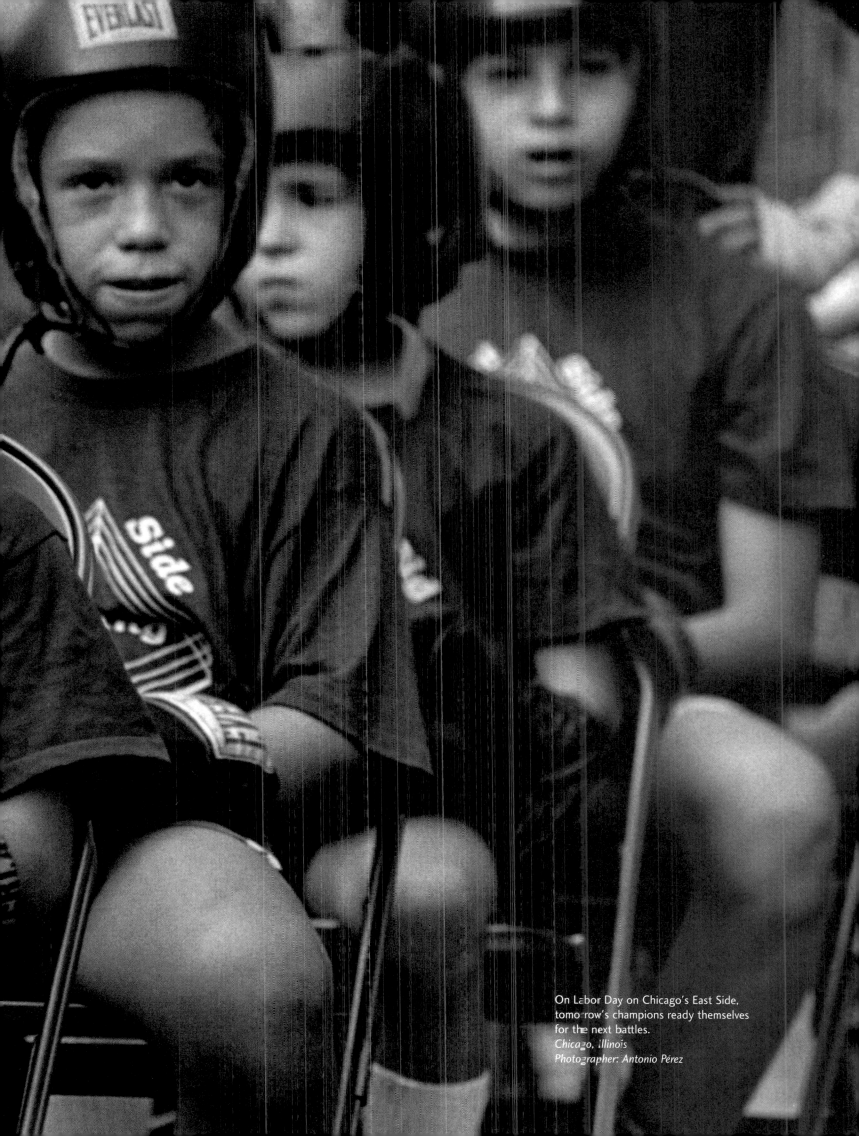

On Labor Day on Chicago's East Side, tomorrow's champions ready themselves for the next battles.
Chicago, Illinois
Photographer: Antonio Pérez

Opposite page top: Sammy Sosa acknowledges the crowd while the Maris family looks on.
Chicago, Illinois
Photographer: Antonio Pérez

Opposite page bottom: George Rodríguez, rugby player, works on a strategy with his teammates to win tonight's game at American River College.
Sacramento, California
Photographer: John Castillo

Above: José Campos, 22, plays a game of handball with his young friend Julio de Santiago, 15, in Pecan Park in Boyle Heights.
East Los Ángeles, California
Photographer: Genaro Molina

Left: Roller Derby players compete at Kezar Coliseum
San Francisco, California
Photographer: Héctor Amezcua

Previous: The shadow of a *charro* against the painted gate of a *lienzo*. The *lienzo* is a keyhole-shaped arena where the *charreada* competitions are held.
Chicago area, Illinois
Photographer: Paul Pérez
This page: A *charreada* in the Chicago area. This *charro* has a prayer card tucked inside his sombrero to protect him during dangerous rides.
Chicago, Illinois
Photographer: Paul Pérez

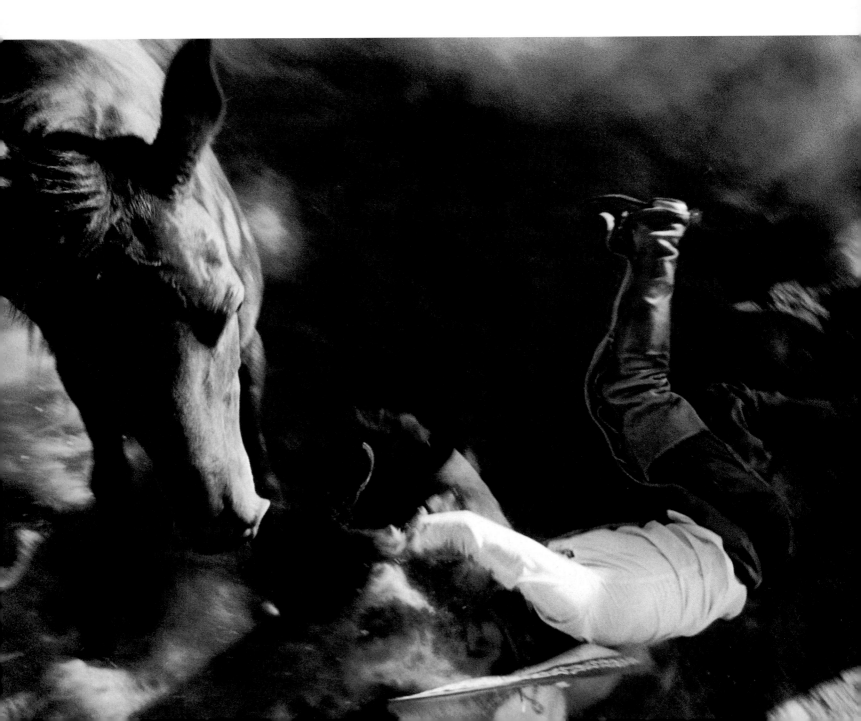

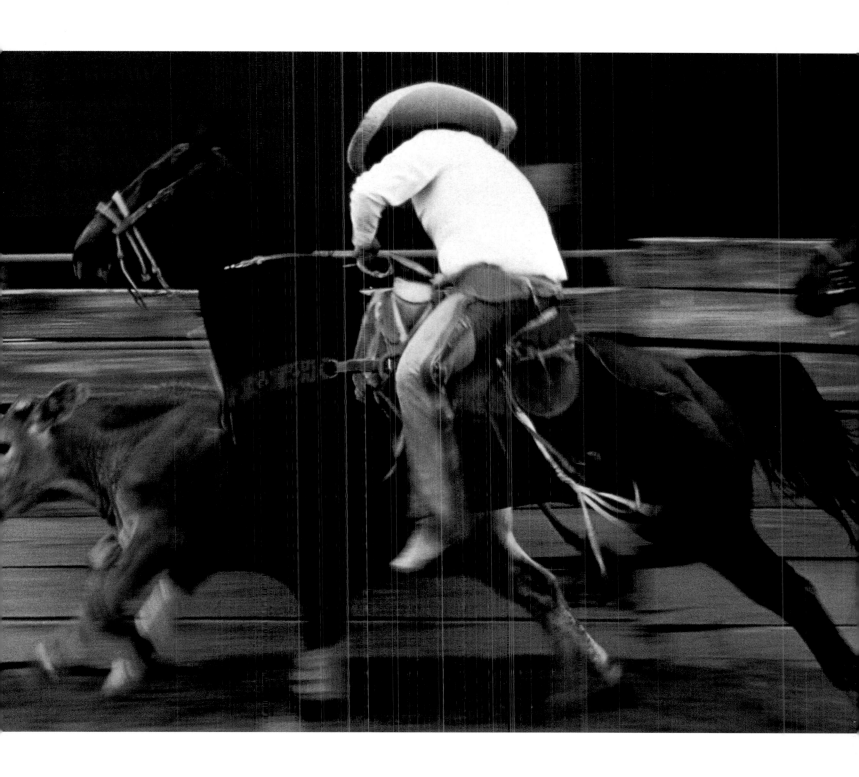

Above: *Charreada* rodeo competition.
Chicago, Illinois
Photographer: Paul Pérez

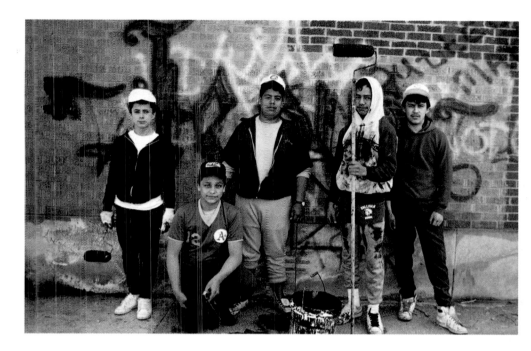

> Art is not just a sign of the past, it is the reflection of the contemporary. The visual life of our communities is filled with the signs of popular culture and everyday struggle. The artist is entrusted with the task of creating from a spirit within and through acts of remembering.

> El arte no es sólo un signo del pasado, es la reflexión contemporánea. La vida visual de nuestras comunidades está llena de los signos de la cultura popular y de la lucha diaria. Al artista se le entrega la tarea de crear del espíritu mismo por medio del acto del recuerdo.

Amalia Mesa-Bains

Left Adolfo, internationally renowned fashion designer at his home in New York City.
New York, New York
Photographer: Alexis Rodríguez-Duarte
Top: Graffiti busters clean up the South Side neighborhood.
Chicago, Illinois
Photographer: Antonio Pérez

Above: Carolina Herrera, internationally
renowned fashion designer.
New York, New York
Photographer: Alexis Rodríguez-Duarte
Opposite: Oscar de la Renta, international
fashion designer.
Kent, Connecticut
Photographer: Alexis Rodríguez-Duarte

Opposite: Haydee and Sahara Scull, and Haydee's son, Michael. The twins, painters and sculptors, graduated from the San Alejandro School of Fine Arts (Havana, 1952) and created their own style of three-dimensional paintings, which combine art and sculpture. Taught by his mother, Michael added his creativity, and the three are known throughout Miami as an artistic team.
Miami, Florida
Photographer: Al Díaz

Top: Poet and artist José Montoya.
Sacramento, California
Photographer: José Luis Villegas

Left: Prominent sculptor Enrique Alférez, 97, was born in México and fought in the Mexican Revolution. He came to the United States in the early twenties.
New Orleans, Louisiana
Photographer: Magdalena Zavala

Above: Romero Britto's colorful canvases and designs grace the homes of many of the world's foremost art collectors.
Miami, Florida
Photographer: Al Díaz

Opposite: Sergio Barragán, 19, is a member of a movement in Los Ángeles called "Punk Mexicano."
Los Ángeles, California
Photographer: Genaro Molina

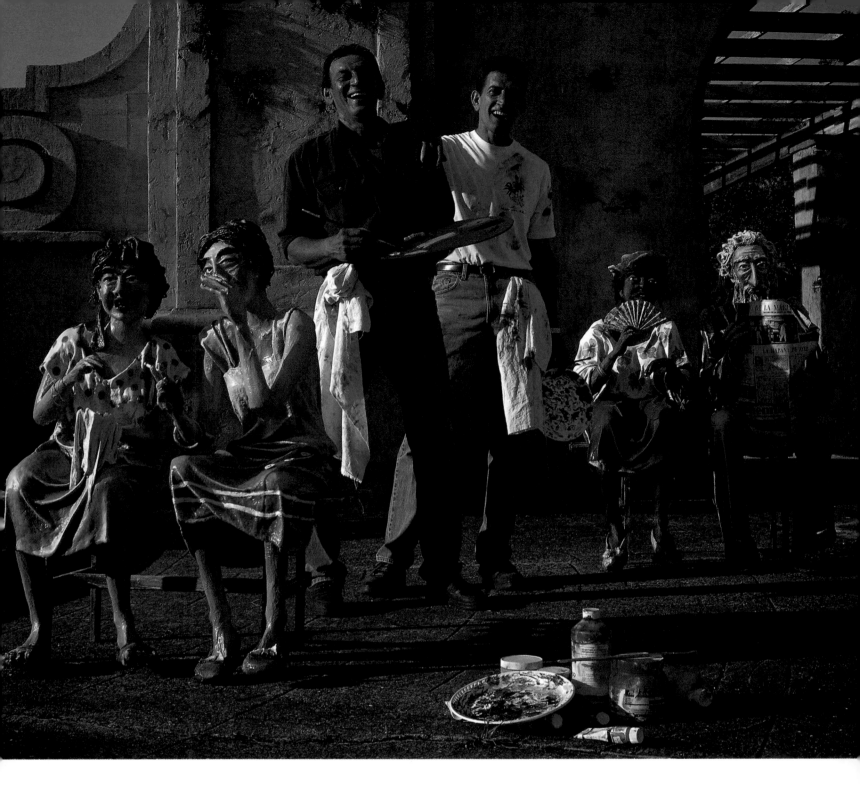

Above: José Chiu (left) and Félix González
with folkloric personalities of old Habana in
papier-mâché.
Coral Gables, Florida
Photographer: Al Díaz
Right: Artist Elisa Jiménez transforms fabrics
into an art form.
New York, New York
Photographer: Miriam Romais
Opposite top: Peruvian sculptor Kukuli
Velarde works on a new terra-cotta sculpture
for an exhibition at a New York City gallery.
Opposite bottom: Well-known Chicano artist
Simón Silva paints scenes of life with vivid
colors and strong composition.
San Bernardino, California
Photographer: Jimmy Dorantes

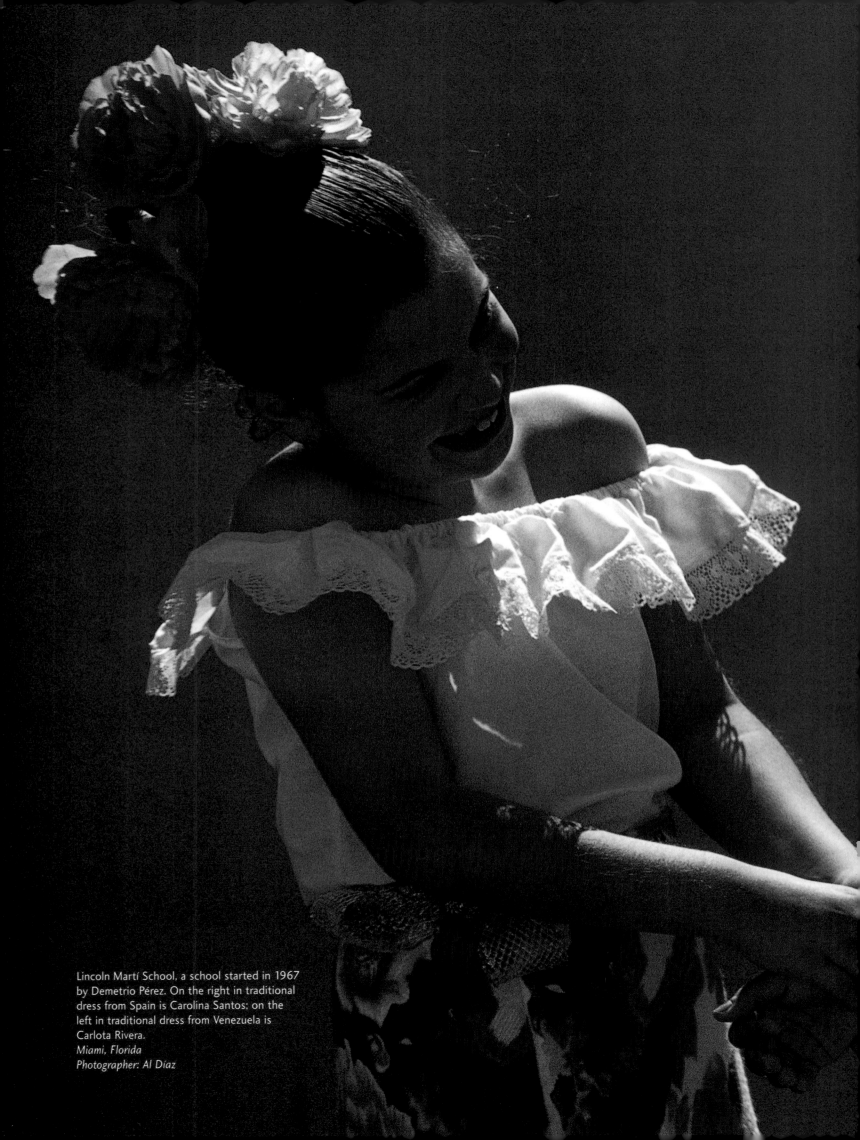

Lincoln Martí School, a school started in 1967
by Demetrio Pérez. On the right in traditional
dress from Spain is Carolina Santos; on the
left in traditional dress from Venezuela is
Carlota Rivera.
Miami, Florida
Photographer: Al Díaz

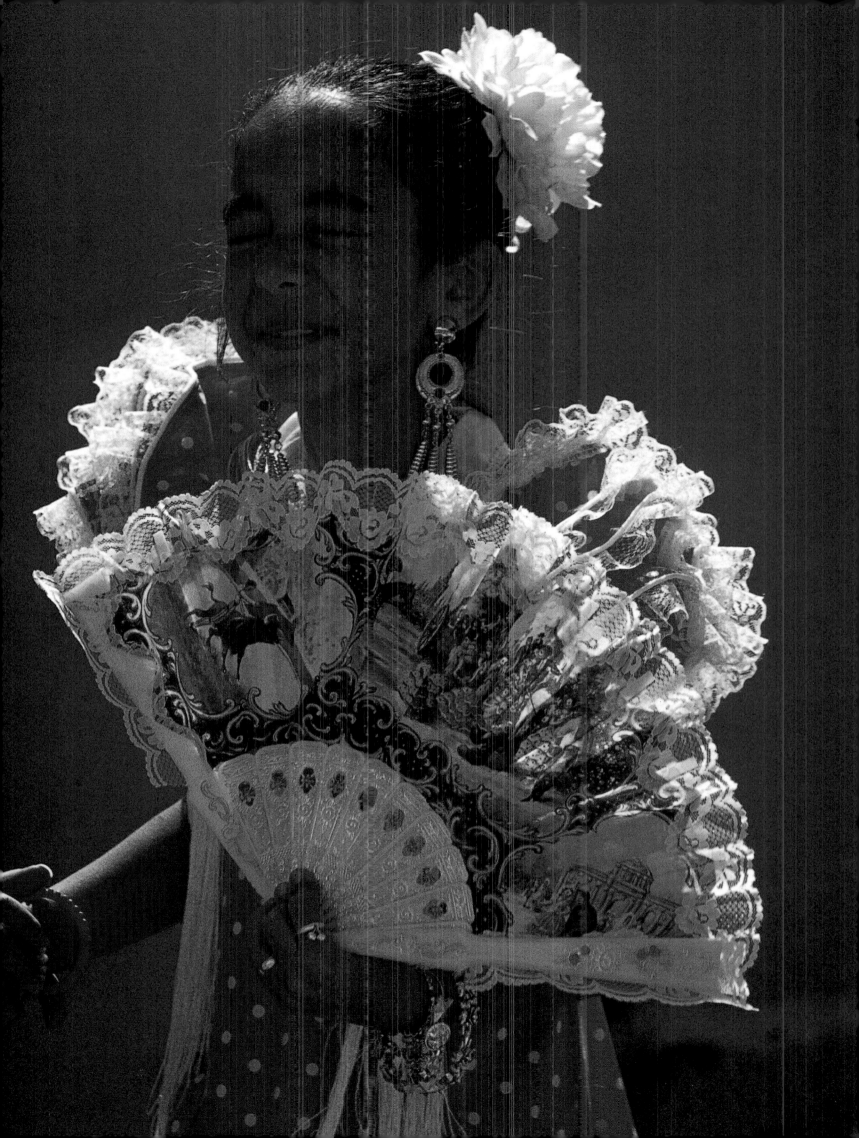

mujer *mujer*

Irene López Aparicio

Mujer,
Branch of an ancient tree,
Cactus Flower,
 Tender
 Niña
 Reaping sugar cane wisdom
 Abuelita's gifts
 Consejos
 Cuentos
 Remedios
 Bendiciones
 Strength for tomorrow,
Mujer,
 Warrior woman
 Purity
 Enriching civilization's tapestry
 With threads
 Time cannot break
 Brilliant blend of fiber
 Weaving lasting designs,
Mujer,
 Ready smile
 Deepening dimples on your
 face
 Your children thrived
 In spite of harshness
 Seeing themselves illuminated
 In your eyes,
Mujer,
 Revolutionary woman
 Prayed in cathedrals
 At death beds
 With love, respect
 Learned to spew out curses
 Y Huelga! Huelga!
 Walking-marching-singing
 Determined to eliminate
 Fifteen-hour day
 Short-handled hoe
 Father, brother's foe
 Unfair wages, nowhere to go
 Hermanas surviving
 Workplace
 By degrees
 Bachelor's, master's, Ph.D.'s

Persistent Woman,
 Learning politics
 Step
 By
 Step
 Patience of pyramid builders
 In her veins
 Centuries of working, toiling
 Struggle, pain.
Mujeres will stand and conquer,
 For purity of childhood
 To prevail
 Not adults in little bodies
 Tending babies, washing
 clothes
 Picking grapes
 Hoeing cotton rows
 No choice for little league or
 summer camp
 Until mujer's focused energy
 Her penetrating look
 Piercing as the sun
 Demanded justice
 Now
 Her children laugh and play,
Mujer, rose of varied hues,
 Blossoming
 Beyond old barriers
 Your gente's pride
 Visionary woman
 Obstacle victor
 Mujer, Mujer
 Receive your pueblo's
 Embrace.

Mujer,
Rama de árbol anciano
Flor de nopal
 Tierna
 Niña
 Cosechando sabiduría dulce
 como caña de azúcar
 Regalitos de abuelita
 Consejos
 Cuentos
 Remedios
 Bendiciones
 Fuerza para mañana.
Mujer,
 Guerrera
 Pura
 Enriqueciendo civilizaciones
 tejidas
 con hilos
 que el tiempo no quiebra
 Brillante mezcla de fibra
 tejiendo diseños duraderos.
Mujer,
 Sonrisa lista
 alegrando tu cara
 Tus hijos sanos
 a pesar de desaires
 viéndose iluminados
 en tus ojos.
Mujer,
 Mujer revolucionaria
 orando en catedrales
 camas de muerte
 con amor y respeto
 Aprendió a maldecir,
 y ¡Huelga! ¡Huelga!
 Caminando-marchando-
 cantando
 determinada a eliminar
 el horario de 15 horas
 de trabajo
 Azadón corto
 enemigo de padres y
 hermanos

Sueldos injustos, sin salida
hermanas sobrellevando
el empleo
a grados
preparatoria, colegio y univer-
 sidad.
Mujer persistente,
 aprendiendo la politica
 paso
 a
 paso
 Paciencia de constructores de
 pirámides
 En sus venas
 siglos de trabajo, sacrificio
 y dolor.
Mujeres luchando por ganar.
 Por la pureza de la niñez
 estableciendo
 gozo para los niños
 Atendiendo bebés, lavando
 ropa
 Trabajando en la labor.
 Sin oportunidad de jugar
 en las pequeñas ligas
 ni disfrutar la alegría del
 verano
 Hasta que la mujer concentró
 su energía
 Su vista penetrante como el sol
 demandó justicia
 Hoy
 sus niños llenos de risa juegan.
Mujer, rosa de varios colores
 floreciendo más allá
 de barreras viejas
 el orgullo de tu gente
 Mujer visionaria
 tumbando obstáculos
 Mujer, mujer
 recibe agradecimiento
 y un abrazo de tu pueblo.

Opposite: Dancer Christina Segura at the
Mexican Mutual Club.
Lorain, Ohio
Photographer: Ramón Owens Mena

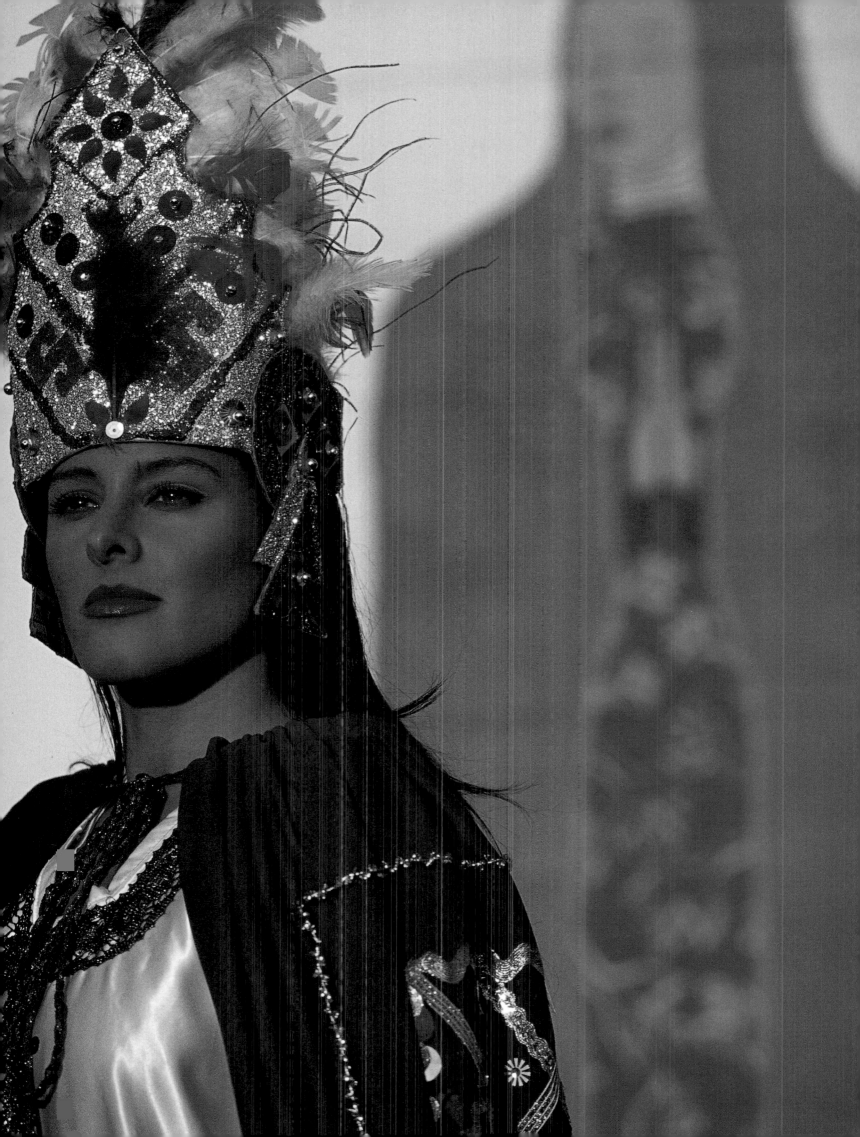

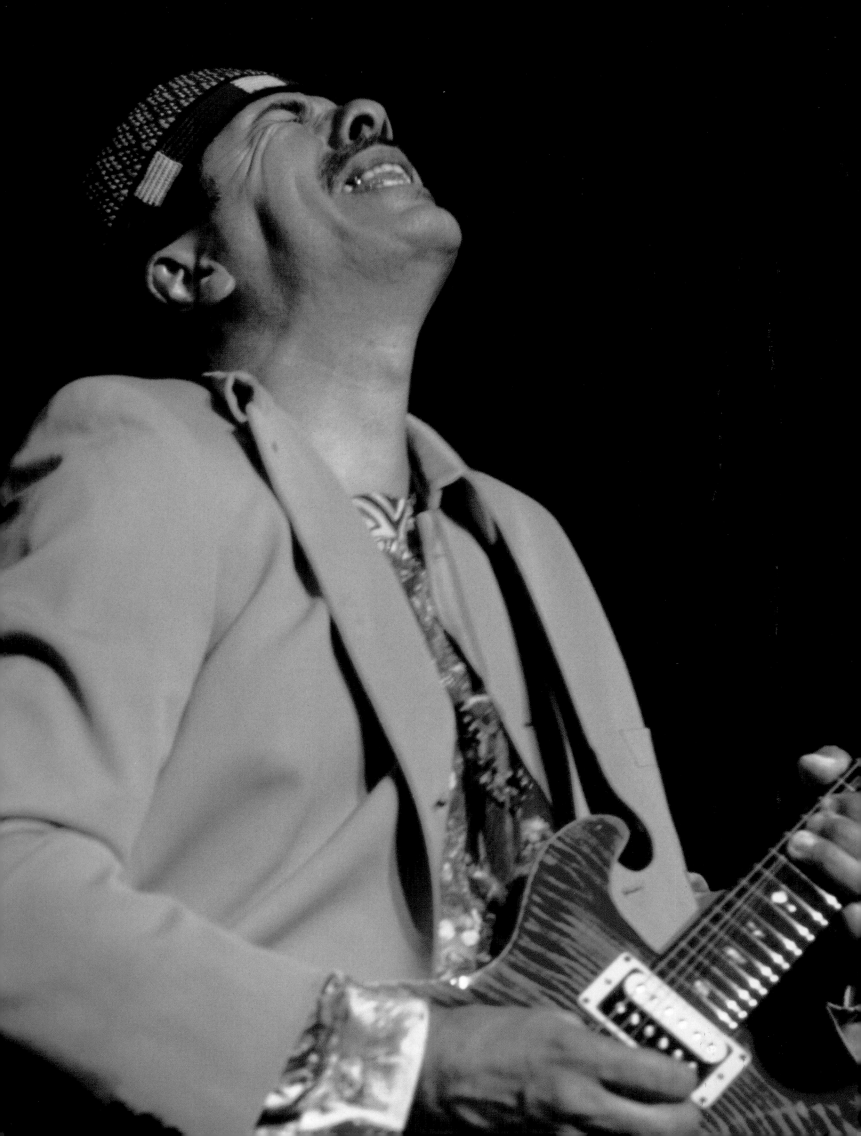

Opposite: Carlos Santana, 1998 tour.
Corcord, California
Photographer: John Castillo
Above: Cristina Saralegui, journalist, author,
anc internationally syndicated talk-show host.
Miami Beach, Florida
Photographer: Alexis Rodríguez-Duarte

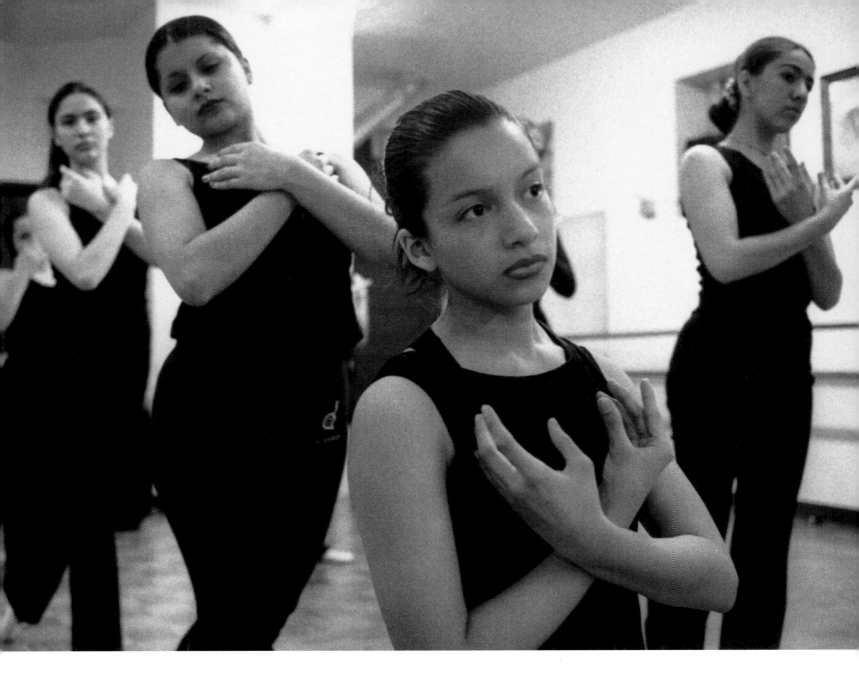

Above: Ballet class in Little Village.
Chicago, Illinois
Photographer: Antonio Pérez
Opposite top: Johnna Vásquez, 12, a member of the Ballet Folklórico Atotonilco.
Kansas City, Missouri
Photographer: Marcio Sánchez
Opposite bottom: Dolores Castillo teaching a folkloric dance class at the YMCA. Classes are free to girls with a certain GPA.
Reno, Nevada
Photographer: Andy Barrón

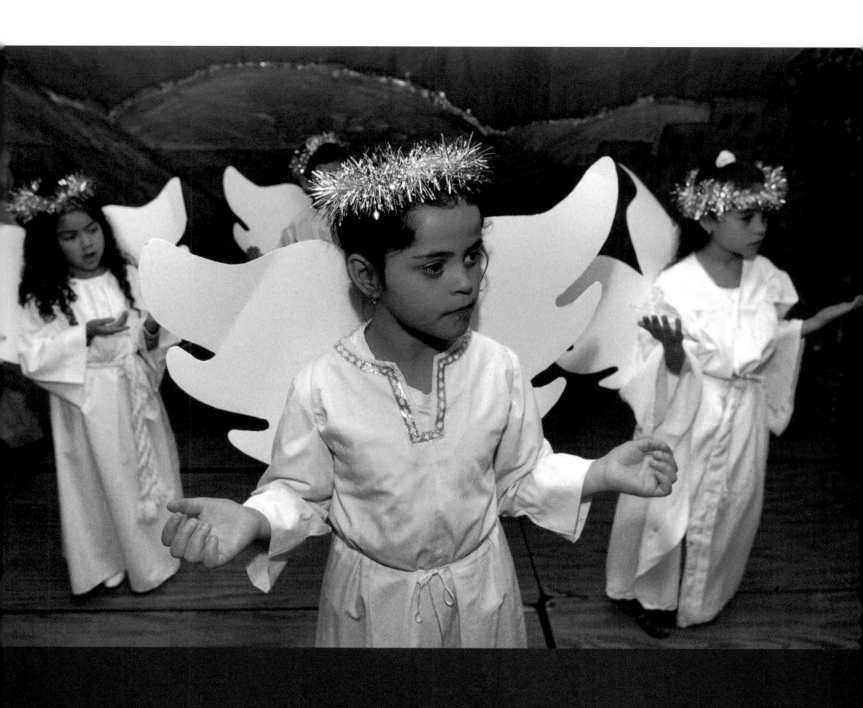

Celebration of Día de las Cruces at Angeles
Catholic School near Pilsen.
Chicago, Illinois
Photographer: Antonio Pérez

if we hold hands

Cecilia Rodríguez Milanes

si nos agarramos de manos

For Ivonne, Elena, and me

If we hold hands and kick hard enough
we will survive this
We will make our way slowly but resolutely toward
that voice until we sing out together with so much
power and harmony and magic that they will be
stunned into listening

My voice cracks now
Very often it falters and I cannot
make it tell the story I want it to

Your voice, so beautiful, melodic, urgently brilliant,
must be squeezed out of your fine fair throat
It hurts to not hear it and pains you just the same
to not speak

You too have been quiet but I know that your voice will
soon join ours and its strength will probably make us dizzy

If there are any others who wish to come, please form a line
Here — not left or right

We will reach the heavens and the saints
We will be the angels and our wings
Our words will sear the azure and burst the clouds into tiny-
puffs of silvery cotton
They will shake their heads in wonder at our halos

Para Ivonne, Elena y yo

Si nos agarramos de manos y pateamos lo suficiente fuerte
podremos sobrevivir esto
Trazaremos nuestro camino despacio, pero con resolución
 hasta llegar a
esa voz y cantaremos juntas con tanto
poder y armonía y magia que quedarán
pasmados al escuchar

Mi voz se quiebra
Frecuentemente vacila y no puedo
contar la historia que quisiera

Tu voz, tan bella, melodiosa, brilla urgente,
debe ser exprimida fuera de tu clara y fina garganta
Duele no oírla y la sientes aun
sin hablar

Tú también has callado, pero sé que tu voz
pronto se unirá a la nuestra y su fuerza probablemente
 nos aturdirá

Si hay otros que deseen venir, favor de hacer fila
aquí — no en la izquierda o la derecha

Alcanzaremos los cielos y los santos
Seremos los ángeles y nuestras alas
Nuestras palabras quemarán el azul celeste y explotarán las
 nubes en pedacitos de algodón plateado
Ellos moverán sus cabezas maravillados de ver nuestras auras

Top: Sara, 12, practices guitar by window light.
East Los Ángeles, California
Photographer: José Barrera
Right: Carlos Ponce, singer, composer, actor.
Gables by the Sea, Florida
Photographer: Alexis Rodríguez-Duarte
Opposite: Celia Cruz, queen of salsa music, with her husband, conductor Pedro Knight.
Coral Gables, Florida
Photographer: Alexis Rodríguez-Duarte

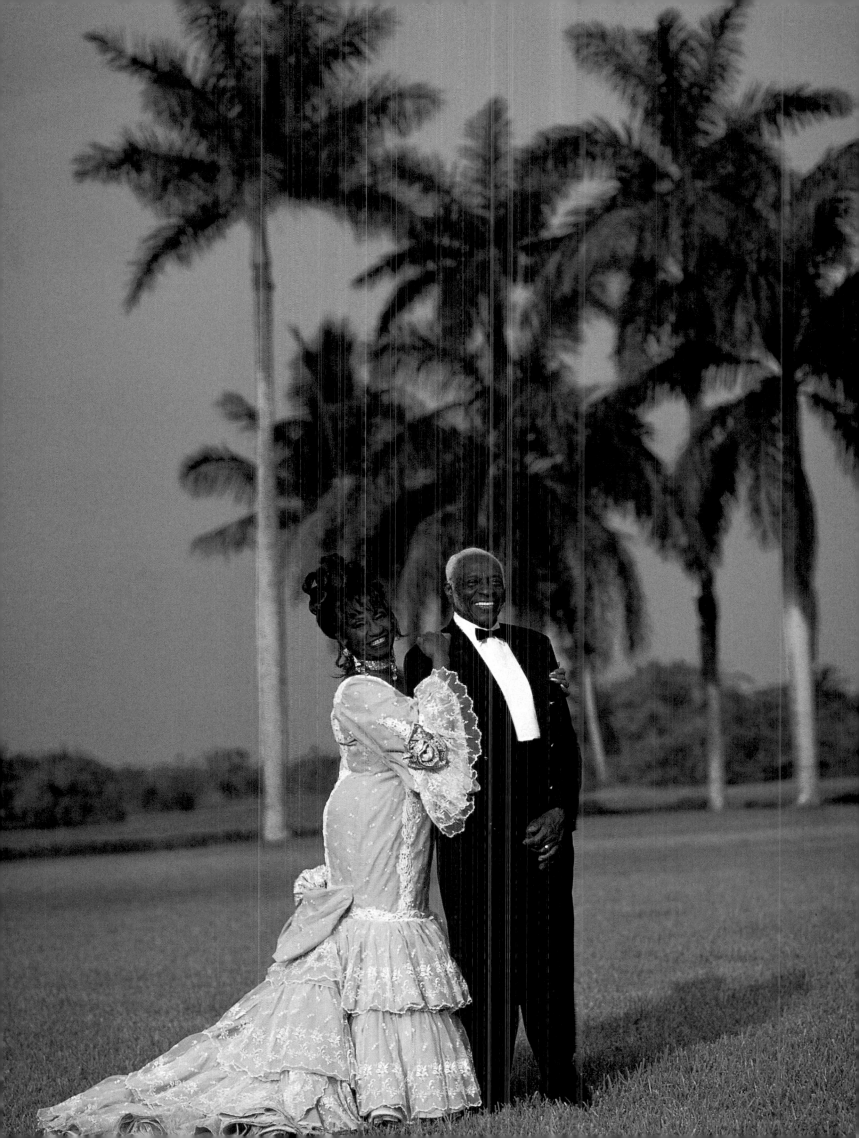

latinos, too, sing america...
los latinos, también, cantan américa...

Juan Flores

> Latinos, too, sing America! The "other" America, *América* in Spanish, English, and broken tongues; songs of hope, struggle, and broken dreams. America sung in *boleros*, in *décimas*, merengues and *corridos, mariachi y mambo, plena y guaguancó. Nuestra América.*

Latino songs resonate with ancestral chords and chants: drums, guitars, flutes from Indoamerica, Africa, Andalusia. *Nuestra música* takes root in the coastlands and cattle ranges of Mexico, the canefields and coffee hills of Cuba, Puerto Rico, the Dominican Republic. Its history is the story of homelands and uprooting, migrant freight cars and steamships, barbed-wire borderlands and Ellis Island holding pens, the America of beet fields and canneries, garment sweatshops and janitor pails, boxcar barrios and tenement stairways. *La migra* and Texas Rangers, United Farmworkers and Raza Unida, Brown Berets and Young Lords. Poverty and pride, racism and struggle, suffering and joy. *Nuestra historia.*

The musical life of this country is unthinkable without its glorious "Spanish tinge," the irresistible infusion of *ranchera* and tango, *cumbia* and *son* into the heartbeat of jazz, blues, country, big band, and rock. New Orleans jazz pioneer Jelly Roll Morton was the first to acknowledge it, but America's "first composer," Louis Moreau Gottschalk, before him, and Dizzy Gillespie and Bo Diddley and scores of others since, have all paid their musical homage to the rich current of rhythms and voices, dance moves and song forms forever emanating anew from the cultural wellspring of Latino culture. Rafael Hernández and Lydia Mendoza, Flaco Jiménez and Celia Cruz, Narciso Martínez and Tito Puente, Santana and Eddie Palmieri, La India and Selena, Kid Frost and Latin Empire, so the presence is old, the influences deep, and the result ongoing: in tune with the "souls of Black folk," Latino traditions and innovations help shape the very history of American musical styles and tastes, be they ragtime or bebop, R&B or doo-wop, rock, disco, or hip-hop.

Rugged *campesino* hands fine-tune the chord of Latino laments, fingers gnarled from scratching parched soil, nails tattered on conveyor belts, sewing machines, and stubborn mop handles; Latino hands work the strings and drumskins, roll accordion and piano licks, shake maracas, and scrape gourds; hands clap and fingers snap to the blare of trumpets, trombones, saxes, and the wail of barrio voices. Tied hands and muzzled voices burst free to tune the chords and set the cadence of Latino music.

V

¡Los latinos también cantan América! La otra América, América en español, en inglés y en otros dialectos, canciones de esperanza, lucha y sueños rotos. América cantada en boleros, en décimas, en merengues y corridos, mariachi y mambo, plena y guaguancó. Nuestra América.

Las canciones latinas resuenan con cuerdas y tonadas ancestrales: tambores, guitarras, flautas de la Amerindia, África, Andalucía. Nuestra música toma raíces en las tierras de la costa y en las tierras de las ganaderías de México. Los cañaverales y los cafetales de Cuba, Puerto Rico, República Dominicana. Su historia es la historia del terruño y del desarraigo, carros del ferrocarril migrante y de barcos cargueros, de líneas divisorias de alambre de púas y centros de procesamiento de Ellis Island, la América de campos de betabel, y de fábricas de conservas y de ropa que pagan por contrato, de baldes de conserjes, de barrios de carros de ferrocarril, y de escaleras de casas del gobierno, la migra y los "rinches" (Texas Rangers), La Unión de Campesinos, y de la Raza Unida, de los Brown Berets y de los Young Lords. Pobreza y orgullo, racismo y lucha, sufrimiento y alegría. Nuestra historia.

La vida musical de este país no se puede concebir sin ese glorioso "son español." La irresistible infusión de la ranchera y el tango, la cumbia y el son en el latido del jazz, blues, country, big bands y el rock. Jelly Roll Morton, el pionero del jazz de Nueva Orleans fue el primero en reconocerlo, pero el "primer compositor" de América, Louis Moreau Gottschalk, antes de él, y Dizzy Gillespie y Bo Diddley y muchos más desde entonces han rendido homenaje a la rica corriente de ritmos y voces, pasos y canciones por siempre emanando en forma diferente del pozo cultural de la cultura latina. Rafael Hernández y Lidia Mendoza, Flaco Jiménez y Celia Cruz, Narciso Martínez y Tito Puente, Santana y Eddie Palmieri, India y Selena, Kid Frost y Latin Empire. Así es que la presencia ya es vieja, la influencia es honda y el resultado continuo, a tono con los "Souls of Black Folk," tradiciones e innovaciones que ayudan a dar forma a la historia de la música, su estilo y sabor, ya sea el ragtime o el bebop, R&B o doo-wop, rock, disco o hip-hop.

Las manos rudas del campesino afinan las cuerdas de los

The music of internationally known Sony recording artist Néstor Torres is influenced heavily by the beauty and simplicity of his Puerto Rican heritage. Kathleen Dreisbach, 10, Cuban-American fourth grader.
Coral Gables, Florida
Photographer: Al Díaz

Through history, Latino music has been many musics, most forcefully the traditions from Mexico and those from the Caribbean, long flowing as parallel but independent currents from different regions of the "other" Americas. Chicanos and Boricuas each had their own sounds, one resounding in Texas and Califas, the other in the streets and clubs of los Nuyores. But in our time, with more and more diverse Latino communities coming to live side by side throughout *el Norte, nuestras músicas* are also converging, intermingling, with new hybrid sounds emerging that would have seemed strange confections but a generation ago: salsa with *conjunto*, Tex-Mex in clave, merengue rap, the sounds of "tropical" L.A., Mixteco and Quisqueya New Yorkers, Miami Nicaraguans, Cubans, and Colombians, Salvadorans in D.C., Chicanos-Boricuas in Chicago, *cumbia y vallenato* from Jackson Heights, Queens. There may never be a single "Latino music," but by now it's clear that no mix is missing, all styles can harmonize, Latino beats can reverberate from different drummers.

Latinos, too, sing *América!*

lamentos latinos, dedos torcidos de tanto trabajar la tierra seca y dura, uñas razgadas por las bandas del "conveyor," máquinas de coser y de los mangos del "trapeador." Las manos latinas trabajan las cuerdas y los cueros del tambor, las teclas del acordeón y del piano, tocan las maracas y suenan los güiros, al tronar los dedos al sonido de trompetas, trombones y saxofones y al grito de las voces del barrio. Manos atadas y voces ahogadas que brotan libremente al tono de los acordes y que empiezan la cadencia de la música latina.

En toda la historia, la música latina ha sido muchas musicas, más forzadamente las tradiciones de México y las del Caribe, que flotan paralelamente pero independientemente de la corriente de las otras regiones de las Américas. Los chicanos y boricuas tenían sus propios sonidos, uno resonando en Texas y Califas, el otro en las calles y clubs de los Nuyores. Pero a su tiempo, con más y más diversas comunidades que venían a vivir lado a lado por todo el Norte, nuestras músicas también se mezclan, haciéndose parte de nuevos sonidos que salen y que hubieran parecido extraños hace una generación: salsa de conjunto, tex-mex en clave, merengue (hablado) "rap," los sonidos de "tropical" L.A., mixteco y Quisqueya New Yorkers, Miami nicaragüenses, cubanos y colombianos, salvadoreños D.C., chicano-boricuas Chicago, cumbia y vallenato de Jackson Heights, Queens. No habrá nunca una sola "música latina", pero por ahora está claro que no hay nada que no se haya mezclado, todos los estilos pueden armonizar, los sones latinos pueden reverberar de diferentes tamborilleros.

¡Los latinos, también cantan América!

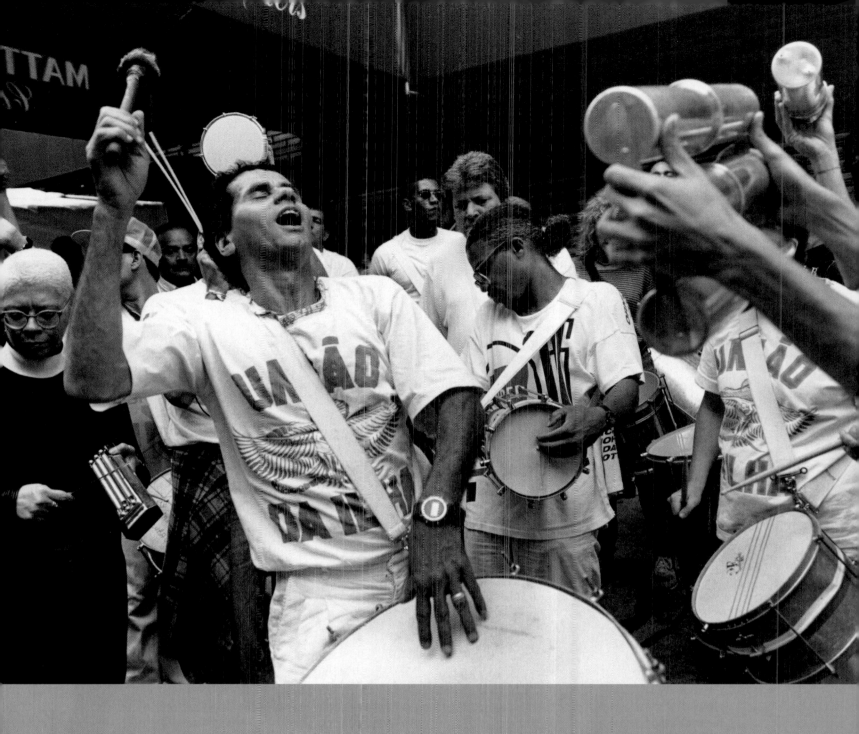

Ivo Araújo, founder of the Brazilian samba
group União da Ilha.
New York, New York
Photographer: Miriam Romais

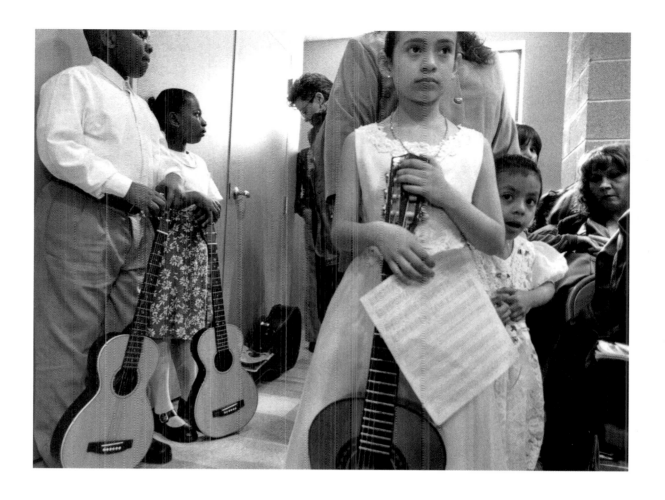

Opposite: Accordion player at the Mission District
San Francisco, California
Photographer: José Osorio
Top: Hazel Delgado and other children wait for their music recital at the Peoples Music School. Rita Simó, founder of the school, was born in the Dominican Republic and funded the school to provide free music lessons to children.
Chicago, Illinois
Photographer: Antonio Pérez
Bottom: Guitar players wait to march in the Cinco de Mayo parade on Cermack Avenue.
Chicago, Illinois
Photographer: Antonio Pérez

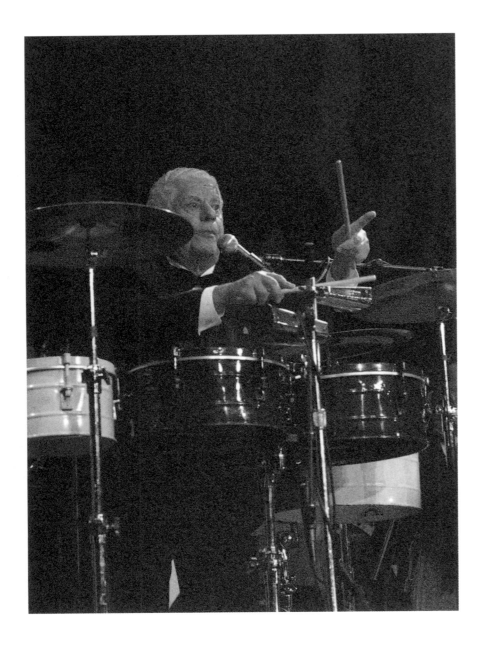

Above: Tito Puente performs at NARAS
benefit concert at Manhattan Center.
New York, New York.
Photographer: Rita Rivera
Right: Young drummer daydreams before the
start of the Puerto Rican Day parade.
New York, New York
Photographer: Rita Rivera

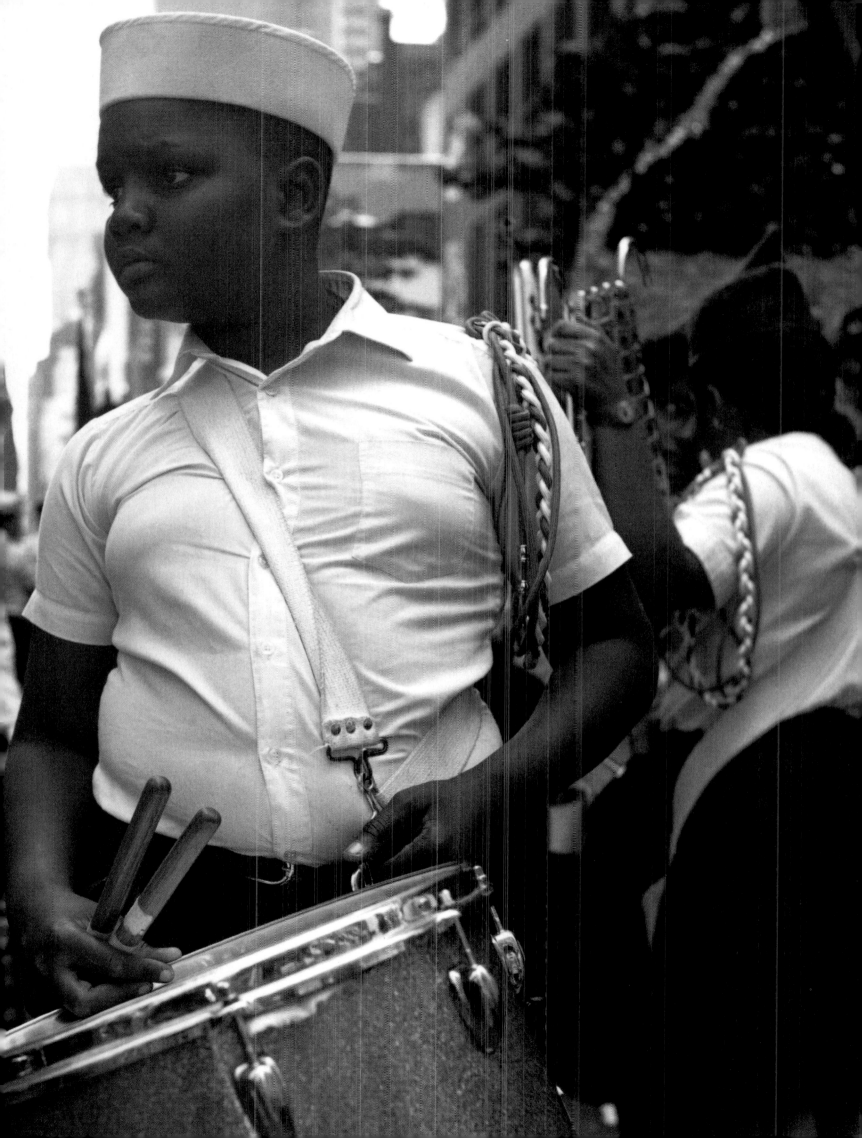

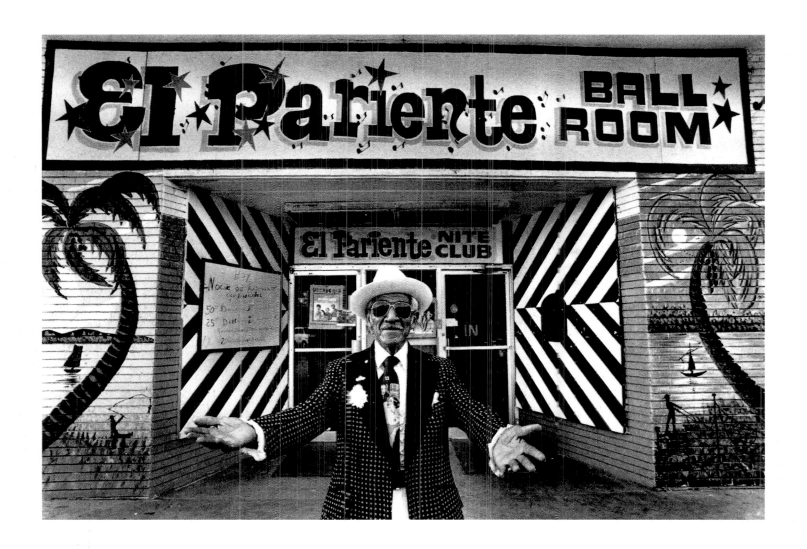

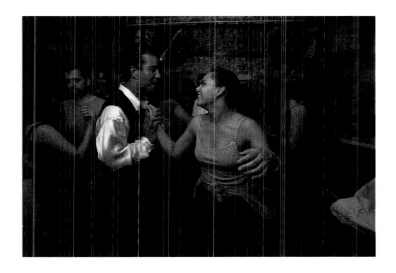

> Spanish, the language in general and the Latino culture in particular, has influenced my own approach to art. The writings of Paz, Márquez, Neruda, Martí, Machado de Asís, Allende, *y otros;* the paintings of Tamayo, Rivera, *y otros;* all the music of Mexico and South America, the dance *folklórica,* the rancheros and *todas las artes* have inspired me, encouraged me, informed me, and uplifted me.

If, as the song says, Jalisco has sweethearts in Guadalajara, it is also true Latino culture has admirers all over the world.

Maya Angelou

V
El español, el lenguaje en general y la cultura latina en particular han influenciado mi propio enfoque del arte. Los escritos de Paz, Márquez, Neruda, Martí, Machado de Asís, Allende y otros; las pinturas de Tamayo, Rivera y otros; toda la música de México y Suramérica, las danzas folklóricas, la música ranchera, y todas las artes, me han inspirado, animado, informado.

Como dice la canción: 'Jalisco tiene amores en Guadalajara', es muy cierto que la cultura latina tiene admiradores a través del mundo.

Above: Tania León, professor, composer, and conductor.
Queens, New York
Photographer: Alexis Rodríguez-Duarte

Opposite: Rita Moreno, actress and singer, is the only female performer who has won all four of the most prestigious show business awards — the Oscar, Emmy, Tony, and Grammy.
Berkeley, California
Photographer: Alexis Rodríguez-Duarte

Above: Director Marcos Zurinaga (left), Andy García (center), and Edward James Olmos during the filming of *Blood of a Poet*.
Hollywood, California
Photographer: John Castillo

Opposite: Gloria Estefan, singer and composer, with her husband, record producer Emilio Estefan, at the Biltmore Hotel.
Coral Gables, Florida
Photographer: Alexis Rodríguez-Duarte

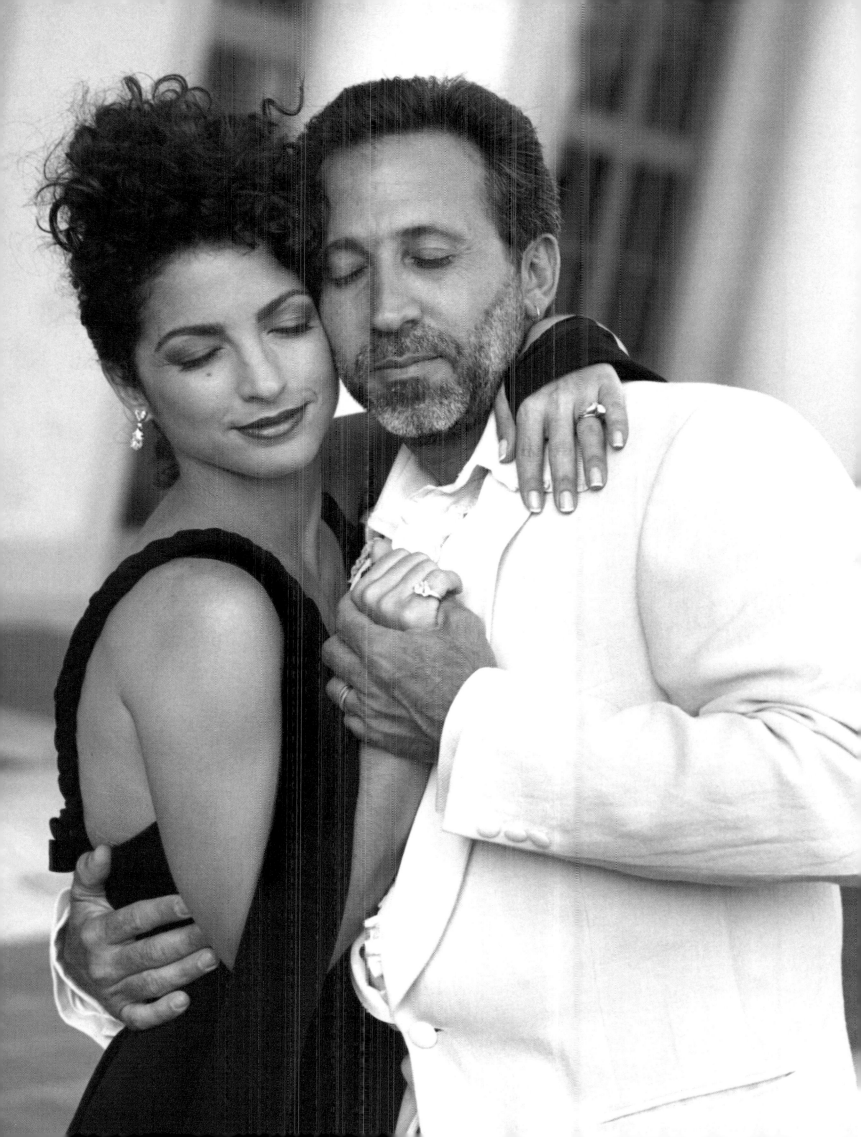

take my hand *toma mi mano*

Juan Carlos Heredia

I have not changed
 I am still so bold as to think that I see
 the sky with different eyes than the rest of the world

But of course there are only a few of us
 Those of us who
 view the sky from the sky
 who taste the rain while its sweetness
 is still cupped by the clouds

who, like me
 can feel the wind against my face in the still of the day
 when the wind can not be seen

who returns to the peaks below
 with the sunset painted on my forehead
 on my chest, on my arms
 my loins
 my legs
 my feet

In the silence of my return I hide the brush
 so you will think
 that it is only the dust
 that makes the sky

The sky for you may be seen only
 as laws
 and principles
 while for me
 what I paint
 is what I view

Here is your brush
 I have saved this one
 just for you
 now come
 take my hand

No he cambiado
 Aún soy tan atrevido que pienso que veo
 el cielo con ojos diferentes al resto del mundo

Pero claro que somos muy pocos
 Esos de nosotros que
 vemos el cielo desde el cielo
 que probamos la lluvia y su dulzura
 mientras todavía está ahuecada en las nubes

Que, como yo
 pueden sentir el viento en la cara durante la paz del día
 cuando el viento no se puede ver

Que regresan a los picachos de abajo
 con el ocaso pintado en la frente
 en el pecho, en los brazos
 en las ingles
 en las piernas
 en los pies

En el silencio de mi regreso yo escondo a un pincel
 para que tú creas que
 es sólo el polvo
 lo que hace el cielo

El cielo para ti se ve solamente como
 leyes
 y principios
 mientras que para mí
 lo que yo pinto
 es lo que yo veo

Aquí está tu pincel
 he guardado éste
 sólo para ti
 Ahora ven
 toma mi mano

Opposite: Jason Pruitt spends some special time walking along a country road with his great-grandmother, María Quintanilla.
Houston, Texas
Photographer: Carlos Ríos

biography *biografía*

EDITORS

Edward James Olmos

Edward Olmos, producer of *Americanos*, is a multitalented actor, producer, director, and community activist. He was born in East Los Angeles and spent many years in theatrical roles until his mesmerizing performance in the musical play *Zoot Suit*, which led to a Tony Award nomination. Later he went on to star in films such as *Wolfen, Blade Runner, Mirage,* and *Triumph of the Spirit.* An Academy Award nominee, Olmos also starred in *Stand and Deliver, American Me, My Family/Mi Familia,* and *Selena.* Olmos was honored with a Golden Globe Award and an Emmy Award nomination for his work in the HBO production *The Burning Season,* the story of Brazilian political activist Chico Mendes. For his portrayal of Lt. Castillo on the popular television series *Miami Vice,* Olmos also won an Emmy Award and a Golden Globe Award. In addition to Olmos's many acting credits and honors, he has received honorary doctorate degrees and participates in many humanitarian efforts. He is the United States Goodwill Ambassador for UNICEF, and is a national spokesman for many community organizations. Olmos speaks every year at an average of 150 schools, charities, and juvenile institutions across the country.

Dr. Lea Ybarra

Lea Ybarra, who served as project director and text editor for *Americanos,* is currently executive director of the Institute for the Academic Advancement of Youth at Johns Hopkins University, Baltimore, Maryland. She has a Ph.D. in sociology from the University of California, Berkeley, and has been a university professor and administrator for twenty-five years. She also serves as senior research associate for Olmos Productions and as president of Olmos Publishing. A recipient of numerous awards for her teaching, research, and community activities, Dr. Ybarra has made hundreds of presentations and has published articles in leading journals. She has directed a variety of projects such as Project EXCEL, which promotes math, science, and computer technology opportunities for young women. She has conducted research in family studies and immigration and has produced several photographic exhibits based on this research. Among the awards Dr. Ybarra has received for her research and community service activities are Hispanic Educator of the Year, the Rosa Parks Award for Outstanding Community Service, Hispanic Women Making History, and the University's Exceptional Service Award for Excellence in Teaching.

Manuel Monterrey

Manuel Monterrey is a photojournalist who began his career with Associated Press in Washington, D.C. in 1984, as a part-time receptionist. He eventually worked his way up through the ranks and worked as a photographer in Central America for nearly two years. After returning from Central America in 1994, Monterrey became a freelance photographer providing his services to many news and private corporations. He served as an assistant chief photographer for the Journal Newspapers, a division of Gannett, and was chief photographer and photo editor for *Black Issues in Higher Education,* a national publication. Monterrey was also a staff photographer for Georgetown University from 1994 to 1996 and freelanced for American and Howard Universities.

PHOTO EDITORS

Michel du Cille

Michel du Cille has been photo editor of the *Washington Post* since 1988. He previously worked for the *Miami Herald* as a photographer. In 1988, du Cille won his second Pulitzer Prize in feature photography, for a photo essay that documented crack cocaine addicts in a Miami public housing project. His first Pulitzer was shared with Carol Guzy, a *Miami Herald* staff photographer. Their work in *Spot News* was awarded the Pulitzer Prize for the coverage of the November 1985 eruption of Colombia's Nevado del Ruiz volcano, which killed 23,000 people. In 1989, du Cille was among the staff of picture editors for the book *Songs of My People,* which documented the lives of African-Americans. In March 1993, he was part of a team of picture editors for a photographic book called *The African Americans.*

Eric Easter

Eric Easter is chief executive officer of One Media, Inc., a Washington, D.C.–based creative agency, and partner in the Akin & Randolph Agency, a New York talent management firm representing authors, artists, and athletes. One Media specializes in publishing, new media, public affairs, and special events. Easter serves as the publisher and editor of *ONE,* a journal of politics and culture, and as publisher of *Black Film Review,* an international scholarly magazine. He served as guest editor of *The International Review of African American Art.* He is also the creator and coeditor of *Songs of My People* (Little, Brown and Company, 1992), a book, international exhibit, and multimedia project, and has collaborated on several book projects including *Jumping the Broom* (Henry Holt, 1994), and *How to Be* (Simon & Schuster, 1997). He is currently developing a book and exhibition on blacks in architecture and industrial design entitled *The Color of Design.*

José Gálvez

For the past twenty-five years, José Gálvez has been photographing Mexican-American communities of the Southwest and West. One of the premier photographers documenting Latinos today, Gálvez won the Pulitzer Prize in community service for his role as lead photographer for a series on Chicanos that ran in the *Los Angeles Times.* He currently directs the Mexican-American Cultural Art Center, a nonprofit organization dedicated to presenting contemporary Latino literary, theatrical, and visual art, in his hometown of Tucson, Arizona.

Mark Hinojosa

Director of photography for the *Chicago Tribune* since 1994, Hinojosa administers a staff of sixty-seven that includes photographers, photo editors, assignment editors, and lab personnel. Hinojosa's challenge has been to develop and maintain a vibrant news-generating department that consistently produces photojournalism that informs and inspires readers. The *Tribune's* photo department has begun to meet some of those goals. In the 1997 Pictures of the Year competition, the *Tribune* was awarded a third place for best use of pictures by a newspaper for the first time in its history. Hinojosa began his newspaper career in 1979, when he joined the staff of the *Kansas City Star* and was selected as the first photographer to participate in the Capital Cities Minority Training program. In 1987, he joined the staff of *New York Newsday,* where he worked for four years as a staff photographer.

Liliana Nieto del Río

Liliana Nieto del Río is a photojournalist based in Los Angeles. Her work has appeared in numerous publications, including the *New York Times,* the *Los Angeles Times, Time, Newsweek,* and *Stern.* Nieto del Rio covered the uprising in Chiapas, Mexico, during 1994 and 1995. Other assignments have included covering the influx of Kurdish refugees into Turkey following the Gulf War, civil strife in Central and South America, and events at the United States–Mexico border. She was awarded the John S. Knight Fellowship for journalists during 1995–96 at Stanford University, where she pursued an interest in the development of documentary work on the Internet. While a staff photographer at *New York Newsday,* she won the 1989 World Press Budapest photojournalism award and received a grant from the Museum of Photographic Arts in San Diego for a traveling exhibit about the borderlands. Recent personal work includes an ongoing project about immigrant women, part of which appeared in 1997 on the Web site of the American Film Institute.

PHOTOGRAPHERS

Victor Aleman

Victor Aleman has been editor for the *Vida Nueva* since 1991. He previously worked for 2 MUN-DOS communications, United Farm Workers Publication Department, Food and Justice, and El Malcriado, among others. Aleman has won numerous awards including Outstanding Spanish Language Weekly, Large Publication, Outstanding Magazine Format for "La mecanica del ojo"; Outstanding Editorial Color Photo—Cultural for "El retiro es bueno"; and Outstanding Editorial Black-&-White Photo—Cultural for "El Aguila de la Union de Campesinos."

Jules Allen

Jules Allen has exhibited his work in numerous galleries throughout New York during the past ten years. He studied photography at San Francisco State College and Hunter College in New York. His work has appeared in several publications including *Black Renaissance*, the *Star Ledger, Amistad Media Limited,* and the *African Contemporary Art International* magazine.

Héctor Amezcua

Mr. Amezcua was born in Mexico City in 1970. He received a B.S. in Chicano studies and a B.A. in journalism in 1993 from California State University, Fresno. He covered the varied aspects of daily life for the *Modesto Bee*, the *Fresno Bee*, and the *Sacramento Bee*. Amezcua has worked on several projects and stories that focus on the selflessness of our people when it comes to helping someone in need. It is with those stories that he hopes to show a positive side of the Latino community.

Juana Arias

Juana Arias started her photojournalism career in 1984 covering the political conflict in Central and South America for Reuters, the Associated Press, *Time, Newsweek*, and others. In 1990, she moved on to a staff position at the *Philadelphia Daily News*, and since 1993 Arias has been at the *Washington Post*. Arias is a native of Lima, Peru.

Aurelio José Barrera

After gaining experience as an intern for the *Los Angeles Times*, Barrera became a photographer on staff in 1987 where he covered daily assignments for the newspaper and special assignments in the Southwest, Mexico, and Nicaragua. In 1994 he became the Orange County Edition's weekend photo assignment editor. He taught photography to youth in public housing complexes through a project called "Empowering Raza Youth Through the Arts" for two consecutive years.

Andy Barrón

Andy Barrón has gained experience in photography throughout various internships. The internships include work at the *Anchorage Daily News*, the *Honolulu Advertiser,* the *Naples Daily News*, and the *San Jose Mercury News*. In 1996 he joined the staff at the *Reno Gazette-Journal* as a photojournalist.

John Castillo

John Castillo has been a freelance photographer since 1980. After studying at UCLA and the Art Center College of Design, he apprenticed with glamour photographer Douglas Kirkland and went on to assist various Hollywood photographers. He continues working in motion picture photography and celebrity portraiture. He has worked with Olmos Productions on several films such as *Deadly Games, Slave of Dreams, Mi Familia, American Me, Roosters,* and *The Limbic Region*. A volunteer with California's Partners in Education program, Castillo mentors underprivileged children in the Sacramento school district.

Al Díaz

Al Díaz is a staff photographer for the *Miami Herald*. He previously worked for the *Gainesville Sun* and the Associated Press. Díaz has won numerous awards including the Pulitzer Prize for public service for team coverage of Hurricane Andrew; the Robert F. Kennedy Journalism Award the National Association of Hispanic Journalists Best of Show; and the Society of Newspaper Design Award of Excellence. In 1998 he was the Visual Task Force chair for the National Association of Hispanic Journalists.

Jimmy Dorantes

Jimmy Dorantes learned to use a 35mm camera when he was eleven years old. By the age of thirteen, he was selling freelance photos to his hometown newspaper, the *Calexico Chronicle*. Among the news organizations he has worked for are the Associated Press, the *Albuquerque Tribune*, and the *Seattle Times*. As a photojournalist at the *Press-Enterprise*, he has won several national photojournalism awards. Dorantes has had several one-man gallery shows, the most recent featuring images taken while living in India. His work has appeared in *Time, Newsweek, Sports Illustrated. Photo District News*, and other international publications. Dorantes is the founder of Latin Focus, a photo agency specializing in images from South and Central America and Mexico, and of Latinos living in the United States.

Héctor Emanuel

Héctor Emanuel's photographs can be seen on a regular basis in *El Tiempo Latino* newspaper and the *Washington Sidewalk*. He has also done work for the American Red Cross, the Washington Performing Arts, *Hispanic* magazine, the *City Paper*, and many other newspapers and organizations in the United States. He has also been published in many newspapers in Latin America such as *El Tiempo* in Colombia, *El Nuevo Dia* in Puerto Rico, *El Pais* in Uruguay, and *El Universal* in Mexico. Mr. Emanuel has received national recognition for his photos from Cuba, Peru, Washington, D.C., and Chiapas, Mexico.

Curtis Fukuda

Curtis Fukuda currently works as a professional photographer in Mountain View, California. He is also a writer and Internet directory topic manager for Infoseek Corp. As an exhibiting artist, Fukuda has shown his work in the United States, Mexico, and Germany. He frequently collaborates with artist Lissa Jones. In 1997, Fukuda published a book of folk tales, *Cuentos de el Dia de los Muertos*, with Salvador Gonzalez. He is currently working on a book about el Dia de los Muertos in Oaxaca, Mexico, with Dr. Shawn Haley, professor of anthropology at Red Deer College in Alberta, Canada.

José Gálvez

(see photo editors)

Timothy J. González

Timothy González is a staff photographer for Oregon's *Statesman Journal*. He previously worked for the *Half Moon Bay Review* and *San Mateo Times*. González's awards include the Oregon Newspaper Publishers Association Better Newspaper Award and numerous awards from the National Press Photographers Association.

Janet Jarman

Janet Jarman is a photojournalist based in London. She formerly worked as a staff photographer at the *Miami Herald* where her work received national and regional recognition. She has dedicated much of her career to covering stories in Latin America and has worked in most countries in the region. Her work has been featured in several national and international exhibits. She lived in Chile for one year before relocating to London in 1996. Continuing her focus on the region, Jarman's most recent photographic essays chronicle environmental problems on the Mexico–United States border, the plight of one Mexican family searching for a better life in the United States, and NGO responses to public health deficiencies in Brazil. Jarman holds a B.A. in journalism from the University of North Carolina at Chapel Hill and an M.S. in environmental issues from the University of London.

Ramon Mena Owens

Ramon Mena Owens is a staff photographer for the *Cleveland Plain Dealer*. He previously worked for the *Columbus Dispatch*, the *Boston Globe,* and the *San Antonio Light*. He has photographed life in Mexico following the devaluation of the peso, the prison conditions in Ohio, the war in El Salvador, and military action in Honduras. Owens has won various awards from the Associated Press and Ohio News Photographers Association.

Genaro Molina

Genaro Molina is a staff photographer for the *Los Angeles Times*. He previously worked for the *San Francisco Chronicle, the San Jose Mercury News, the Claremont Courier,* and *the Sacramento Bee*. He has photographed Pope John Paul II at the Vatican; the impact of the Exxon Valdez oil spill in Alaska; the misuse of pesticides in Culican, Mexico; the tragedy of AIDS in eastern Africa; and the plight of Guatemalan refugees. Molina has won numerous awards, including California Photographer of the Year (California Press Photographers Association), the Clarion Award, and second place Photographer of the Year (National Press Photographers Association).

Liliana Nieto del Río

(see photo editors)

José M. Osorio

José Osorio is a native of the San Francisco Bay Area and a graduate of San Francisco State University. Since 1991 he has worked at the *Chicago Tribune* as a staff photographer. Besides shooting general news and sporting events, Osorio has worked on a wide range of special projects, including the effects of the North American Free Trade Agreement on border towns in Mexico, recruitment of priests for the Catholic church, and, most recently, baseball in Cuba. He was awarded the 1997 Baseball Hall of Fame Feature Picture of the Year and has also garnered many Illinois and Chicago Press Photographers Association awards.

Antonio Pérez

Antonio Pérez is a full-time photographer for *¡Exito!*, a Spanish publication at the *Chicago Tribune* that focuses on the Latino community, featuring community, news, sports, features, and entertainment. He photographs a wide array of subjects from superstars of Latino entertainment to the champion Bulls. At *¡Exito!* Pérez has been photographing covers, sports, photo essays, and hard news. His work at *¡Exito!* has taken him on assignments to El Salvador, Guatemala, and Mexico. In addition to *¡Exito!*, he has also contributed to the *Chicago Tribune, Chicago Magazine,* and many other publications. He has private collections at Chicago's Art Institute, the Museum of Contemporary Photography, and the Stuart Baum Gallery.

Paul Pérez

Paul Pérez was a freelance photographer for *¡Exito!* newspaper, a Spanish-language weekly published by the *Chicago Tribune*. He has also worked as a freelance photographer for the United Way of Chicago, *People* magazine, Motorola Inc., and Mongoose Performance Bicycle Company. He currently works for the *Yuma Daily Sun* newspaper in Yuma, Arizona. His most notable assignment, of Scottie Pippen of the Chicago Bulls, was for *People* magazine. He recently won first place in the Sports Feature category and second place in the Portrait category of the Associated Press 1998 Arizona News and Photo Excellence Awards.

Pedro Pérez

Pedro Pérez is a staff photographer for the *Seattle Times*. He previously worked for the *Bellingham Herald*, in Washington, and several daily newspapers in the Fresno area.

Eugene Richards

Eugene Richards, a freelance photojournalist and writer, is the author of nine books. He received the Guggenheim Fellowship and the W. Eugene Smith Memorial Award, and was awarded the Kodak Crystal Eagle Award for Impact in Photojournalism. He won the Nikon's Book of the Year award in 1986 for *Exploding Into Life* and the Kraszna-Krausz Award for Photographic Innovation in Books for *Cocaine True, Cocaine Blue* in 1994. He was also the 1995 recipient of the International Center of Photography's Infinity Award for Best Photographic Book for *Americans We*. Richards was named Magazine Photographer of the Year in 1996 by the National Press Photographers Association, and was a media fellow of the Henry J. Kaiser Family Foundation in 1997.

Rita Rivera

Rita Rivera's work has recently been published in *Nueva Luz*, a photographic journal, and has been exhibited in Japan and throughout New York. She has done freelance photography for *NY Latino, El Diario La Prensa,* Avanti Greeting Cards, Houghton Mifflin, Penguin Books, Simon & Schuster, and *People en Espanol,* among others.

Carlos Antonio Ríos

Carlos Antonio Ríos has been a staff photographer with the *Houston Chronicle* since 1978. He is a native Texan from San Antonio and a member of the National Association of Hispanic Journalists, the National Press Photographers Association, and the Houston Hispanic Media Professionals. He is an award-winning photographer who has covered hard-hitting national and international stories. He has had the opportunity to cover dangerous, breaking stories and wars in Central America and the Persian Gulf, and conflicts in Mexico, Cuba, and throughout the United States.

Alexis Rodríguez-Duarte

Alexis Rodríguez-Duarte's work appears in publications such as *Vanity Fair, Esquire, Out, The New Yorker, People en Espanol, L'Uomo Vogue,* the *New York Times, Harper's Bazaar, Time Magazine On-Line,* and *Town & Country.* His sitters have included Victor Alfaro, Pedro Almodovar, Princess Marcelia Borghese, Ben Bradlee, Gloria Estefan, Lauren Hutton, Enrique Iglesias, Rossy De Palma, Gianni Versace, Gloria Vanderbilt, and Xuxa. The fashion stylist for many of Rodríguez-Duarte's photos is his associate, Tico Torres.

Miriam Romais

Miriam Romais is managing director for En Foco, a photography organization that publishes and exhibits works by Latino, African, Asian, and Native American photographers. She has been awarded residencies at Light Work, Syracuse, New York; the Photographic Resource Center in Boston; and has won the Visual Arts Travel Grant from the Mid Atlantic Arts Foundation. Romais is a photographer and curator for the *Fire Without Gold* exhibitions, which feature works by contemporary photographers of color.

Marcio J. Sánchez

Marcio Sánchez is a staff photographer at the *Kansas City Star* in Kansas City, Missouri. He previously worked for the *Gazette-Journal* in Reno, Nevada; the *Press Telegram* in Long Beach, California, and the *Press Telegram* in Palm Beach, Florida. Sánchez has traveled to Mexico for a story on Amish people from the Midwest seeking alternative health care from that country; and to South Africa with a curator from the Kansas City Zoo to transport a wild rhinoceros to America. He is currently covering the Kansas City Royals baseball team, which included a month stint in Florida for spring training.

Beatriz Terrazas

Working at *Fort Worth Star-Telegram*, Beatriz Terrazas covered a variety of assignments that included the resignation of U.S. House Speaker Jim Wright, Pope John Paul II's visit to Mexico, and the 1992 Republican National Convention. At the *Dallas Morning News,* she worked on a project, "Violence Against Women: A Question of Human Rights," that focused on the women of Mexico and Brazil. The project later won the 1994 Pulitzer Prize for international reporting. Terrazas also covered Pope John Paul II's visit to Denver, Colorado, in 1993, his historic trip to Cuba in 1998, the 1996 Republican Convention, and various immigration issues in Mexico and the United States. She has received many awards, but her most recent honor was being selected by the Nieman Foundation at Harvard University as a 1998–99 fellow where she will study Latin American history and creative writing.

Nuri Vallbona

A *Miami Herald* photojournalist, Nuri Vallbona started as an intern at Long Island's *Newsday,* followed by a job at the *Longview* (Texas) *News Journal* and then a few years at the *Colorado Springs Sun.* From there she worked at the *Fort Worth Star-Telegram,* the *Dallas Morning News,* and the *Houston Post.* Her work has won numerous awards from the Pictures of the Year Competition, Atlanta Seminar on Photojournalism, Southern Short Course, Associated Press, United Press International, Society of Newspaper Design, and the National Association of Hispanic Journalists.

José Luis Villegas

José Luis Villegas is a staff photographer at the *Sacramento Bee.* He previously worked for the *San Jose Mercury News,* the *Los Angeles Daily News,* the *Arizona Daily Star,* and the *Orange County Register.* Villegas has won numerous awards, including the Pulitzer Prize Team Entry for the coverage of the Loma Prieta earthquake; the Inter-American Press Association Award; the National Association of Hispanic Journalists Photography Award; and several awards from the Society of Newspaper and Design. Villegas and writer Marcos Breton were awarded the Alicia Patterson Fellowship, to continue their project on Latin baseball. The book will be published by Simon & Schuster in the spring of 1999.

Magdalena Zavala

Magdalena Zavala is a staff photographer at the *New Orleans Times-Picayune.* She previously worked for the *Laredo Morning Times* and *Newsday.* Zavala's work includes photographing the major social, political, and physical changes along the United States–Mexico border in Laredo, Texas, after the signing of the North American Free Trade Agreement.

GUEST PHOTOGRAPHER

George Elfie Ballis

George Elfie Ballis received a double B.A. from the University of Minnesota in journalism and political science. While editor of the *Valley Labor Citizen*, an AFL-CIO weekly in Fresno, he began photographing farm workers' conditions in the San Joaquin Valley. He has done photo work for

the Sierra Club, *Sunset, Natural History,* and the *Saturday Evening Post,* among others. Mr. Ballis left the *Labor Citizen* to become field director for Self Help Service Corps, where he trains rural community organizers. He is currently a freelance photographer, film maker, and director of Sun MTN. His films include *I Am Joaquin, The Dispossessed, The Oakland Five, Toughest Game in Town,* and *The Richest Land.* His farm-worker photos have appeared in many books and periodicals, including *Life, Time, People,* and *Vogue.* With Matt Herron he recently produced a large installation of farm-worker photos, a multimedia, multicultural, bilingual poem called *Dream What We Can Become and Rejoice.*

WRITERS

Dr. Carlos Fuentes

Carlos Fuentes is a prolific writer and Mexico's leading novelist. He has authored many books including *La Region Más Transparente, Aura, Terra Nostra, Burnt Water, Distant Relations, The Old Gringo, The Death of Artemio Cruz, The Hydra Head, The Crystal Frontier,* and *A New Time for Mexico.* In addition to teaching at Columbia, Harvard, Princeton, Brown, and other universities, Dr. Fuentes has been Mexico's ambassador to France. He has won many prestigious awards including the Romulo Gallegos Prize, in Venezuela; the Cervantes Prize, the highest honor given to a Spanish-language writer; Mexico's National Award for Literature; Principe de Asturias Prize from Spain; and the Cavour Prize from Italy. Dr. Fuentes has degrees from the University of Mexico and the University of Geneva (Switzerland) Law Schools. He has held the Robert F. Kennedy Chair at Harvard University and the Simón Bolívar Chair at Cambridge University. He is a world-renowned scholar.

Humberto Ak'abal

Humberto Ak'abal was born in 1952, in the village of Momostenango, Totonicapán, Guatemala. His poems have been translated into English, Portuguese, French, German, and Italian. They have also been published in newspapers and magazines in Guatemala, Mexico, the United States, Venezuela, Brazil, Colombia, Spain, France, Switzerland, and Germany. *Guardian de la caida de agua* was nominated as book of the year and awarded the "Quetzal de Oro" in 1993 by the Guatemalan association of journalists, APG. He has also received the international poetry award "Blaise Cendras" in 1997 given by the Cultural Department of the City of Neuchâtel, Switzerland

Maya Angelou

Maya Angelou is an author, poet, historian, actress, playwright, and civil rights activist. She was the first black woman to have an original screenplay produced, in 1972, *Georgia, Georgia* and she was nominated for an Emmy Award for her acting in *Roots* and *Georgia, Georgia.* She has written several volumes of poetry and is fluent in French, Spanish, Italian, and West African Fanti. Ms. Angelou was the northern coordinator for the Southern Christian Leadership Conference at the request of Dr. Martin Luther King Jr. She was

appointed to the Bicentennial Commission by President Gerald Ford, and to the National Commission on the Observance of International Women's Year by Jimmy Carter. She has published ten best-selling books, including *I Know Why the Caged Bird Sings,* and countless magazine articles. In 1993 she wrote and delivered a poem for President Bill Clinton's inauguration.

Irene Lopez Aparicio

Irene Lopez Aparicio received a B.S. in administration of recreation therapy and a master's in social work from California State University, Fresno. She has worked in the field of mental health for thirty years and has worked as recreation therapist specialist in acute mental health at Fresno Community Hospital and as a foster care therapist at Genesis. She is currently a therapist for Children, Youth and Family Services at Kings View Madera Counseling Center as well as a workshop presenter in the area of stress management and child development. She writes poetry, short stories, and articles for professional publications. She has received awards and recognition for her services in the health field and for her community involvement.

Dr. David Carrasco

David Carrasco is a professor at Princeton University and has a Ph.D. from the University of Chicago. He is a historian of religions who works on Aztec and Maya cultures as well as the symbols, narratives, and religions of the mestizo borderlands and the brown millennium. He is one of the first Chicano tenured faculty members in the Ivy League and teaches courses at Princeton University on Mesoamerican Religions, Religion and Latin(o)-American Imaginations, and American Indian Religions. Among his books are the best-selling *Religions of Mesoamerica: Cosmovision and Ceremonial Centers* and the prize-winning *Quetzalcoatl and the Irony of Empire: Myths and Prophecies in the Aztec World.* He also explores the religious dimensions in the works of Carlos Fuentes, Toni Morrison, and Russell Banks.

Dr. Virgilio Elizondo

Virgilio Elizondo, a native of San Antonio, Texas, has an S.T.D./Ph.D. degree from the Institut Catholique (Paris, 1978); an M.A. degree in religious studies from the Ateneo University (Manila, 1969); a diploma in Pastoral Catechetics from the East Asian Pastoral Institute (1969); and a B.S. degree in chemistry from St. Mary's University (1975). He was rector of San Antonio's San Fernando Cathedral (1983–1995). He was founder and first president of the Mexican American Cultural Center and founder of Nuestra Santa Misa de las Americas, an international weekly televised Mass for the Americas. Dr. Elizondo has been a professor or a visiting professor at various major universities throughout the United States and at the major pastoral institutes throughout the world. He is currently senior research scholar for a project on the study of San Fernando Cathedral as the cradle of the Mestizo Christianity of the United States and producer of religious programs for CTSA-22, the Catholic television station of San Antonio.

Dr. Juan Flores

Juan Flores is a professor in the Department of Black and Puerto Rican Studies at Hunter College, and in the Sociology Program at the CUNY Graduate School. From 1994 to 1997 Dr. Flores served as director of the Center for Puerto Rican Studies at Hunter College. He received his Ph.D. from Yale University in 1970. His doctoral training and early teaching career at Stanford University were in the field of German literature and intellectual history. He is the author of *Poetry in East Germany* (*Choice* magazine award), *Insularismo e ideologia burguesa* (winner Casa de las Américas prize), and *Divided Borders: Essays on Puerto Rican Identity.* He is also translator of *Memoirs of Bernardo Vega* and coeditor of *On Edge: The Crisis of Contemporary Latin American Culture.* He is currently working on a new book, *From Bomba to Hip Hop: Popular Culture and Puerto Rican/Latino Identity,* forthcoming from Columbia University Press. His work has appeared in numerous journals and newspapers in the United States and internationally, including *Dædalus, Modern Language Quarterly, Revista de Ciencias Sociales, Casa de las Américas,* and *Harvard Educational Review.* He is coeditor of two book series, "Cultural Studies of the Americas," for University of Minnesota Press, and "Puerto Rican studies," with Temple University Press. In the spring 1998 semester he was Visiting Professor of Ethnic and Latino Studies at Harvard University.

Dr. David Hayes-Bautista

Dr Hayes-Bautista is currently professor of medicine and director of the Center for the Study of Latino Health at the School of Medicine at the University of California, Los Angeles. He previously served as professor, School of Public Health, University of California, Berkeley. He graduated from University of California at Berkeley and completed his M.A. and Ph.D. in Medical Sociology at the University of California Medical Center, San Francisco. His research and professional interests focus on Latino demographics and health policy, culturally effective care delivery, and Latino culture, identity, and behavior. He has published extensively in *Family Medicine,* the *American Journal of Public Health, Family Practice, Medical Care,* and *Salud Publica de Mexico.* He has received many honors including the 1996 City of Los Angeles Mayor's Award, 1996 Aztec Award for Exemplary Achievement, 1996 Lifetime Achievement in Health Sciences, Eagle Award, and the 1994 Hispanic Business Magazine Hispanic Influential Award.

Juan Carlos Heredia

Juan Carlos Heredia was born and raised in Los Angeles and is a veteran of the Vietnam War. He is an artist, a singer, a musician, and an actor. He has a B.A. and an M.A. from the College of Communication Arts at Michigan State University and undertook his doctoral studies at MSU in the College of Education. For many years he was owner of a business in the commodities market. He currently teaches interpersonal communication and film contruction and criticism at Grand Rapids Community College.

Dr. Ada María Isasi-Díaz

Ada María Isasi-Díaz was born and raised in La Habana, Cuba. She is professor of Christian Ethics and Theology at Drew University. She has worked for the past twenty years at elaborating a theology that takes into account the religious understandings and practices of Latinas in the United States. Dr. Isasi-Díaz has coedited three books and has written four, the most recent one called *Mujerista Theology — A Theology for the 21st Century.* An accomplished lecturer in both English and Spanish, Dr. Isasi-Díaz has addressed audiences in three continents on social justice issues, women's struggles for liberation, and the marginality of racial/ethnic peoples.

Dr. Amalia Mesa-Baines

Amalia Mesa-Baines is an independent artist and cultural critic. As an author of scholarly articles and a nationally known lecturer on Latino art, she has enhanced the understanding of multiculturalism and reflected major cultural and demographic shifts in the United States. As an educator and community advocate, Dr. Mesa-Baines has served the San Francisco Unified School District, the San Francisco Arts Commission, and the Board of Directors for both the Galeria de la Raza and the Center for the Arts at Yerba Buena Gardens. Currently she is director of the Visual and Public Art Institute, California State University at Monterey Bay. She received her B.A. from San Jose State College, her M.A. from San Francisco State University, and an M.A. and a Ph.D. in psychology from the Wright Institute in Berkeley. She is a recipient of a distinguished MacArthur Fellowship.

Dr. Julia E. Curry Rodriguez

Julia E. Curry Rodriguez received a Ph.D. in sociology in 1988 from the Department of Sociology at the University of Texas at Austin. Her research addresses immigrant women, immigration, racial and sexual stratification, and a variety of issues pertaining to Chicanos and Latinos in the United States. She is currently a research associate at the Chicano/Latino Policy Project of the Institute for the Study of Social Justice at the University of California, Berkeley. She has held positions as assistant professor in the Department of Ethnic Studies at the University of California, Berkeley, and in the Sociology Department at Arizona State University.

Dr. Cecilia Y. Rodriguez Milanes

Dr. Rodriguez Milanes studied at the University of Miami where she received her B.A. She completed her M.A. in English literature at Barry University. At State University of New York at Albany, she received her doctorate in African-American women writers, composition, and critical theory. She currently teaches at Indiana University, and has taught at State University of New York at Albany. Dr. Rodriguez Milanes has written numerous essays, short fiction, poetry, and review pieces. Her awards include the Rockefeller Grant Award and the Senate Fellowship Committee Award.

TRANSLATOR

Hortencia Moreno-Gonzáles

Hortencia Moreno-Gonzáles, a native of Juarez, Chihuahua, Mexico, has been an educator in the Fresno, California, area for the past twenty-two years. She completed her formal education as an adult at Roosevelt High School. She attended Fresno City College and completed her degree in education at California State University, Fresno, in 1975. She graduated summa cum laude and holds credentials as a bilingual specialist and for secondary school and junior college. Besides teaching Spanish at Clovis West High School and ESL classes at Clovis Adult School, she has also been certified by the state as an interpreter and translator since 1983. From 1976 to 1985 she was an active member and president of the Association of Mexican American Educators, Fresno chapter. In 1989 she was a finalist for the "Professional Women of the Year" award, sponsored by the Clovis Chamber of Commerce.

DESIGNER

Michael G. Rey

Michael Rey has worked in numerous areas in design from movie campaigns, advertising, packaging, editorial design, logo/identities, catalogues, brochures, and film and television graphics to album covers. He has taught graphic design at the Art Center College of Design in Pasadena, the School of Visual Arts in New York, and the Otis School of Art and Design in Los Angeles. He earned his B.F.A. in advertising and his M.F.A. in fine arts from Art Center College of Design. He was formerly publisher and art director of *The Picture Newspaper,* New York City. Staff positions have included design director of *California* magazine and creative director of Container Corporation of America (Mexico City Division). He is owner of Rey International design studio (soon to be Intersection Studio), whose design and logo typography have received numerous national and international awards. The studio's diverse group of clients includes the Getty Center, Xerox, Pepsi, Warner Brothers, and E! Entertainment.